ENCAUSTIC ART

THE COMPLETE GUIDE TO CREATING FINE ART WITH WAX

LISSA RANKIN

Watson-Guptill Publications

NEW YORK

Published in the United States by Watson-Guptill Publications, an imprint of the Crown Publishing Group, a division of Random House, Inc., New York.

www.crownpublishing.com

www.watsonguptill.com

WATSON-GUPTILL is a registered trademark and the WG and Horse designs are registered trademarks of Random House, Inc.

Library of Congress Cataloging-in-Publication Data

Rankin, Lissa.

 Encaustic art : the complete guide to creating fine art with wax / Lissa Rankin.

 p. cm.

 Includes bibliographical references and index.

 ISBN 978-0-8230-9928-3 (alk. paper)

 1. Encaustic painting--Technique. I. Title.

 ND2480.R36 2010

 153.3'5--dc22

 2010001928

Printed in China

Design by Karla Baker

10 9 8 7 6 5 4 3 2 1

First Edition

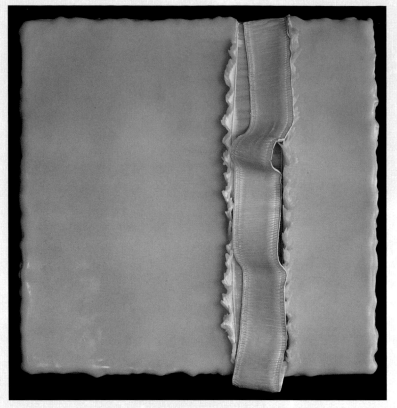

ABOVE Lissa Rankin, *Uncovering the Truth*. Encaustic on panel, 12 x 12 inches (30.5 x 30.5 cm), 2009. Photo by Matt Klein.

FIRST PAGE Daniella Woolf, *Beauty at My Feet*. Encaustic and eucalyptus leaves on panel, 24 x 48 inches (61 x 121.9 cm), 2006. Collection of Juana and Craig Meyer. Photo courtesy of rr jones.

TITLE PAGE Tina Vietmeier, *Nothing That We Are Not Study #1*. Encaustic with mixed media on panel, 16 x 12 inches (40.6 x 30.5 cm), 2005. Courtesy of Andrea Schwartz Gallery. Photo courtesy of J. W. Diehl.

For Matt Klein, my precious husband, muse, and backbone;
and for my daughter, Siena, who breathes life into my art
with every beautiful smile.

acknowledgments

How do I begin to say thank you, when I am completely indebted to an entire army of people without whom my dream would never have come true? Writing a book like this is akin to stitching together a quilt that spans multiple countries. Every stitch is necessary to hold the whole thing together. Without the assistance of dozens of friends, artists, gallerists, and product manufacturers, this book would lack the depth I hope it achieves. I must start by kissing the feet of Joy Mazzola, my tireless friend, personal assistant, and editor-in-chief of OwningPink.com. At one point, I was ready to throw in the towel, but Joy picked up the pieces, rallied me, and walked with me every step of the way. Deep bow. Namaste. I love you, sister.

Extra special gratitude to Richard Frumess, founder of R&F Handmade Paints, for his assistance with editing, his contributions to the book, and his pioneering spirit, without which encaustic would be much less popular and this book would be much less necessary.

To my husband, Matt Klein, thank you for your hundreds of photographs, your help with editing, for being both mother

and father to Siena when I jetted around the world for studio visits, and for supporting this project in every possible way. To my brother, Chris Rankin, thank you for your graphic design assistance and constant enthusiasm. Without your tireless work and creative vision, this book might still be a dream. To my mother, Trish Rankin, thank you for giving me life, holding my hand, being my angel investor, and helping me make this book happen.

Many thanks to Monique Feil, who got on a chartered plane, lost her flash in the Atlantic Ocean, and followed me through this process, photographing many of this book's most beautiful images without expecting anything but friendship in return. For your amazing photographic expertise and dearest friendship, I will always be grateful. Thank you to Rodney Thompson, who helped write the "Supports and Grounds" chapter and also provided consultation, photography, advice, art, and unflagging moral support. Thank you to Tracey Adams for your printmaking wisdom, your personal inspiration, and for editing this manuscript. Many thanks to Stephanie Walker, owner of Walker Contemporary, for your tireless support, loads of advice, and contributions to this book. Your friendship has been invaluable to me during this process.

Thank you, Cari Hernandez, for journeying beside me for many of this book's adventures and for always listening and believing in me. To Ed Angell, who answered my many technical questions with cheerful support, I send my gratitude. To Joanne Mattera, author of The Art of Encaustic Painting: Contemporary Expression in the Ancient Medium of Pigmented Wax, I owe a debt of heartfelt gratitude. Without your inspiration, I might still be painting with latex paint and many others would still be reinventing the wheel. To Mike Lecszinski of Enkaustikos! Wax Art Supplies, thank you for your contributions to the history chapter and for your many photographic contributions. Thank you to Ann Huffman for your help with the history chapter and for your support and enthusiasm for this project. Thank you, Reni Gower for writing the introduction to this book and championing the cause. Thank you to Monona Rossol, author of The Artist's Complete Heath and Safety Guide, for your patience in helping me untangle the myths from the truths on issues of safety.

To Rebecca Hyman, Rifka Angel's granddaughter, thank you for contributing the work of this medium's pioneer. To Blossom Segaloff and Maria Norton, thank you for providing art and information about Karl Zerbe, whose work and art inspired a generation of artists.

To Hylla Evans, of Evans Encaustics, thank you for all of your energy and support. To John Dilsizian, of Strahl & Pitsch, Inc, thank you for your technical advice about wax.

To Deborah Fritz of GF Contemporary and Giacobbe-Fritz Fine Art, the first dealer to take a chance and represent my art, I eternally bow at your feet. To the other dealers who represent my art—Bill Lowe of Bill Lowe Gallery, Susan Lanoue of Lanoue Fine Art, Candace Kaller of Kaller Fine Art, Kathryn Buchanan of Buchanan Gallery, and Sanja Simidzija of Art Projekts—thank you for your support and for believing in me as an artist. To the many other dealers who helped me collect information, reproduction rights, and photographs, thank you.

Special thanks to Katrina Klaasmeyer, formerly of Bill Lowe Gallery; Amanda Snyder of Winston Wächter Fine Art; and Anelecia Hannah of Betsy Eby Studio for responding to dozens of emails and helping with countless details. Thank you to the doctors at Women's Health Care—Peter Dietze, Helen Lee, Colleen McNally, and Rovena Reagan—for forgiving me the distraction this book became. And, of course, to Candace Raney, James Waller, and Autumn Kindelspire, as well as everyone else at Random House, a deep bow of thanks for believing in this book and holding my hand through this sometimes harrowing process. And to Monkey Barbara (a.k.a. Barbara Poelle): No author could be blessed with a better agent. Thanks for believing in me.

Finally but most importantly, to the artists who shared their art, technical information, and inspiration to this book, I extend my sincerest thanks. Without you, this book would have been a pale, weak account of my own solitary experience. Special thanks for your creative spirits and for the many ways you've inspired me and will certainly inspire readers of this book.

With love to you all,
Lissa

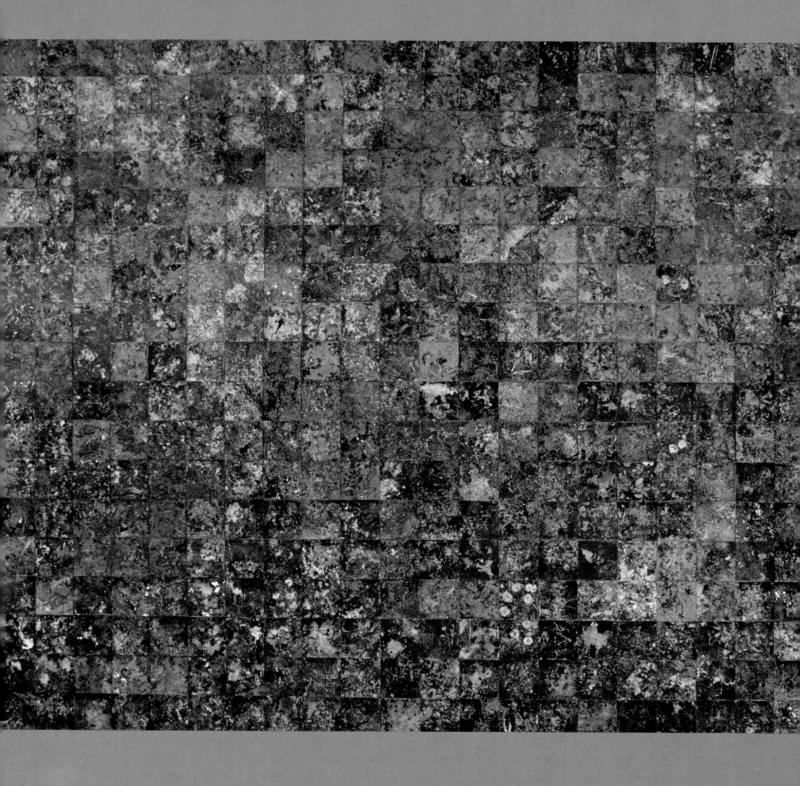

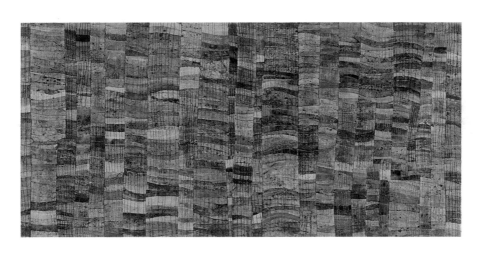

ENCAUSTIC ART

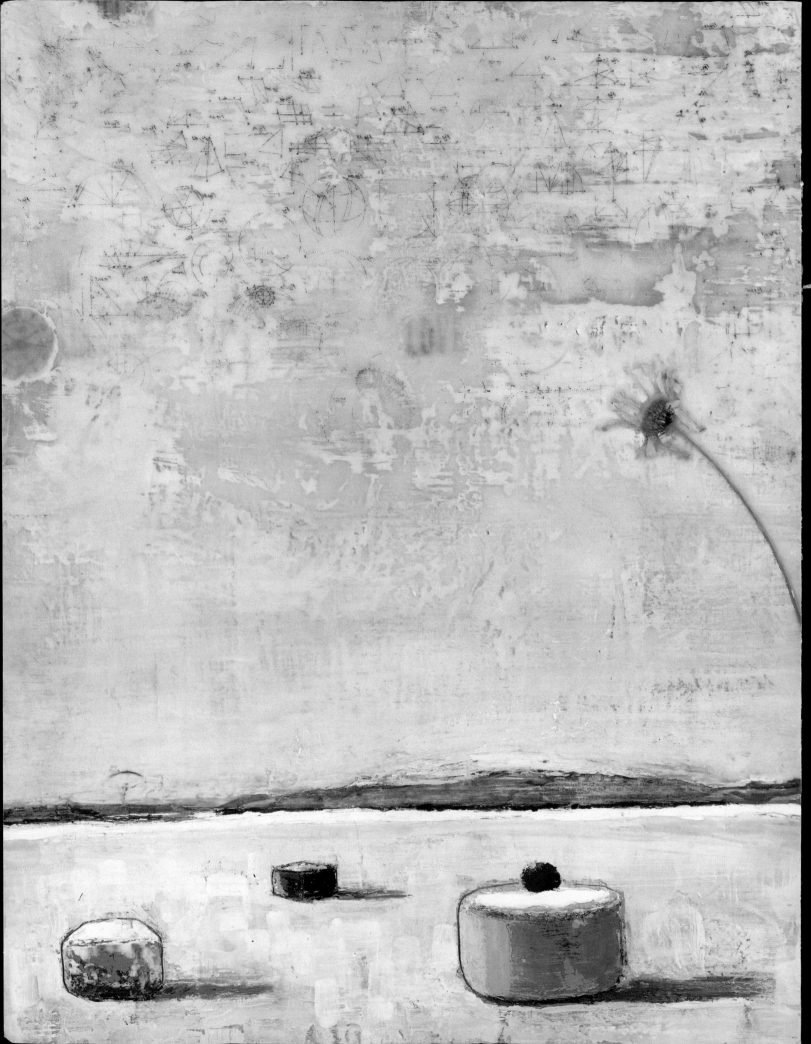

Contents

Michelle Stuart, *Paradisi: A Garden Mural*. Encaustic on mounted canvas, 198 x 396 inches (500.9 x 1005.8 cm), 1985-1986.
Commissioned by the Brooklyn Museum, Brooklyn, N.Y. for its main lobby. Photo courtesy Phillips/Schwab.

FOREWORD

Encaustic: The Complete Guide to Creating Fine Art with Wax is a welcome and much anticipated addition to the literature on encaustic art. If this book is your first introduction to the medium, expect to be captivated by this seductive process. If you are already familiar with encaustic, you will find the book—with its focus on technique—a valuable addition to your library.

Traditional encaustic (pigmented molten wax mixed with damar resin) is an ancient medium whose history can be traced back to the realistic, life-size Greco-Roman mummy portraits found in the mortuary temples near the Fayum oasis in the Egyptian desert. The word encaustic comes from Greek and means "to burn in," referring to the process by which the pigmented wax, after being applied, is fused by heat to the artwork's surface. While electricity has greatly simplified this process, the medium has remained basically the same since its wood-fire beginnings.

Over time, however, many of the ancient encaustic techniques were lost. Among modern artists, Jasper Johns was one of the first to use encaustic for a body of work. In seminal works such as his flag and target paintings, Johns's process was simple: On canvas, he collaged layers of newsprint, which functioned as an absorbent ground for the wax, which was melted in a single pot. He then fused the wax to the ground using an iron, a heat gun, or lamps. Most artists working with encaustic today have likewise reinvented the process for themselves through countless hours of experimentation and exploration. These

Reni Gower, *Divot*. Encaustic and collage on panel, 15 x 18½ inches (38.1 x 47 cm), 2006.
Photo courtesy of the artist.

explorations, coupled with the innovations of several paint manufacturers, have immensely expanded the parameters of contemporary encaustic, and numerous recent exhibitions and publications have fostered increasing interest among artists, dealers, curators, and collectors in this versatile and malleable medium.

The fluid nature of encaustic makes the medium particularly well suited to process-based abstraction. Encaustic can, however, also be manipulated to create dramatic three-dimensional effects, subtle atmospheric illusions, or realistic details. Its unique properties allow encaustic to appear molten or solid, translucent or opaque, smooth or textural, thick or thin, shiny or matte. It can be polished to an enamel-like luster or used with subtlety to create muted but luminous surfaces. It can also be modeled, sculpted, textured, or combined with collage materials. While it is relatively easy to achieve interesting results with encaustic, it is difficult to master the full range of its subtle effects and properties because encaustic does not allow the extended wet-into-wet mixing of traditional oil painting. Because molten wax hardens rapidly once the heat source is removed, illusions and images must be crafted one stroke and one layer at a time. Artists working in encaustic therefore employ various additive and subtractive techniques—fusing, scraping, casting, pouring, inscribing, stenciling, dipping, and burnishing—to fabricate a painterly or sculptural surface.

By respecting a few simple but important guidelines, you can achieve amazing visual effects through a variety of means. This book's primary aim is to provide an introduction to sound encaustic techniques, which are described through step-by-step procedures and photographs. In addition, since art is never solely defined by its medium, the author takes care to encourage experimentation and the development of personal intent, meaning, and message.

The responsive qualities of this medium link the artists featured in this book. For them, encaustic is

Works by Timothy McDowell (left) and Kristy Deetz (right). Installation view, The Divas and Iron Chefs of Encaustic, UTSA Gallery, University of Texas–San Antonio, November 2007.
Photo courtesy of Reni Gower.

a hands-on, labor-intensive process that combines materiality, metaphor, and mystery. I suspect that, for some, the ritualistic process of encaustic provides an antidote to our techno-media driven culture; for others, it generates a respite for the contemplative mind. For me, encaustic resonates with sensual materiality. The aromatic scent of honeyed beeswax is an intoxicating perfume. Tactile surfaces reveal or conceal unique traces of the artist's hand, while encaustic's gleaming colors and complex image layers orchestrate finely tuned compositions. The medium is a compelling option for contemporary artists, one that, when handled correctly, is capable of producing physical and ethereal results. Encaustic's luminosity, unpredictability, and transformative ability to convey mystery are all compelling reasons to work with hot wax!

RENI GOWER

Professor, Painting and Printmaking Department, Virginia Commonwealth University

Curator, The Divas and Iron Chefs of Encaustic (traveling exhibition and workshop)

INTRODUCTION

Although wax has long been used in creating works of art, today's artists are embracing wax as a primary material for creating art of all kinds. A once-archaic medium, encaustic (from the Greek word *enkaustikos*, "to burn in") now enjoys popularity among artists and art lovers alike. For the first time in the history of encaustic, museums are mounting shows of works by artists using the medium, encaustic workshops are popping up across the world, artists are organizing associations promoting the medium, and art collectors and dealers not only know what the word encaustic means but have also begun to assimilate wax art into their exhibitions and collections. Easy access to electrical equipment, the development of commercial encaustic art supplies, wide distribution of educational materials related to the medium, and a fascination with the luminous, organic quality of wax have all contributed to this encaustic renaissance.

If oil paint is the prose of painting,
then encaustic is its poetry.

CHESTER ARNOLD

The artists who use wax to express themselves share a passion for their materials. We love wax. Working with wax is intimate, tactile, emotional, and gestural: The very hand of the artist is revealed in each stroke of the brush. And because of encaustic's nature, artists who work in the medium are a special breed. First, we must be willing to relinquish some element of control. The wax has a mind of its own, and while we learn to guide it and mold it to manifest our creative expression, we also learn from its guidance. There is something meditative about the experience—the alchemy of tempering the wax; mixing colors; painting, pouring, or coating with wax; and using heat to melt and fuse it. We must be willing to be patient, to become one with our process, and to overcome the challenges of encaustic in service of our vision. But that doesn't mean that only certain artists can paint with encaustic. On the contrary, encaustic offers something for everyone, whether you love painting, drawing, printmaking, sculpture, or photography.

Lissa Rankin, *The Dizzy Dancing Way You Feel*. Encaustic and oil stick on panel, 88 x 48 inches (233.5 x 121.9 cm), 2008.
Courtesy of Lanoue Fine Art.

But loving wax is only part of making encaustic art. Because the process of working with wax is so compelling, it's easy for artists to become obsessively focused on process. All too often, I hear artists who work with wax dissecting their process when speaking about their art, neglecting to mention the message they are trying to communicate with their work. Likewise, the people who view work created with wax are equally spellbound by the physical qualities of the medium and tend to direct questions away from content and toward process.

Granted, I have written a book about encaustic technique, an educational manual in which various processes are broken down into step-by-step instructions and illustrated with detailed photographs of the contemporary masters at work. I nonetheless hope to help artists move past the challenges of the encaustic process itself so that they can move deeper into what they wish to say with their art. With tips from the experts and easy-to-follow guidelines, you can overcome any hurdles you might face in mastering the process. Then comes the fun part. My personal challenge to the readers of this book is to study and practice encaustic technique, master the process, and then dig deep inside, using the medium to express yourself.

LEFT Betsy Eby, *Pearl*. Encaustic on panel, 30 x 30 inches (76.2 x 76.2 cm), 2007.
Private collection. Photo courtesy of Nick Herro.

ABOVE Kandy Lozano, *Ocean*. Encaustic and mixed media, 48 x 48 inches (122 x 122 cm), 2009.
Photo by Thomas O'Hara.

OPPOSITE Dusty Griffith, *I Will Pour Out My Spirit 1*. Wax, oil, and acrylic on panel, 58 x 42 inches (147.3 x 106.7 cm), 2006.
Courtesy of Bill Lowe Gallery.

The artists who have participated in this book have done so with an incredible generosity of spirit, sharing the techniques they have invented through countless trials and many errors. These artists have developed a level of proficiency that allows them to distill the incredibly complicated and individualized creative process down to series of simple, easy-to-follow steps. Once you learn from their techniques, you will tap into your own unique artistic voice. Just like the paints, hot plates, hake brushes, and blowtorches used to create encaustic art, the techniques themselves are simply tools. Once you master a technique, you will be able to integrate it into your own creative process in a way that makes that technique uniquely yours.

The artists who shared their techniques did so with a sense of trust in those who will be reading this book. They have confidence that you will learn from them, embrace that sense of sharing in your own interactions with other artists, and use these techniques in an individual way rather than imitating the work of the artists represented here. Without these artists' participation, this book would have been a narrowly focused presentation of my own solitary experience. With their help, it has blossomed into a resource for us all.

In researching this book, I interviewed and visited the studios of many experienced artists who have been painting with wax for

decades, long before encaustic achieved its current level of popularity. Some approach working with encaustic with a rigidly defined set of do's and don'ts, but I've discovered that many others—artists whose work is exhibited at galleries around the world and included in museum collections—are pushing the boundaries and breaking the rules with radiant and critically acclaimed results. Artists tend to be rule breakers, antiestablishment rebels, and limit pushers. I respect that, and this book is not intended to restrict creativity. On the contrary, I hope this book inspires you to try new things and to find ways that wax can enhance your own artistic style.

I have, however, tried to set guidelines for best practices, knowing that artists who follow best practices have the best chance of creating encaustic art that will last as long as the Fayum portraits. While some artists working with wax are very concerned about limiting the fragility and ensuring the permanence of their work, some are more interested in the ways that working with wax helps them to express their message. While museum conservators may appreciate attempts to create work that will survive the test of time, individual curators and collectors may have other goals. I caution artists to keep in mind that, as participants in this enthusiastic encaustic revival, what we create today will define how this medium is perceived in the future. Our legacy will pave the way for future artists, and I hope that we can contribute work that reflects this movement and inspires the next generation of artists working in the medium.

In my own work, I try to adhere to the best-practice guidelines put forward in this book. I think that, in general, it behooves us, as artists working with wax, to consider permanence when we create our art, which will encourage museums, galleries, and collectors to approach the art with confidence. But for those who are experimenting with working outside these boundaries, I applaud your creativity, encourage your discovery, and expect that we will all learn lessons from you in the future. In truth, we may not know what you should or shouldn't do with wax until centuries down the road, when we will be able to

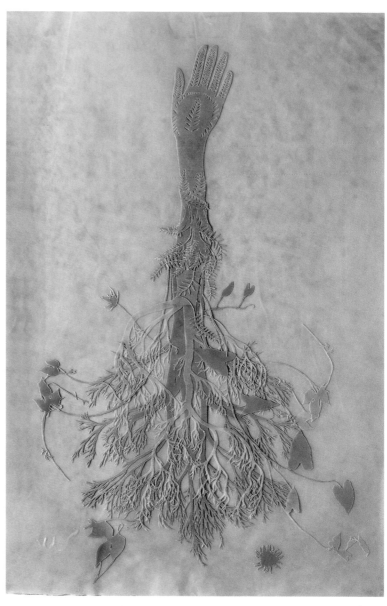

ABOVE Valerie Hammond, *Ether*. Encaustic on Japanese paper, 36 x 25 inches (91.4 x 63.5 cm), 2007. Photo courtesy of Andy Wainwright.

Lorraine Glessner, *Seep*. Encaustic and mixed media on branded and composted silk on panel, 36 x 36 inches (91.4 x 91.4 cm), 2006.
Photo courtesy of the artist.

compare which techniques are successfully conserved in museums and private collections and which techniques have failed to survive the test of time. In the real world of fine art, artists experiment with every possible permutation of the process. At times, the rule breakers create the most successful art. In this book, I have attempted to report, not judge.

So go forth, wax on, and share with others what you have learned along the way. I believe that by communicating the knowledge we have collectively acquired, we all grow. Most of all, have fun, embrace the playfulness of wax, and enjoy painting. It's hot stuff—literally—and it's all the buzz these days.

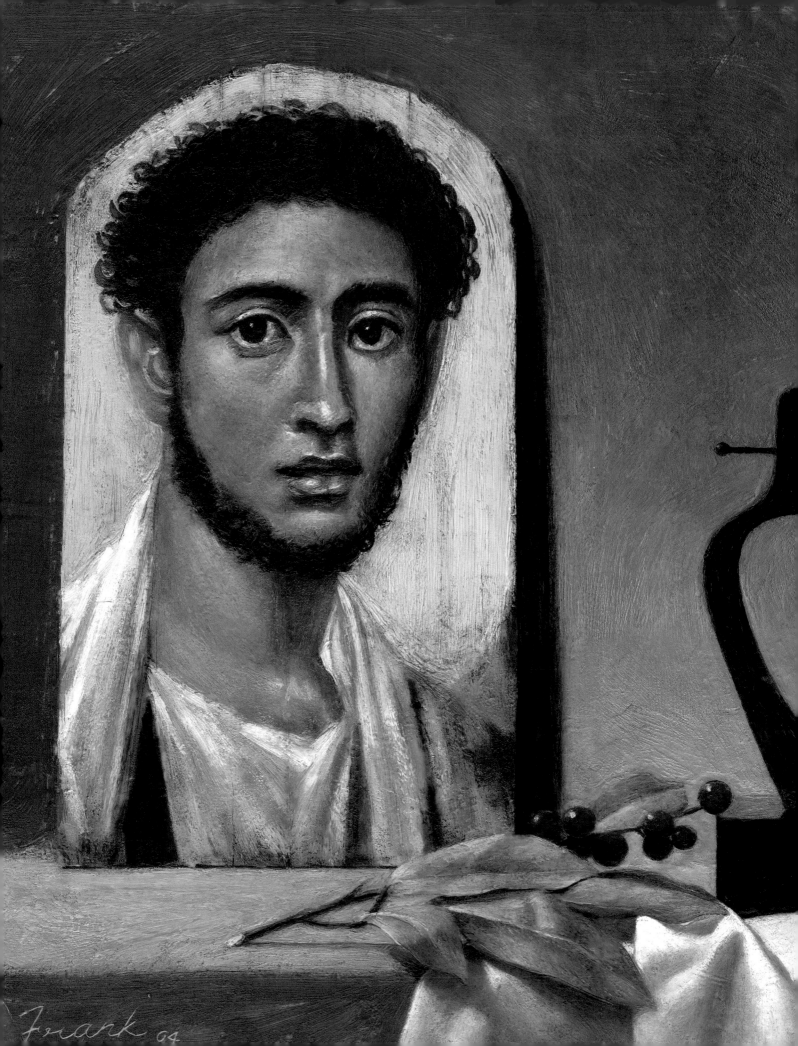

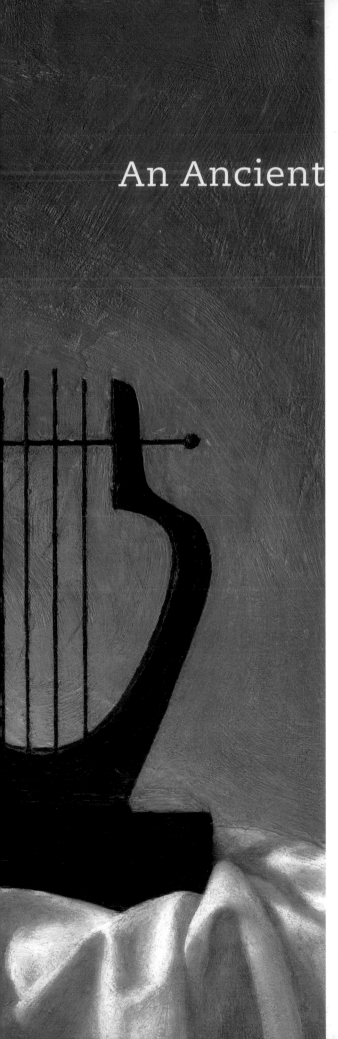

An Ancient Medium Revived

In Greco-Roman Egypt from the first century BC through the second century AD, encaustic was widely used to paint mummy portraits—naturalistic likenesses painted on wood panels that were attached to the mummy cases in which people were entombed. These so-called Fayum portraits—named for the Egyptian oasis town where many such portraits have been discovered—survive as the most luminous and well-preserved of the ancient artworks created with the medium.

Encaustic painting techniques are described as early as the first century AD by Roman authors, including Pliny the Elder, who mentions artists working in the medium several hundred years earlier. The use of encaustic waned following the end of the Roman Empire, however. It was used, in a limited way, for creating icons during the Byzantine period, but as tempera painting grew in popularity, encaustic nearly disappeared. While wax was still used for other artistic purposes during the Middle Ages and encaustic was in limited use during the Renaissance, encaustic painting did not enjoy renewed interest until the mid-eighteenth century, when dialogue between artists about encaustic appeared in art publications. Interest continued throughout the nineteenth century, facilitated by the invention of the Bunsen burner. Several notable nineteenth-century painters, including Paul Gauguin and possibly Georges Seurat, experimented with painting with wax.

Kevin Frank, *The Lyre* (detail). Wax on wood panel, 22 x 26 inches (55.9 x 66 cm), 2004.
Photo courtesy of the artist.

THE FIRST MODERN EXPERIMENTS

Although art publications of the eighteenth and nineteenth centuries occasionally refer to the medium, it wasn't until the twentieth century that artists—now equipped with electric hot plates, heat guns, and irons—began to incorporate the medium into their process in ways that moved beyond experimentation. Mexican artist Diego Rivera used wax to create a mural in Mexico City by applying pigmented wax to a wall and fusing it with a blowtorch. Rivera also created encaustic paintings on canvas and panel. In the 1930s and 1940s, American modernist Arthur Dove experimented with wax-based media, primarily wax emulsion. In the 1930s, Rifka Angel emerged as one of the first artists in the United States to use a true encaustic technique, mixing beeswax with pigment in muffin tins and fusing.

Shortly afterward, Karl Zerbe, who from 1937 to 1955 was the head of the Department of Painting at the School of the Museum of Fine Arts in Boston, came across a reference to the Fayum portraits. Frustrated by the long drying time required by oil paint, Zerbe grew excited about finding a way to update the ancient process of encaustic. For more than a decade, he painted in encaustic, teaching courses in the technique. Zerbe, whose exhibitions were widely publicized, is often credited with reviving the use of encaustic and inspiring a generation of artists. One of his students, David Aronson, carried the flame of Zerbe's enthusiasm after Zerbe's respiratory problems led him to abandon encaustic and switch to other media.

With the exception of brief mentions in Ralph Mayer's landmark text *The Artist's Handbook of Materials and Techniques*, published in 1940, and Hilaire Hiler's *The Painter's Pocket-Book of Methods and Materials*, published around the same time, there was little technical information about encaustic in print until 1949, when Francis Pratt and Becca Fizel published *Encaustic: Materials and Methods*. Pratt and Fizel's book included historical information about the medium and described various recipes and formulations for wax-based mediums,

Rifka Angel, *Sonya (or Remembering Dostoyevsky's Literature)*. Encaustic on panel, 13 x 10 inches (33 x 25.4 cm), date unknown.
Courtesy of Blossom Segaloff and R&F Handmade Paints.

many utilizing solvents and many quite unsafe. Although the book received rave reviews, few copies were published, and the book is long out of print.

Pratt and Fizel also played another important role in the history of encaustic, convincing a small art store in New York City, Torch Art Supplies, to begin carrying encaustic materials in the 1940s. Pauline and Josephine Torch took Pratt and Fizel's suggestion to Dair Color Laboratories in Brooklyn, which formulated encaustic paint made from a combination of beeswax and damar resin that was safer than the traditional mixture of wax and damar varnish. Dair made the paint in bulk, and the Torches remelted it at their home in Yonkers, pouring it into molds. They sold twenty-three colors of encaustic paint, as well as an electric palette with seventeen color wells.

Karl Zerbe, *Melancholia* (triptych). Encaustic on canvas, 100 x 216 inches (254 x 548.6 cm), 1946.
Harvard University Art Museums, Fogg Art Museum, gift of the Estate of Herbert D. Schutz in memory of Herbert D. Schutz, Harvard College, Class of 1944, and Betty Prescott Schutz, Radcliffe College, Class of 1946, 2006.72.A-C. Photo by Katya Kallsen. © President and Fellows of Harvard College.

MID-CENTURY ENCAUSTIC PIONEERS

Beginning in the 1940s, several Abstract Expressionist artists, including Jackson Pollack, experimented with wax-based media. Articles about encaustic began to appear in art periodicals, drawing the attention of younger artists, including Jasper Johns, whose seminal encaustic collage paintings elevated the prominence of the medium. In the 1960s and 1970s, Brice Marden and Lynda Benglis created art that demonstrated their own interpretations of the medium.

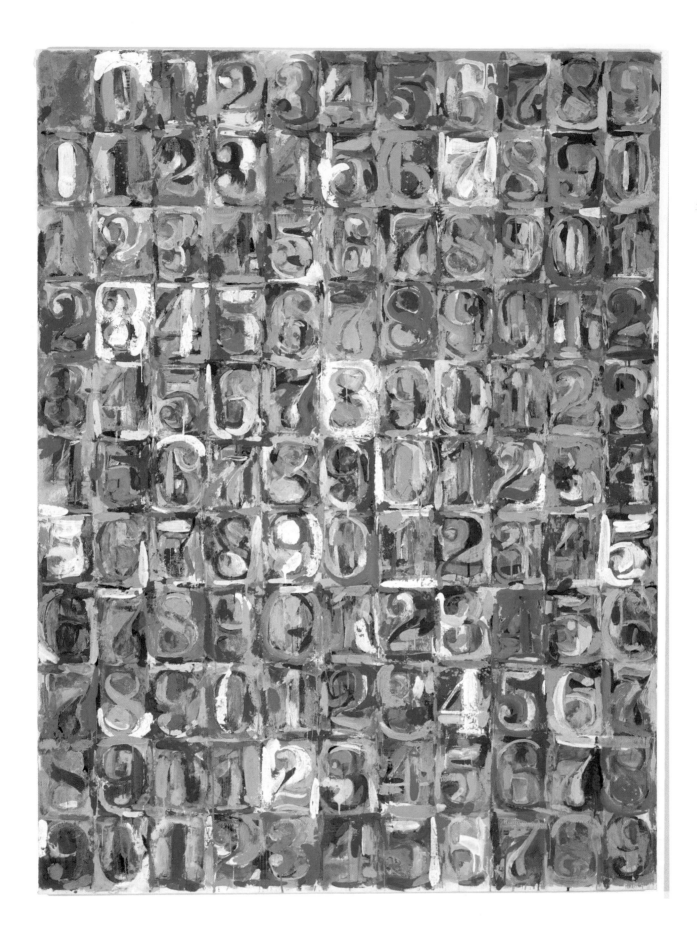

Painters working in encaustic during this period faced the challenge of having few commercially made materials and little information about medium, which meant that each had to reinvent the wheel. With the exception of a few of Zerbe's students, most artists had to experiment to find a way to use wax to serve their individual artistic goals. No forum existed for artists to share what they were learning. Artists interested in learning to work with wax sought advice from other artists, and education spread by word of mouth, with most painters making their own paint.

In 1966, Thelma Newman published *Wax as Art Form*, which covered techniques ranging from encaustic painting to lost-wax techniques to batik. In the book, she reviewed the history of the use of wax as a means for artistic expression and included some technical information, including formulas for mixing wax for a variety of purposes. But, like Pratt and Fizell's book, *Wax as Art Form* has long been out of print.

ENCAUSTIC'S INCREASING POPULARITY

In 1982, Richard Frumess planted the seed for a new way to disseminate information about encaustic and make commercial encaustic paints more widely available. Frumess approached Torch Art Supplies after the gallery he worked with in Brooklyn suggested he experiment with encaustic. Frumess asked Torch's owners if they could instruct him in the use of the medium, but no one remaining at the company knew how to use the remnants of the paint they had on hand. A short time later, he contacted George Stegmeyer, who had been a student of Zerbe's and who shared information with Frumess. Frumess started experimenting with encaustic and shortly afterwards was hired to clerk at Torch Art Supplies, the only place in the world that was selling encaustic paint at that time. Frumess soon became Torch's technical researcher and paint maker.

Before Frumess arrived at the company, interest in the line of encaustic paints had died down, and the laboratory had stopped making the paint. All that remained were some five-gallon cans of encaustic paint in eleven colors, which had been made in the 1960s and were being broken into pieces and sold by the pound. But times were changing, and enthusiasm for encaustic was growing. Frumess was given a rudimentary formula for making encaustic paint for the company, and he began melting beeswax and resin on his kitchen stove, stirring in the pigment by hand. (He switched to blenders and mixers soon afterward.) With Frumess making the paint, Torch expanded its line to twenty-nine colors by 1987. That year, Torch Art Supplies

Paint from Torch Art Supply.
Courtesy of R&F Handmade Paints.

OPPOSITE Jasper Johns, *Numbers in Colors*. Encaustic and newspaper on canvas, 66½ x 49½ inches (168.9 x 125.7 cm), 1958–1959.
Courtesy of Albright Knox Art Gallery. Art © Jasper Johns/ Licensed by VAGA, New York, N.Y.

closed its doors, but Frumess continued to make encaustic paints, opening R&F Encaustics in his basement studio in Brooklyn in 1988.

Meanwhile, in 1987, Ann Huffman, who had first read about encaustic in an article by Dorothy Masom that appeared in *Artist* magazine in 1985, was researching the subject for an article she was writing for *Inksmith.* That article, titled "The Whole Ball of Wax," included technical information she had gathered by making an open call to artists using the medium. Torch Art Supplies contacted her, looking for technical information about working with the medium, and Huffman continued to communicate with artists about how they used encaustic. Huffman, herself an artist working with encaustic, began making her own paint, and in 1987 she began a new company, Mrs. Appletree's Studio, making paint with her husband in their eastern Oregon home. In 1987–1988, with the help of Shirley Charnell, she founded the first encaustic artists association, Encaustic Network Unlimited, which continued for several years before disbanding. The result of Huffman's meeting and sharing technical information with other artists was her book, *Enkaustikos! Wax Art*, published by Encaustic Network Unlimited in 1991.

Within a few years, several art supplies retailers in the United States and abroad were carrying both the R&F and Mrs. Appletree's Studio brands of paint, and more and more artists were beginning to paint with encaustic. As demand for commercially made encaustic paint grew, R&F moved to Kingston, New York, in the Hudson Valley, while Huffman continued production in Oregon. In 1990, Frumess joined forces with Jim Haskin and upgraded the company's paintmaking process from the blenders, mixers, and stirrers that R&F had been using to a stone mill and, ultimately, to the three-roll miller R&F still uses today. Because the company required that all its paint-makers be artists, the employees played a crucial role

Pamela Blum, *Dwelling #5.* Encaustic and oil on curved basswood, 9 x 7 x 3 inches (22.9 x 17.8 x 7.6 cm), 2001. Photo courtesy of Ted Diamond.

in the evolution of the company, and many of the paint makers went on to become teachers, filling a vacuum in encaustic education.

In 1995, Mike and John Lesczinski, owners of Rochester Art Supply, in Rochester, New York, were battling the large chain art suppliers in their area by specializing in high-quality, "niche" art supplies. An art products manufacturer visiting their store suggested that they contact Huffman about her encaustic paints. They requested samples, and, after receiving rave reviews from their resident artist, they began carrying the Mrs. Appletree's Studio line. Huffman also sold the company her hot brass-bristle brushes and other heated tools she had designed to help artists manipulate wax more easily. A year later, Huffman sold her company to the Lesczinskis, and they moved the operation to Rochester, where Enkaustikos! Wax Art Supplies was born in 1996. Beginning with simple paint-making methods, they have since upgraded their operation three times to improve the quality of paint they produce.

While commercially available paint provided greater accessibility, educational outreach spawned greater experience with the medium, as artists taught other artists in workshops across the country. In 1994, Richard Frumess taught his first workshop after Pamela Blum (who later became Frumess's wife) asked him to teach her to paint with encaustic. In 1995, R&F sponsored its first group workshop at the Women's Studio Workshop in Rosendale, New York, and the workshops moved to the company's factory in 1996, when the company changed its name to R&F Handmade Paints. By sponsoring workshops, R&F established itself as a clearinghouse for encaustic information, bringing together artists interested in the medium.

R&F's outreach expanded, with the company offering workshops in New York City, San Francisco, Atlanta, Seattle, Jackson Hole, San Antonio, and Chicago. Students became teachers, extending the network of encaustic education across the country. The educational offerings grew under the guidance of former paint maker Cynthia Winika, joined by Laura Moriarty. With the help of their students, they began to incorporate new information into their teaching, drawing from disciplines as diverse as carving, casting, etching, lithography, photography, ceramics, gold leafing, painting, drawing, collage/assemblage, and bookmaking. Information spread exponentially as R&F workshop students took what they'd learned back to their hometowns and became teachers themselves. Wherever R&F offered workshops, artists became missionaries of the medium, spreading information, art, technical information, and education to the art community and the

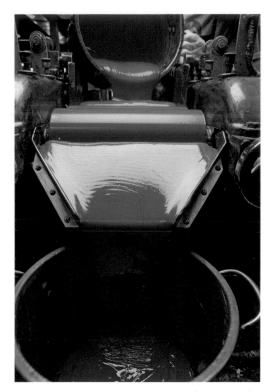

Encaustic paint milling at R&F Handmade Paints, Kingston, N.Y.
Courtesy of R&F Handmade Paints.

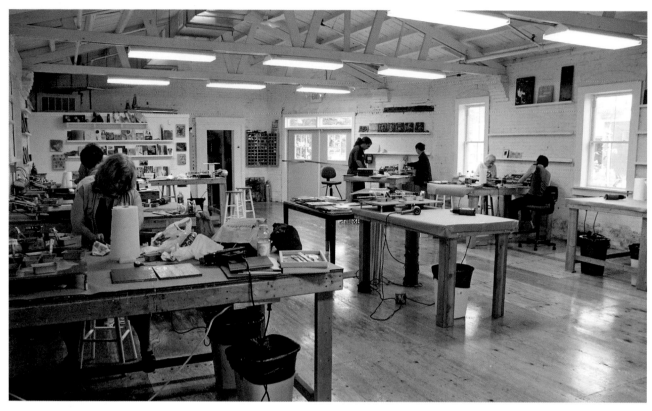

public at large. Before long, loci of encaustic education developed in the Hudson Valley, in the San Francisco Bay area, and in the Pacific Northwest, as the numbers of students who had studied the medium reached critical mass.

ABOVE Workshop studio at R&F Handmade Paints, Kingston, N.Y.
Courtesy of R&F Handmade Paints.

OPPOSITE Lissa Rankin, *Signs from the Universe*. Encaustic, rice paper, and oil stick on panel, 96 x 24 inches (243.8 x 61 cm), 2008.
Photo by Matt Klein.

AN EXPLOSION OF INTEREST

In 1995, at the same time that it was beginning to offer workshops, R&F Handmade Paints opened a gallery at its Kingston factory and began exhibiting encaustic art. The Gallery at R&F's premiere show, a regional encaustic invitational, was the first exhibition of artworks all made with the encaustic process. R&F's first juried show, selected by New York art dealer Stephen Haller, opened in 1997. Since then, R&F Handmade Paints has sponsored biennial exhibitions that together document how the use of the medium has evolved over time. R&F has also collected a slide registry, which can be accessed by dealers, curators, artists, and writers.

Frequenting galleries in New York City's SoHo district and noticing the growing use of the medium, Gail Stavitsky, chief curator of the Montclair Art Museum in Montclair, New Jersey, began collecting names of artists working with encaustic. Over several years, Stavitsky made dozens of studio visits, which resulted in her curating Waxing

Poetic: Encaustic Art in America, which opened at the Montclair museum in 1999 and later traveled to the Knoxville Museum of Art. The exhibition catalog included Stavitsky's essay about the artists as well as essays by Danielle Rice and Richard Frumess. This show—the first museum exhibition celebrating the medium—signaled that encaustic was becoming an increasingly recognized medium. By bringing together a community of artists working in encaustic, the show also provided an opportunity for the artists to meet and share ideas.

Joanne Mattera's book *The Art of Encaustic Painting: Contemporary Expression in the Ancient Medium of Pigmented Wax* was published in 2001, making technical information about encaustic more widely available, showcasing the work of contemporary artists working in encaustic, and further popularizing the medium.

In recent years, R&F Handmade Paints has added an artists' forum to its website, encouraging artists to post technical questions and links to their own websites, as well as news about upcoming exhibitions, calls for entries, and the like. The forum quickly evolved into a network of artists who began communicating independently. Given the budding workshops across the country, Mattera's book, and educational offerings like the R&F forum, artists using encaustic no longer work in a vacuum. In 2005, a second association for artists working in the encaustic medium emerged: the West Coast Encaustic Artists (later renamed International Encaustic Artists), founded by Gail Steinberg. Shortly thereafter, Kim Bernard founded New England Wax. These artist associations began sponsoring juried shows, and opportunities for exhibition grew. Since then, two more companies, Evans Encaustics and Wagner Encaustics, have begun making encaustic paint, and art schools have started to incorporate more education about the medium into their curriculums.

Collaborative workshops, in which artists learn to incorporate wax with photography, printmaking, papermaking, and other media, have also evolved. As Richard Frumess has said, "Encaustic negotiates well with other art disciplines and lends itself to collaboration." Contemporary encaustic has emerged as a melting pot of collaborative techniques, as artists combine painting, drawing, printmaking, photography, collage/assemblage, installation work, and sculpture with wax. More than just a medium or a technique, encaustic has become an artistic unifier.

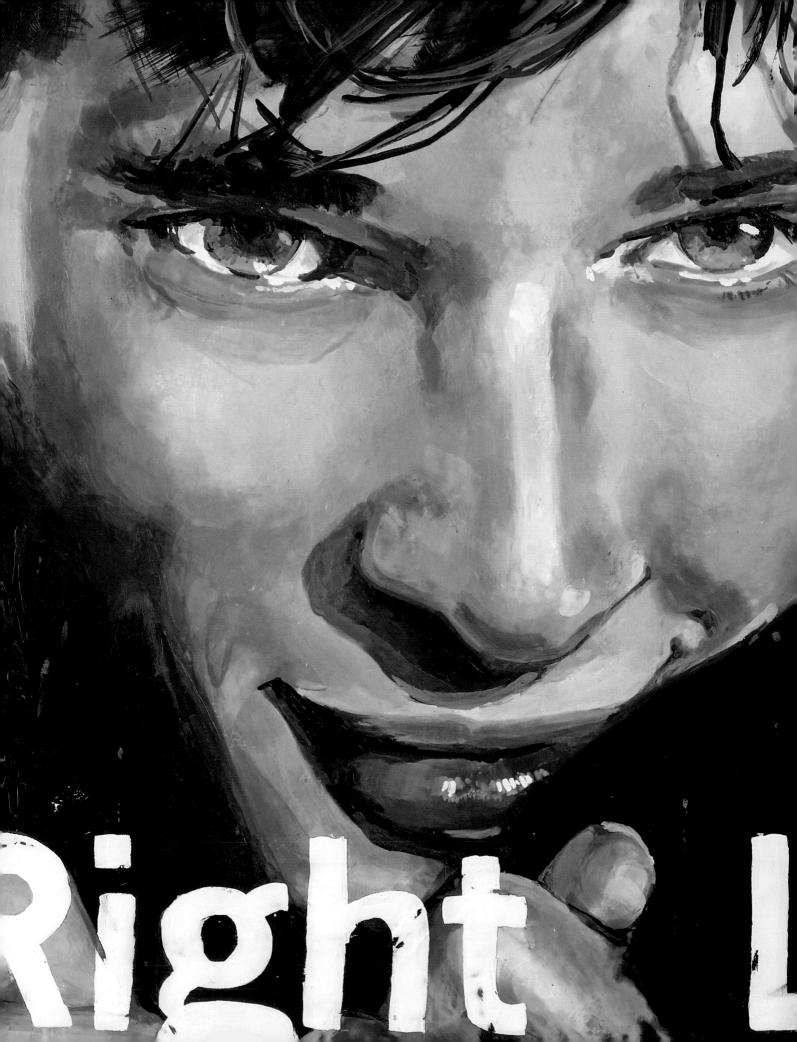

Encaustic Painting

Painting with wax requires a few steps: melting the wax, applying it to a surface, and then fusing to that surface. While not as simple as some media, encaustic can be accessible to artists of all levels, from beginners to professionals. The things encaustic offers—instant drying, versatility, the uniquely luminous optical quality of pigment in wax—make learning the process well worth the effort.

If you have access to an encaustic workshop, I highly recommend taking it, since a workshop offers an excellent opportunity to experiment with the medium before investing the time and money needed to safely create an encaustic studio. A workshop may help you decide whether you wish to pursue creating fine art with wax. Because encaustic workshops are not available everywhere, this book includes some of the technical guidance you might find in a workshop setting. But nothing can come close to the experience of picking up a paintbrush and trying it yourself. By interviewing professional encaustic artists and visiting their studios around the country, I have compiled detailed information about how artists work with wax, how they overcome challenges, and how they have embraced the medium to express their artistic vision.

Jeff Schaller, *Mr. Right Left* (detail). Encaustic, 24 x 24 inches (61 x 61 cm), 2009.
Courtesy of Galerie I.D., Switzerland, Photo by the artist.

MATERIALS FOR ENCAUSTIC

Put simply, to paint with encaustic you will need wax (usually in the form of encaustic medium), encaustic paint, a heated surface on which to melt the wax, a surface on which to paint, a heat source for fusing, and brushes and other tools for manipulating the art. You can acquire everything you need from encaustic art supplies companies, but many artists working exclusively with wax prefer to prepare their encaustic medium and/or paint themselves. For many, mixing their materials is part of the alchemy of the creative process. Experimenting with materials allows them to manipulate the wax, resins, pigments, and other additives in ways that serve their artistic vision.

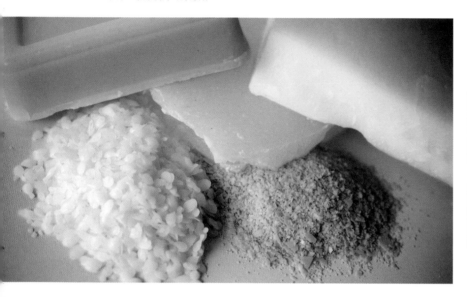

LEFT Types of wax. *Top:* natural beeswax (left), microcrystalline (right). *Center:* paraffin. *Bottom:* mechanically bleached beeswax (left), carnauba (right).
Photo by Monique Feil.

ABOVE Timothy McDowell's studio in Noank, Conn.
Photo courtesy of the artist.

WAX

Wax is the signature element of encaustic art and gives the medium its unique properties. Encaustic medium, which generally consists of beeswax mixed with damar resin, acts as the base for encaustic paint and is often used in unpigmented form to create visual depth in paintings, to coat sculptures, or to layer over photographs or fine art prints. Although beeswax is the most common wax used for encaustic, other waxes can also be used, and they can be combined to achieve different effects.

BEESWAX

Organic and fragrant, beeswax demonstrates that it is hard to improve upon nature. Pliable when warm, beeswax combines well with pigments or oil paints, is safe when used appropriately, and is unbeatably luminous. The wax traditionally used for encaustic, it continues to be the most popular despite the advent of synthetic waxes.

When secreted by bees, beeswax is white in color, but it turns yellow when mixed with pollen and propolis (bee glue) in the beehive. To return beeswax to a white color, it must be treated—selectively filtered or bleached—to remove the pollen.

John Dilsizian, of the Dilco Refining Division of Strahl & Pitsch, Inc., recommends mechanically bleached beeswax for use with encaustic. Mechanical bleaching filters out the pollen and other contaminants to return beeswax to its natural white color. Chemical bleaching with agents such as phosphoric acid or potassium permanganate causes yellow beeswax to become white by oxidizing the colorants, but because the colorants are not actually removed, the wax may revert to a yellow color if it is used unpigmented, and it can interact unpredictably with certain pigments. Because mechanical bleaching removes the colorants, the wax remains colorless over time, making it the most suitable for encaustic. It should be noted, however, that some artists prefer using unpigmented natural beeswax (also called filtered beeswax or refined beeswax), appreciating its warm, yellow color.

MICROCRYSTALLINE

Microcrystalline, a petroleum-based wax, can also be used for encaustic art. It comes in a variety of formulations, ranging from very low to very high melting points. Of all of the alternative waxes, microcrystalline is the most similar to beeswax, but it does differ in several respects:

Rodney Thompson, *Ryokan #11*. Encaustic, paper, comb wax, maple leaves, 8 x 6 inches (20.3 x 15.2 cm), 2006. Photo courtesy of the artist.

1 **Lower Cost.** Because microcrystalline costs less than beeswax, some artists mix microcrystalline with beeswax when making medium. For the same reason, some encaustic artists paint exclusively with microcrystalline.

2 **Greater Pliability.** Depending on the exact formulation, microcrystalline can have significantly greater plasticity than beeswax, making it easier to use on flexible surfaces such as canvas, since any movement of the surface is less likely to crack or otherwise harm a painting. This pliability also makes microcrystalline less likely to crack or chip at a painting's vulnerable edges.

3 **Higher Melting Point.** Some microcrystalline waxes have melting points as high as 200°F (93.3°C), much higher than the 144–149°F (62.2–65°C) melting point of beeswax. In addition to protecting the art from the potentially damaging effects of environmental heat, the higher

melting point allows the artist to use microcrystalline for creative purposes. For example, microcrystalline can be used to create sculptural effects, which may be fused to a lower-melting-point beeswax surface without losing surface detail of the sculpture.

4 Chemical Composition. Because it is petroleum based, microcrystalline lacks some of beeswax's appealing qualities: its organic composition, its lovely scent, its natural properties, and its long history.

5 Color. Although microcrystalline may initially appear whiter than filtered beeswax, it can yellow significantly over time. Because of this, microcrystalline is best used in a pigmented form.

CARNAUBA WAX

A wax extracted from a palm tree, *Copernicia cerifera*, carnauba can be added to beeswax to improve its moisture-resistant properties and to harden the beeswax. In addition to being extremely brittle, it has a distinctly yellow color.

CANDELILLA WAX

Made from the candelilla plant (either *Euphorbia antisyphilitica* or *Pedilanthus pavonis*), candelilla wax can also be added to beeswax as a hardening agent.

PARAFFIN

Also a petroleum product, paraffin is the least expensive and most widely available form of wax. Used for everything from candles to food canning, paraffin can be purchased at grocery stores, craft stores, and candlemaking suppliers. Because of paraffin's low cost and easy

melting points of waxes

Beeswax	144–149°F / 62.2–65°C
Microcrystalline	145–202°F / 62.8–94.4°C
Paraffin	122–165°F / 50–73.9°C
Carnauba	176–187°F / 80–86.1°C
Candelilla	155–162°F / 68.3–72.2°C
Impasto modeling wax	170°F / 76.7°C
Encaustic medium with 2:9 wax/resin ratio	157°F / 69.4°C
Encaustic paint with 2:9 wax/resin ratio	157°F / 69.4°C

availability, many artists experiment with it before discovering superior materials. Its most appealing characteristics are its colorlessness and transparency. While both beeswax and microcrystalline have a slight opacity, paraffin is almost completely clear.

Paraffin has several important limitations, primarily its low melting point (120–140°F/48.9–60°C) and brittle texture, which means that it tends to crack and chip. Some artists mix paraffin into their encaustic medium, at about 25 percent of the total, to save money or to add transparency. If you do wish to experiment with paraffin, Strahl & Pitsch's John Dilsizian suggests blending a high-melting-point (145°F) paraffin with selected microcrystalline waxes to create a product that has characteristics similar to beeswax. Paraffin may also be used to clean brushes.

SOY WAX

Because of its very low melting point (113–122°F/45–50°C), soy wax has limited use in encaustic art, although because it is a clean burning, nontoxic, renewable resource, it may be used as a substitute for paraffin. Naturally biodegradable and relatively easy to remove from brushes, it can be used to clean brushes, which can then be washed with soap and water and used with other media. Its natural oil content makes it a good brush conditioner for natural-bristle brushes.

DAMAR RESIN

Damar resin, a natural fir-tree resin, is the material most commonly mixed with beeswax to create the base for encaustic paint. It has many positive attributes as an additive. In the history of encaustic, damar *varnish* was often mixed with beeswax and heated to create encaustic medium, but the safer damar resin has largely replaced it in contemporary encaustic. (The varnish, which consists of damar resin dissolved in turpentine, is quite a different product and is highly toxic.)

Adding damar resin to beeswax has the following advantages:

- It raises the melting point of the wax.
- It allows the wax to cure and harden over time.
- It adds gloss and polish to the surface of an artwork when the piece is buffed with a soft cloth.
- It prevents "bloom," a whitish haze caused by unsaturated hydrocarbons in beeswax.

Those unsaturated hydrocarbons can crystallize at cold temperatures and form a film over an encaustic painting. Because damar

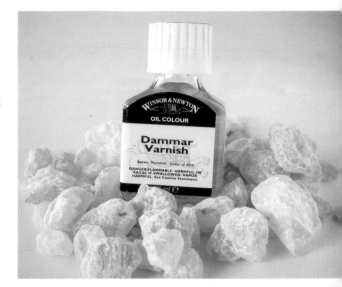

TOP Damar resin and damar varnish.
Photo by Monique Feil.

ABOVE Lissa Rankin, *Solar Eclipse*. Encaustic on wood panel, 36 x 36 inches (91.5 x 91.5 cm), 2006.
Photo by Matt Klein.

OPPOSITE Matt Klein, *Totem*. Encaustic on recycled oak heating grate, 11 x 30 inches (27.9 x 76.2 cm), 2008.
Photo by the artist.

resin and microcrystalline both contain saturated hydrocarbons, which solubilize the unsaturated hydrocarbons, their addition to beeswax reduces the problem of bloom.

DAMAR VARNISH

Many traditional encaustic recipes, such as the formulations detailed in Pratt and Fizell's 1949 book, mention damar varnish, which, as was mentioned above, is a mixture of damar resin and turpentine. Many artists represented in this book still use this traditional mixture, but the mixture can be very unsafe. The damar varnish mixture is quite different than the encaustic medium recipe detailed in this book, as the addition of the solvent makes the wax mixture thinner when applied and allows the mix to stay warm longer, giving the artist more time to manipulate it. For those tempted to experiment with this mixture, it is very important to understand how toxic this combination can be. (See page 54 for more on this subject.)

Encaustic medium in production at R&F Handmade Paints, Kingston, N.Y.

ENCAUSTIC MEDIUM

While some artists do paint with pure beeswax, most use a combination of wax and damar resin. *Encaustic medium* is the term used for the base substance of all commercially available encaustic paints. Typically, the medium is composed of beeswax mixed with damar resin, but, depending on the effect you want to achieve, you may add other waxes, including microcrystalline, carnauba, candelilla, or paraffin. Each additive has distinct characteristics, and creating an encaustic medium with unique properties can be part of the creative process.

PREPARING THE MEDIUM

Different artists mix their own encaustic mediums using various recipes, but artist Rodney Thompson recommends adding 2 parts of damar resin to every 9 parts of white filtered beeswax. Increasing the percentage of resin will result in a medium that is less malleable, harder, glossier, and more brittle and one that has a higher melting point. Richard Frumess, of R&F Handmade Paints, also cautions against using too much resin in the mix, as the resin can cause the art to become very brittle after the wax cures.

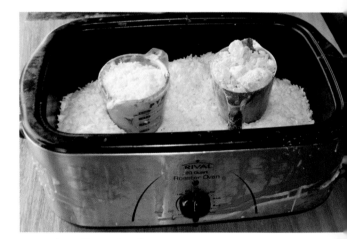

Encaustic medium being made in roaster oven, demonstrating mixture of beeswax (left) and damar resin (right).

You can prepare medium in any type of heated vessel, and the artists I interviewed used all manner of vessels, including Crock-Pots, roaster ovens, electric woks, pots on griddles or hot plates, and propane camp stoves. I use a 20-quart electric roaster oven with a removable insert pan to prepare 10 to 12 pounds of medium at a time. The roaster oven has an adjustable setting, which allows the medium's components to be melted and mixed at an optimal temperature of 180°F (82.2°C). Resist the temptation to turn up the heat to melt your

Encaustic medium in production at R&F Handmade Paints, Kingston, N.Y.
Photos by the author.

medium more quickly. Overheating can burn the medium, releasing toxic aldehyde and acrolein fumes into the air. Too much heat also weakens the chemical structure of wax, significantly darkening the medium to a yellow-brown color. A stable, relatively low temperature is the key to creating clear, colorless medium. Although the process takes patience, medium-making days infuse the studio with the faint scent of honey, and making your own medium can significantly reduce the cost of working with encaustic.

COMMERCIALLY MADE ENCAUSTIC PAINTS

To my knowledge, four companies currently sell premade encaustic paint: R&F Handmade Paints, Enkaustikos!, Evans Encaustics, and Wagner Encaustics.

R&F Handmade Paints intensively mills its paint with a three-roll mill. Because the natures of the pigments differ, R&F mills each paint individually, giving attention to both the top and the base tones within each pigment. The fine particles of pigment are then evenly suspended within the paint, which is critical to avoid clumping or settling when the paint melts. R&F makes eighty colors of encaustic paint, as well as encaustic medium and impasto modeling wax, the last being a special blend of microcrystalline waxes and beeswax that is designed to be cast, carved, and layered to create textured surfaces. Paints are available in 40 mL, 104 mL, and 333 mL sizes.

Enkaustikos! also offers finely milled paint. Enkaustikos! paints come in eighty-three colors and are available in a variety of sizes, ranging from 1 ounce to 16 ounces. The company has a line of ready-to-use Hot Cakes paints, which come in tins that can be placed directly on a hot palette, and Enkaustikos! also sells impasto modeling wax. Over the years, Enkaustikos! has continually upgraded its paint-

Paint from Enkaustikos! Wax Art Supplies.
Photo courtesy of David Hoffend and Enkaustikos! Wax Art Supplies.

BELOW LEFT R&F Handmade Paints' encaustic paints, shown in 40 mL, 104 mL, and 333 mL sizes.
Courtesy of R&F Handmade Paints.

BELOW Encaustic paint at R&F Handmade Paints in Kingston, N.Y.
Photo by the author.

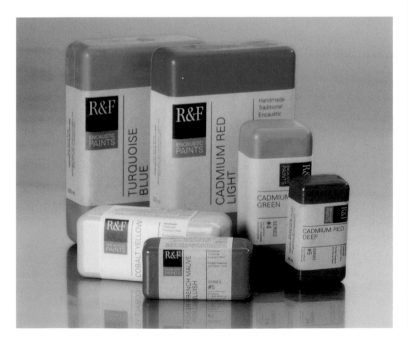

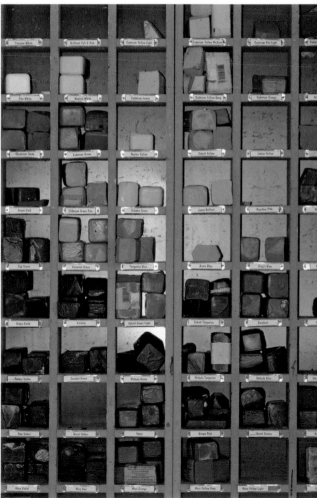

RECIPE Encaustic Medium

Matt Klein offers this recipe for making 12 pounds of encaustic medium in a roaster oven.

INGREDIENTS

10 pounds beeswax

2 pounds damar resin

EQUIPMENT

Roaster oven, 20-quart capacity

Wooden spoon or paint stirrer

Heated palette

Large pot

Metal colander

Tight-weave cloth (for example, lint-free microfiber auto cloths)

Nonstick cookie pans with sides at least 1 inch high, or silicon muffin pans

STEP 1 Place beeswax in the roaster oven, setting the oven's temperature to 160°F (about 70°C). (The beeswax should melt very slowly; at this setting, it will take between 12 and 24 hours to melt completely, depending on the ambient temperature.)

STEP 2 Add damar resin to the melted beeswax. To reduce clumping, stir the mixture with a wooden spoon or paint stirrer as you add the resin. Raise the roaster oven's setting to 180°F (about 80°C).

STEP 3 To speed the process of combining the wax and resin, stir the mixture about once every half hour. When the resin begins to melt, it will form a gummy residue; use the stirrer to lift this residue from the bottom of the pan. Except when stirring, keep the lid on the roaster oven during the melting process.

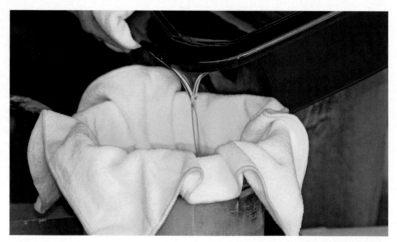

Medium being filtered through microfiber auto cloths.

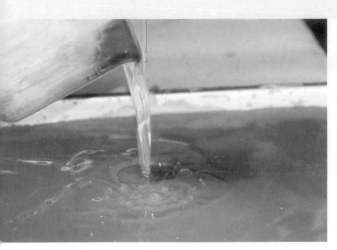

Pouring medium into pan.

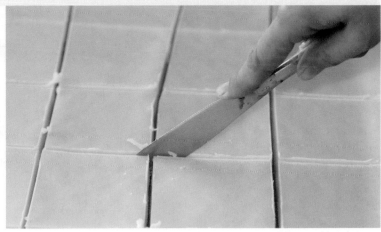

Cutting the medium into squares.
Photos by the author.

STEP 4 When the resin has completely melted and beeswax (which usually takes from 12 to 24 hours), filter the medium to remove the particulate matter. To filter, place a large pot on your heated palette, place a metal colander over the pot, and line the colander with a tight-weave cloth. (The lint-free microfiber auto cloths available at most hardware stores are one option. Rodney Thompson uses cotton muslin fabric, and Tracey Adams uses flannel sheets. Do not use cheesecloth, which does not capture all of the fine particulate matter.)

STEP 5 Pour the filtered medium into cookie pans, filling each pan as full as possible without overflowing. The medium will take from 30 to 60 minutes to solidify.

STEP 6 When the medium has solidified but is still warm and pliable, use a table knife to cut it into 2-inch squares.

STEP 7 Wait another 6 to12 hours for the medium to fully harden. Turn the pan over on a clean surface and bang the back of the pan with your fist. The squares should fall out easily.

note Silicon muffin pans can be used instead of cookie sheets. If your working environment is particularly warm, you may want to put the cookie sheets or muffin pans in the freezer for several hours to facilitate the hardening and removal of the medium.

making process and now employs a computerized milling machine, which allows the company to use a wider variety of pigments.

Evans Encaustics offers paint that is handmade in small batches. Making highly pigmented paint sticks, Hylla Evans mixes her paint to order and works individually with artists to customize over one hundred colors.

Wagner Encaustics, founded by Elise Wagner, hand-mixes its paint from earth pigments and packages the paints in reusable, 4 ounce (118 mL) tin containers with lids. Each lid serves as a container for diluting the paint with medium, enabling the user to experiment with mixing to achieve the desired tint and transparency. Wagner Encaustics' paints come in nine colors; white paint and encaustic medium are available in 6-ounce (177 mL) and 16-ounce (474 mL) sizes.

Depending on the concentration of color you desire, you can use commercially made paint at full strength or dilute it with medium to

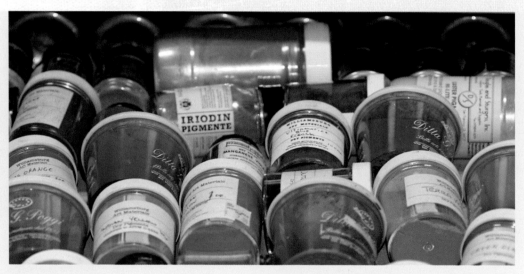

Dry pigments used for pigmenting encaustic medium to make encaustic paint.
Photo by the author.

Making Paint with Dry Pigment

Many of the artists I interviewed mix their own encaustic paints by stirring dry pigment into melted medium. Monona Rossol, author of *The Artist's Complete Heath and Safety Guide* (3rd ed., 2001), cautions, however, that there is no safe way for an individual artist to work with pigments, which often contain highly toxic substances. If you are tempted to make your own paint with dry pigment, please make the effort to fully understand the dangers and take the appropriate precautions. At the R&F Handmade Paints factory, paint makers wear HEPA-filtered respirators and full body protection, mixing paint inside a closed work space with a custom-fitted air-purification system. (See pages 50–55 for more on safety.)

create paints of varying levels of translucency. While buying premade paint is more expensive than making your own, every artist working with encaustic should experiment with commercially made paint to fully appreciate its qualities. Also, buying paint allows you to bypass the significant safety hazards of working with raw pigment and spares you the time, mess, and hassle of making your own, allowing you to proceed with the joy of painting without getting bogged down in the tedium of paint making.

MAKING ENCAUSTIC PAINT WITH OIL PAINT

Many artists pigment their wax using oil paints, as it is easy to use and significantly safer than working with dry pigment. Because the pigments in oil paint are mixed with linseed oil, however, it is impossible to create encaustic paints with oils that are as saturated as encaustic paints made with pure pigments. The linseed oil softens the encaustic and dulls its color, so encaustic paint created with oil paint will be less vibrant than that made with pigment. Also, because adding too much oil to wax softens the resulting paint, you can only add so much

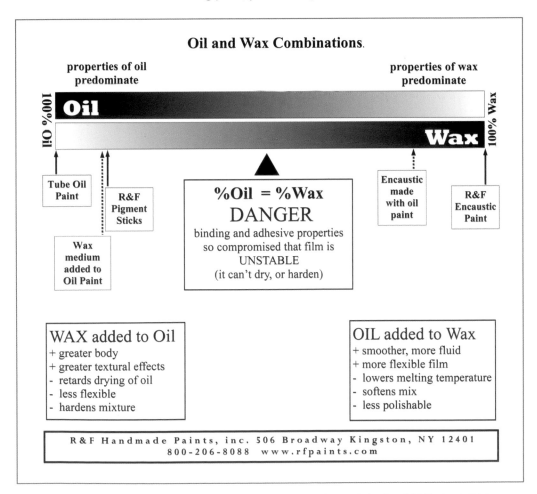

Reprinted with permission from R&F Handmade Paints technical data sheet TDS1100.2.

oil paint, limiting the amount of pigment in the resulting mixture. Because coloring encaustic medium with oil paint is easy to do—and because many artists have a drawerful of oil paints ready to hand—mixing paint this way has long been a common practice, particularly among the pioneers of encaustic art, who were using the medium before commercially made encaustic paint was widely available.

To create mixtures of oil and wax that are chemically/structurally sound, you must combine them at stable ends of the oil/wax continuum. At one end, wax is added to oil, with oil predominating. Wax adds texture and gloss, but the mixture most closely resembles oil paint. The paint requires more drying time, retains more flexibility, and behaves more like oil paint. At the opposite end of the continuum, oil is added to wax, and the properties of wax predominate. As long as the proportion of wax to oil or that of oil to wax is small, the mixture is stable. But as the proportions approach the center of the continuum, with nearly equal parts oil and wax, the mixture becomes unstable and may not harden or dry appropriately.

R&F Pigment Sticks®, composed primarily of linseed oil and natural waxes, in production at R&F Handmade Paints, Kingston, N.Y.
Photo by the author.

Oil Sticks

Oil sticks represent a workable mixture of wax in oil. When wax is added to oil at a ratio of about 15 percent wax to 85 percent oil, the properties of oil predominate. Made of beeswax, linseed oil, and pigment, paper-wrapped oil sticks are marketed by a number of art-supply companies, including R&F Handmade Paints. Because oil sticks include wax, marks made with them can be fused to underlying and overlying layers of encaustic. With their lipstick-like consistency, oil sticks are easy to apply and manipulate, and many of the artists I interviewed regularly use oil sticks to accent their encaustic art.

HEAT

Although wax is the primary component in encaustic, it is heat that defines the medium. As I've said, the term *encaustic* derives from the Greek *enkaustikos*, "to burn in." Merely applying heated wax to a surface is not enough to make a painting encaustic; the painting does not become technically encaustic until a heat source is used to fuse the wax to the underlying layers, binding each layer to the one beneath. Many artists who list "encaustic" among the media they work in do not practice *true* encaustic. Some work with hot wax, but do not fuse it. Some work with cold wax mixtures, which are applied cold and not fused. Although the term *encaustic* is used somewhat loosely, the majority of the artists showcased in this book practice the traditional method, which is similar to that used by the painters of the Fayum portraits. Because these ancient examples have survived the test of time, we can hope that art created with contemporary fusing techniques will last as long and will retain their vibrancy for centuries to come.

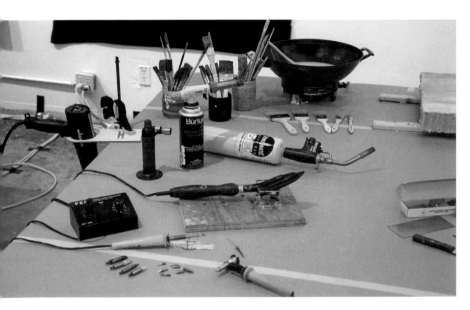

ABOVE Howard Hersh's hot plate in his studio in San Francisco.
Photo by the author.

LEFT A selection of tools for working with encaustic, in Rodney Thompson's studio.
Photo courtesy of Rodney Thompson.

HEATING THE PAINT AND MEDIUM

To work with encaustic, you must heat the paint and medium to a safe working range of between 170° and 210°F (76.7°–98.9°C). There are commercially made encaustic palettes, which consist of an anodized aluminum or stainless steel plate placed over a heat source. For example, R&F Handmade Paints and Enkaustikos! Wax Art Supplies both offer anodized aluminum palettes designed specifically for encaustic. These palettes allow you to control temperature more accurately than you can using kitchen equipment, and the palettes' colorless surface allows you to mix colors directly on the palette, just as you would mix oil paints on an ordinary palette.

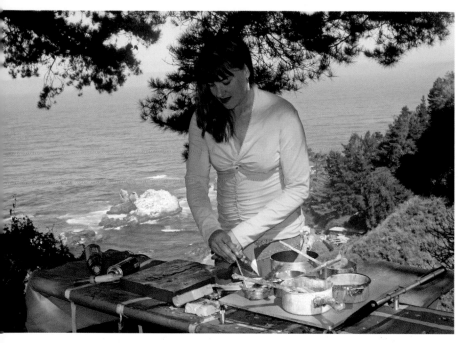

ABOVE Encaustic HotBox in Paula Roland's studio in Santa Fe, N.M.
Photo by the author.

LEFT Lissa Rankin with anodized aluminum hot palette in Big Sur, Calif.
Photo by Matt Klein.

But you don't have to buy specialized equipment. You can use any heating surface—a griddle, an electric skillet, a hot plate—to heat your paint and medium. Some kitchen appliances, however, have unreliable rheostats and can vary in temperature unpredictably. For this reason, you should keep a specially designed palette thermometer, available from R&F Handmade Paints, on the surface of your palette to prevent dangerous overheating and protect the integrity of your paint.

You can also keep large batches of medium or paint warm in electric woks or Crock-Pots. Paula Roland uses an "Encaustic Hot-Box" that she herself designed; it consists of an insulated wooden box fitted with four 100-watt light bulbs in porcelain sockets, which are wired to a rheostat that controls the light and therefore the amount of heat emitted.

Howard Hersh uses a printmaker's hot plate, designed for sugar lift and etching, while Robin Hill, who works primarily with unpigmented wax, mixes her encaustic medium in a heated metal trough she built specifically for the purpose.

INSTRUMENTS FOR FUSING

When fusing encaustic, I use different kinds of heat sources, depending on the surface or other material I'm working on. For my initial fusing of beeswax on a panel, I use a MAPP gas torch because it allows me to work quickly. For fusing wax on fabric, I use a heat gun, since a blowtorch could ignite the fabric. When fusing over masking tape, I use a tiny crème brûlée torch, because a heat gun or blowtorch would apply too much heat to the tape and damage the surface underneath. For fusing wax over photographs, I use a tacking iron. For general use, I prefer the Iwatani torch, model CBTC2, which has an adjustable flame that ranges from very low to moderately high heat and that lets me vary both the amount of gas and the focus of the flame.

Fusing techniques can be extremely low-tech. Adele Shaw sometimes uses the sun, focusing the heat with a large lens or magnifying glass, while Mari Marks uses a heat lamp. Most of the artists I interviewed had a favorite fusing method; experimenting with different heat sources will help you find the ones you like best. In each of the technique lessons in this book, I make a recommendation for a particular kind of heat source, but, as you gain experience, you will discover what works best for you.

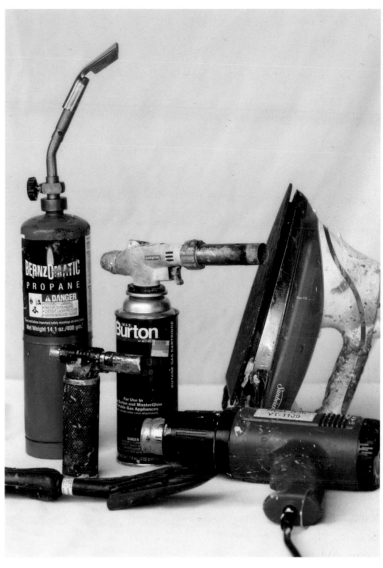

Fusing tools. *Clockwise from left:* Propane torch, adjustable butane torch, household iron, heat gun, tacking iron, and small butane crème brûlée torch.
Photo by Monique Feil.

BLOWTORCHES

Blowtorches provide an excellent and fast way to fuse a surface. For quick, diffuse fusing, large butane, propane, or MAPP gas blowtorches, sold by hardware and kitchen supply stores, can quickly fuse large surface areas. For detailed, specific fusing, I use a small crème brûlée torch. For using stencils, creating straight-line edges, fusing etched lines, and other detail work, a small, fine, temperature-controlled blowtorch works beautifully. I don't recommend using a blowtorch for collage, transfers, or paper or cloth elements, as they can ignite. In my studio, I have a flat-topped torch stand where I always place the torch after use, to prevent it from tipping over.

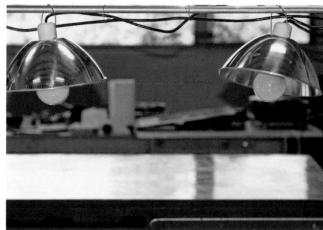

HEAT GUNS

Electric heat guns, which can deliver heat at temperatures up to 1,200°F (648.9°C), are convenient for fusing a painted surface. Heat guns can be bought at most large hardware stores, but take note: Not all heat guns are equal. Many of the less expensive heat guns sold in the paint departments of hardware stores have only one setting and blow too much air, moving the wax on the surface and causing air bubbles. They also are significantly heavier than the more expensive models and can cause muscle strain and fatigue. To be safe, purchase your heat gun through an encaustic products supplier; these are usually superior to those found in hardware stores.

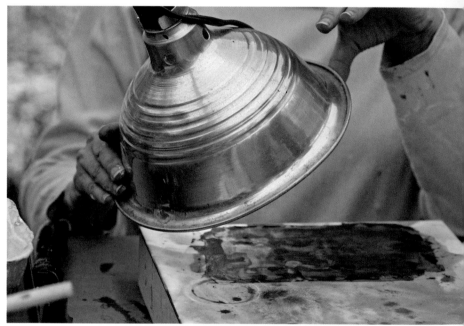

IRONS

You can also use irons to apply heat to an encaustic surface. A full-sized clothing iron covers a large surface but allows little control. Most artists prefer tacking irons or quilting irons, which are smaller, more versatile, and more precise. These work particularly well with collage and photography elements and can create beautiful surfaces that look as if the wax has been applied with a palette knife. While it may intuitively seem that an iron would create a very flat surface, using an iron is trickier than it sounds, as wax can pool and melt unevenly. You must take care to move the iron evenly over the surface, wiping excess wax from the iron as you go. By the way, an iron used for encaustic should not be used for other purposes.

TOP LEFT Gay Patterson fusing with a tacking iron.
Photo courtesy of the artist.

TOP RIGHT Heat lamps in Gay Patterson's studio in Santa Fe, N.M.
Photo by the author.

ABOVE Mary Farmer demonstrating use of a heat lamp at an International Encaustic Artists retreat in Carmel Valley, Calif.
Photo by the author.

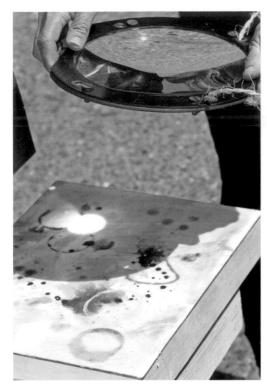 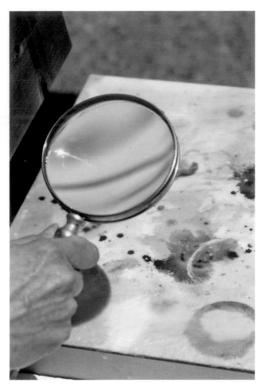

Adele Shaw using the lens from a stoplight to focus solar energy for fusing.

Shaw using a magnifying glass to fuse.
Photos by the author.

HEAT LAMPS

You may place a painting under heat lamps for a slow, even fuse. Multiple lamps can be grouped together to create a heat source big enough to suspend over a larger piece. When using heat lamps, you must make sure the painting is lying on an absolutely level surface and watch the painting closely to ensure that the wax doesn't melt completely off the surface. Gay Patterson uses heat lamps in series to prepare the encaustic surfaces of her large collages of photographs printed on silk. Mari Marks uses a handheld heat lamp to fuse her graphite-on-wax paintings.

THE SUN

Hot, sunny days offer fusing that's free of charge. While unpredictable and difficult to control, solar energy can be used to fuse encaustic. Working outside in Carmel Valley, California, Adele Shaw focuses solar energy using a magnifying glass or a large glass lens.

TOOLS AND ACCESSORIES

Besides wax, paint, and heat sources, you will also need tools to help you apply, inscribe, sculpt, carve, burnish, and scrape the molten wax. Like other painting media, encaustic is often applied with a brush. Once the molten wax is brushed onto a surface and fused with heat, various tools can be used to further manipulate the surface.

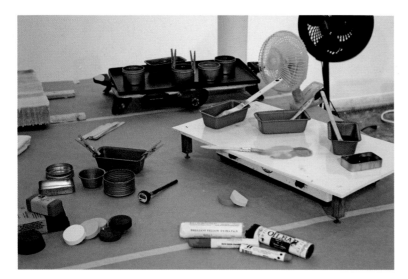

Rodney Thompson's studio in Redding, Calif.
Photo courtesy of Rodney Thompson.

PAINT CONTAINERS

Melting encaustic paint directly on the surface of a heated palette enables you to mix only small amounts of a color. To create larger quantities, you will need containers in which to melt your paint. Because they have handles and can easily be lifted and moved, stainless steel measuring cups and butter warmers work well. (But do be careful: The handles can get quite hot.) Some artists use small aluminum loaf pans for mixing colors; others use muffin tins, tuna cans, cat-food tins, metal palette cups, or old pots and pans. If the container you use doesn't have handles, you can attach clothespins or metal clips with plastic handles to the container so that you can remove it from the heating surface more easily, but again, caution is in order: These makeshift handles can be unstable, leading to spills. Latex or nitrile gloves offer a limited barrier against heat and allow for safer handling of hot containers.

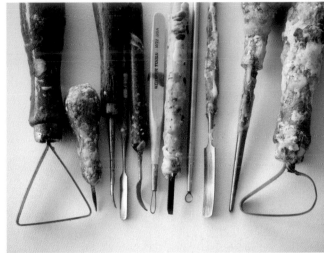

Photos by Monique Feil.

BRUSHES

You may use any natural-bristle brush with encaustic paint, but beware of brushes with synthetic bristles, which can melt at high temperatures. For applying wax over a large surface, I prefer Japanese hake brushes, made of sheep's hair. Their flat, soft bristles coat surfaces evenly and smoothly. Brushes with thicker bristles, such as those made with boar bristles, leave brushstrokes and are good for creating textured surfaces. Portraitist Kevin Frank finds that sable brushes give him good control for fine detail. Some artists reserve specific brushes for each color, some clean their brushes with paraffin or soy wax, and some don't worry about it, allowing paint to mix when moving brushes between colors.

Bristles often fall out of brushes and lodge themselves in the painted surface. (I find that this shedding is usually worse when I first use a new brush.) If a bristle lodges in the surface, use the tip of a single-edge razor blade to gently lift it off, then fuse the defect.

TOOLS FOR INSCRIBING AND TEXTURING

You can use a variety of tools—dental instruments, awls, ceramics tools, single-edge razor blades, printmaking tools, and burnishing tools—to inscribe surfaces, create textured finishes, and smooth surfaces. Use your imagination. Kitchen stores offer creative ideas when you view cooking utensils through the lens of painting with wax.

HOT TOOLS

Ann Huffman developed two brass-filament brushes: the Classic, designed to use with a heat gun without burning the brush, and the Hot

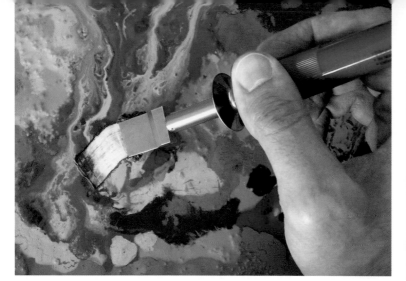

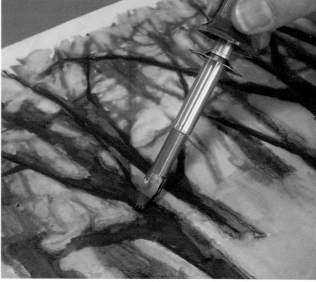

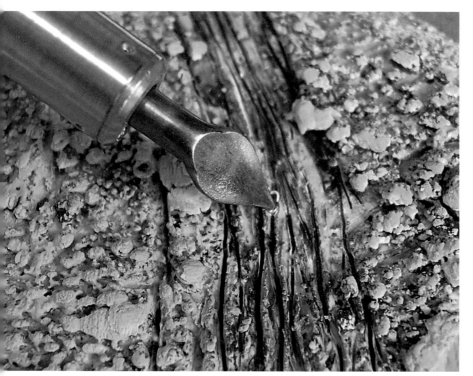

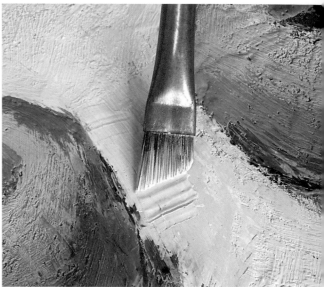

Brush, an attachment for a heated wax pen, which keeps the paint in liquid form until applied to the painting surface.

Enkaustikos! offers an Encaustic Flow Pen, which has a heated paint reservoir that keeps the wax in a liquid state and a stylus that opens and closes the tip, releasing the wax paint onto the substrate. The Encaustic Flow Pen can be used for creating dots or consistent lines of paint.

The Hot Wax Pen, a wood-burning tool specially adapted for encaustic, can be used to write or draw into a wax surface. It comes with a variety of tips, include a small chisel-edged palette-knife tip, a mini palette-knife tip, a pointed stylus tip, a blunted bullet tip, several brass drawing and sketching pens, and a full range of brass-bristle brush attachments.

TOP LEFT Using a hot palette knife.

TOP RIGHT Painting a thick line with a Hot Pen.

BOTTOM LEFT Etching with a Hot Tip.

BOTTOM RIGHT Painting with a Hot Brush.
Photos courtesy of David Hoffend and Enkaustikos! Wax Art Supplies.

CREATING AN ENCAUSTIC STUDIO

Setting up an encaustic studio is easier than many people think. For most, adequate ventilation is the biggest hurdle, since to paint safely with encaustic you must find a way to ventilate your work space adequately. Installing a reverse-flow fan in a window provides the easiest ventilation solution, although more sophisticated ventilation systems can be installed. (For more on ventilation, see page 52.) One obvious limitation of ventilating your studio is a lack of temperature control. Artists who work in very cold or very warm environments may find it difficult to keep the studio at a comfortable, workable temperature. Placing weather stripping and caulking around a fan can minimize this problem, as can a space heater. Maintaining a studio temperature between 60° and 75°F (15° and 24°C) makes many of the techniques described in this book easier.

An encaustic studio must also have an adequate electrical power supply, as you may have a studio lights, a heated palette, a heat gun, an iron, and a fan all running at the same time. An electrician can ensure that your electrical system is sufficient to operate all your equipment simultaneously. Where electricity is limited, creative solutions are possible; for example, in her studio on an island off the coast of Maine, artist Betsy Eby uses a propane camp stove to heat the paint and a blowtorch to fuse it.

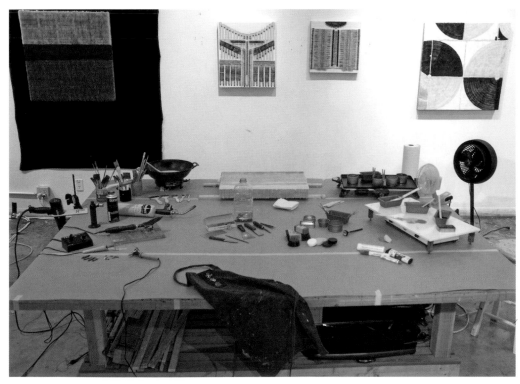

Rodney Thompson's studio in Redding, Calif.
Photo courtesy of Rodney Thompson.

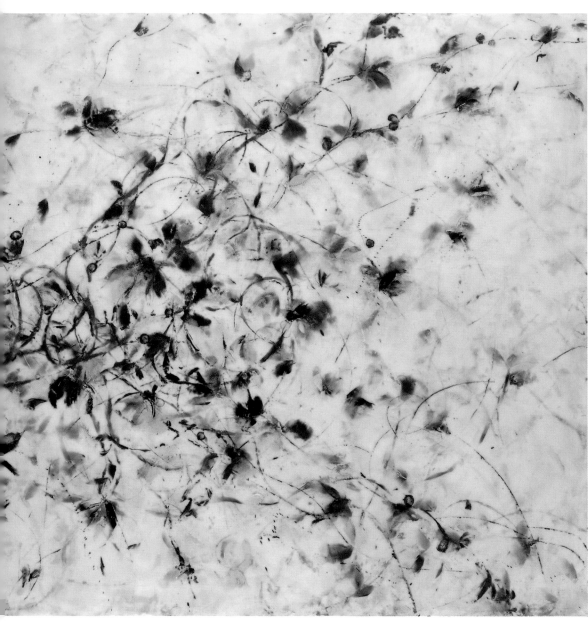

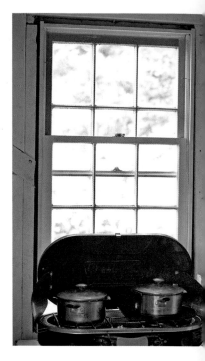

ABOVE Betsy Eby, *Wing on Wing.* Encaustic on panel, 60
x 60 inches (152.4 x 152.4 cm), 2007.
Courtesy of Winston Wächter Fine Art. Photo courtesy of Nick
Herro.

ABOVE RIGHT Propane camp stove in Betsy Eby's stu-
dio on Wheaton Island, Maine.
Photo by Monique Feil.

An Encaustic Studio on a Budget

Putting together an encaustic studio can be an expensive undertaking, but with a little imagination, you can create an affordable encaustic studio. Here are some money-saving tips:

- Purchase used hot plates, Crock-Pots, electric woks, griddles, muffin tins, pots, and irons at thrift stores.

- Buy inexpensive natural-bristle brushes.

- Make your own encaustic medium. Purchase beeswax from candlemaking suppliers, whose prices are often much cheaper than those of art-supply stores. If beeswax is too expensive, use micro-crystalline. Purchasing wax in bulk is often much less expensive per pound.

- Mix your own encaustic paints, coloring them with oil paints.

- Paint on 3/4-inch plywood or experiment with working on paper before investing time and money in building or purchasing cradled wooden panels.

- Purchase an inexpensive heat gun or blowtorch at a hardware store.

Even if you're on a budget, however, you'll still have to pay careful attention to safety issues. Be sure to read the following section on safety before creating your studio or beginning to work with encaustic.

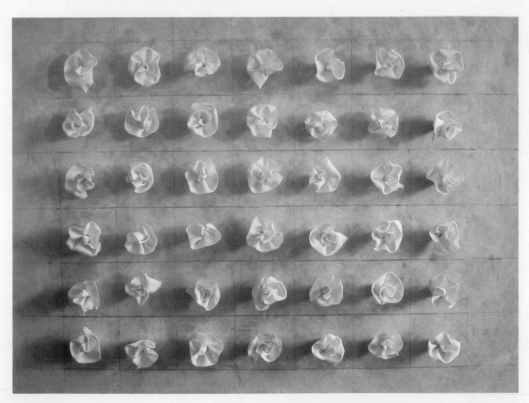

Cari Hernandez, *Floral Grid*. Encaustic and oil on panel, 36 x 38 inches (91.5 x 96.5 cm), 2009.
Photo by the artist.

SAFETY

At least some of the materials used by artists working in any medium have potentially toxic effects, and it is always important to understand the safety hazards associated with the materials you work with and to take precautions to minimize risks. The encaustic medium poses more risks than some other media, but these, too, can be minimized with proper precautions. This section makes safety suggestions for artists working in encaustic in home studios. It does not cover the scope of safety measures necessary to adhere to federal, state, and local regulations that apply to workplaces and other public environments. For more information about providing a safe work environment, contact your local Occupational Safety and Health Administration (OSHA) office. For more detailed safety information about encaustic and other media, refer to Monona Rossol's *The Artist's Complete Heath and Safety Guide* (3rd ed., 2001).

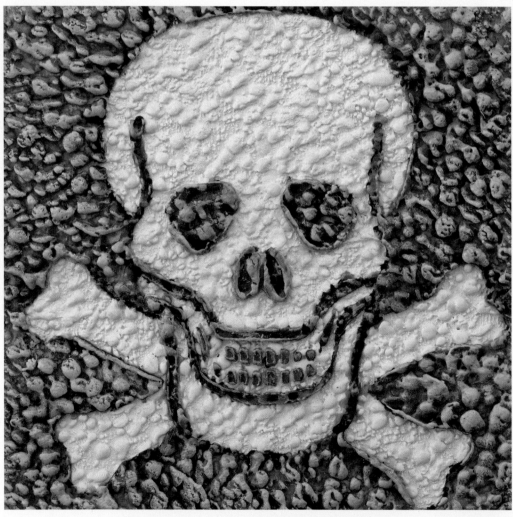

Matt Klein, *Trouble Ahead*. Encaustic on panel, 12 x 12 inches (30.5 x 30.5 cm), 2008.
Photo courtesy of the artist.

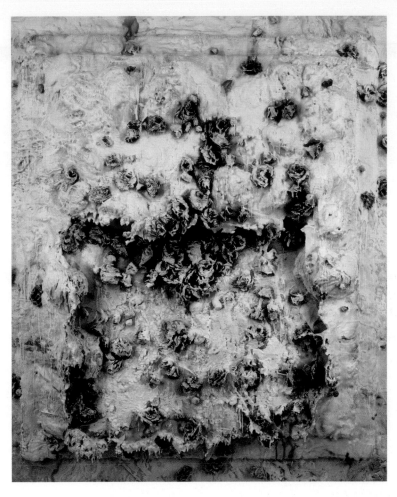

Michael David, *Chorten (#777 2nd state)*. Oil and wax on wood, 51½ x 58½ inches (13.8 x 148.6 cm), 2003–2006.
Courtesy of Bill Lowe Gallery. Photo courtesy of Oren Slor.

Michael David – A Case Study

For thirty years, artist Michael David worked with wax, often heating it to very high temperatures and mixing it with solvents, unaware of the potential toxicity of working in this manner and failing to take precautions. Over time, David developed a peripheral neuropathy, which resulted in permanent nerve damage in his legs, affecting his sensation and his ability to walk. Although he has undergone numerous treatments aimed at helping him regain nerve function, he continues to suffer from his disability. While a number of variables make it impossible to determine the exact cause of David's neuropathy, his physician suspects that it is at least partly related to his years of unsafe artistic practices. Because of his experience, David has become a strong advocate of safety, cautioning other artists to resist the temptation to ignore safety and preaching to his students about the dangers of working with encaustic improperly.

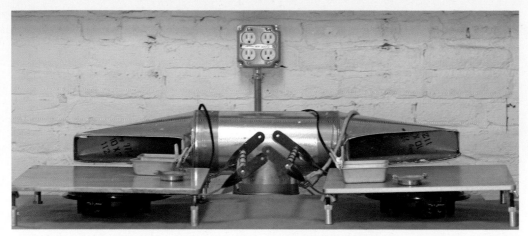

Heated palette and ventilation system in an encaustic studio.
Photo by the author.

PROPER VENTILATION

As wax and resin melt, they release decomposition products that include acrolein and alde-hydes such as formaldehyde and acetaldehyde. Decomposition occurs when heat breaks large wax molecules into smaller molecules. When wax is just warm enough to melt, little decom-position occurs, but as the temperature of the wax rises, decomposition accelerates and the concentration of toxins in the surrounding atmosphere increases. As with other environmental toxins, the concentration of the contaminant determines the extent of the danger. At low con-centrations, acrolein and aldehydes can cause headache and nausea. At higher concentra-tions, they act as respiratory-tract irritants, increasing susceptibility to infections and possibly leading to bronchitis or chemical pneumonia. Also, formaldehyde, in addition to being an irritant, can cause allergic reactions in some people and is a known carcinogen.

Some people are more sensitive to these fumes than others. If you find that you are expe-riencing respiratory irritation while working in encaustic, it is highly probable that wax decom-position products are responsible and that your studio is not adequately ventilated.

Many of the potential hazards of creating encaustic art can be substantially reduced with adequate ventilation. If your studio has windows on two sides, you can create a simple ventila-tion system by opening a window on one side of the studio and installing an exhaust fan in a window on the opposite side, no more than a foot or two above your worktable. Wax fumes are most easily exhausted as they first begin to rise. If you are using large containers of molten wax or paint, adjust the height to your fan accordingly. Seal off the open space around the fan with weather stripping or caulking to ensure that the air cannot reenter around the sides of the fan. To test your ventilation system, blow out a candle or light an incense stick and watch the direction and speed of the smoke. It should move steadily away from you and out the window.

If your studio does not have a window, you may need to seek help from a ventilation expert. Engineers who specialize in industrial ventilation can help you design a system with a fume hood, adjacent to your work area, that will exhaust fumes out of your studio via a duct system. If neither of these options is possible, you should definitely consider working outside, where fumes will disperse more quickly.

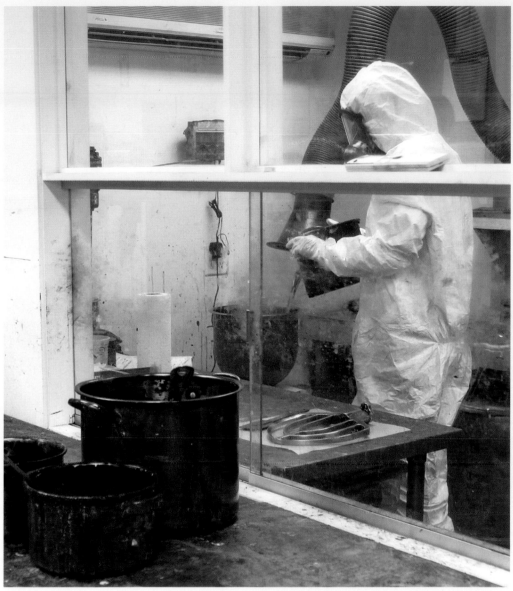

Paint maker mixing pigment into wax at R&F Hand-made Paints in Kingston, N.Y.
Photo by the author.

DRY PIGMENT TOXICITY

If you mix paint from dry pigment, be aware that many dry pigments are highly toxic and environmentally threatening. While installing a local exhaust ventilation system may help protect your studio environment, exhausting certain toxic metal pigments into the environment violates Environmental Protection Agency (EPA) regulations. Pigments made from the following metals fall under the guidelines of the EPA's Resource Conservation and Recovery Act (RCRA): arsenic, barium, cadmium, chromium, lead, mercury, selenium, and silver. While household hobby use of these pigments is not regulated, artists whose business is selling their work are subject to laws requiring businesses to pay for proper disposal of any waste containing these pigments. They cannot simply be exhausted out a window, washed down the drain, or put in the trash.

Toxicities include but are not limited to the following: Pigments containing lead may cause anemia, kidney damage, damage to the reproductive system, fetal injury, convulsions, central

nervous system damage, coma, or even death. Pigments with cadmium may cause lung, liver, and kidney damage, as well as anemia, damage to the reproductive system, fetal injury, and cancer. Chromium pigments may cause asthma and cancer. Cobalt pigments may cause lung damage and pneumonia. Those with manganese may cause a degenerative nervous system disease similar to Parkinson's. Graphite powder can cause black lung or silicosis. (A fuller list of known pigment-related toxicities can be found in Rossol's *The Artist's Complete Health and Safety Guide.*) To avoid these safety and environmental hazards, use commercially prepared encaustic paint or mix your own encaustic paint with oil paints. When pigment is in colloidal suspension in the wax, the toxicity of the pigments is eliminated with normal usage.

The toxicity of nonmetallic organic pigments is unknown because they have never been studied for chronic toxicity. Under current labeling laws, pigments about which there are no data can be labeled "nontoxic," but this may be misleading. While some artists attempt to minimize risk to themselves by wearing particle masks approved by the National Institute for Occupational Safety and Health (NIOSH) or HEPA-filtered respirators, author Rossol cautions that the particles composing most dry pigments are significantly smaller than the 0.3-micron particles captured at 99.97 percent efficiency by a HEPA filter, which means that even higher-grade N100, R100 and P100 respirators will not catch all particles. In addition, to meet OSHA guidelines, a specialist with training in fitting respirators must ensure an adequate seal. If you decide to mix your own paints with dry pigment, please understand that wearing a fitted P100 respirator will reduce but not completely eliminate the risk.

SOLVENT TOXICITY

Many of the early twentieth-century recipes for encaustic medium call for heating solvents and mixing them with hot wax. But working with solvents is extremely dangerous, and heating them increases the risk; as a result, some of the modern pioneers of encaustic experienced severe health problems. Mixing wax with heated solvents such as damar varnish, turpentine, or mineral spirits puts you at significant risk. Solvent vapors can irritate and damage membranes in the eyes, nose, throat, and lungs, and solvents can also affect the brain and central nervous system (CNS). Chronic exposure can cause permanent CNS damage, resulting in memory loss, depression, and sleep disorders. Some solvents can also damage the peripheral nervous system, causing numbness and tingling of the extremities, weakness, and paralysis. Solvents can damage internal organs such as the liver, kidney, and heart. Some solvents are also known carcinogens. Solvents can also create explosive or flammable air-vapor mixtures.

To limit your risk when using solvents, avoid breathing vapors and use solvents only in areas with adequate local exhaust ventilation. Wear a respirator with organic cartridges for extra protection. Avoid skin contact and protect your eyes from splashes by using chemical splash goggles and setting up an eyewash station. Protect against fire and explosion by not using solvents anywhere near an open flame or where solvent vapors might be ignited by sparks.

FIRE HAZARDS

When working with encaustic, you must also always consider the risk of fire and burns and always have a fire extinguisher on hand for emergencies. When wax is melted, wax molecules vaporize and condense to form airborne particles collectively called "wax fume," which is usually invisible but can appear as a fog when wax is greatly overheated. This fog can explode

or flash into fire if a spark or flame is present. Wax left on a burner at high temperatures can spontaneously ignite. Blowtorches or heat guns used near paper or solvents can cause fires or explosions. Keep electrical outlets and cords at a safe distance from heat sources. Ensure that all flammable objects are kept far away from heat sources.

Also, because of the danger of being burned by hot wax, it make sense to keep ice or cool water nearby. If hot wax touches your skin, cool the wax with cool water until you get medical attention. Never peel wax off your skin, as it can tear the skin. Note, however: If a wax fire occurs, do *not* throw water on the burning wax. Use a fire extinguisher to put out the flames.

GOOD STUDIO PRACTICES

Following good studio practices can also reduce risk. Such practices include those discussed above—maximizing ventilation, avoiding use of solvents, keeping a fire extinguisher handy, having cool water and an eye-wash station nearby in case of spills or splashes—but there are a number of others: Keep wax temperatures just above the melting point. Dispose of waste safely. Avoid eating or drinking in your studio. Wear clothing that provides a layer of protection from wax burns, and wear gloves or use barrier creams to protect your hands.

Matt Klein, *Gone Fishing*. Encaustic on panel, 22 x 30 inches (55.9 x 76.2 cm), 2007.
Photo by the artist.

Supports and Grounds

The structure of an encaustic painting consists of two elements: (1) the support, or substrate, and (2) the ground, which is the actual surface on which you paint. For a stable and long-lasting result, wax must be absorbed by and bond to the underlying surface when fused. Among the various supports you might choose, those with rigid, absorbent surfaces yield the most permanent result. Porous surfaces—wood, paper, or unglazed ceramic—allow the layers of paint to absorb into the support, making the painting one with its support. Rigid supports add another element of protection to an encaustic work, since a well-braced, rigid, absorbent support will help protect the artwork against damage from flexion or nonadhesion.

Art historians often remark on the Fayum portraits' incredible longevity. Chances are, they have survived in such marvelous condition not only because of the vivid permanence of the pigmented wax and the extremely dry climate of Egypt but also because they were painted on wood panels that provided a rigid, absorbent base for the wax medium.

Gail Gregg, *Burgundy* (detail). Encaustic on cardboard, 18½ x 33½ inches (46.9 x 85 cm), 2005.
Photo courtesy of the artist.

A selection of Rodney Thompson panels.
Courtesy of Rodney Thompson.

Proper fusing creates a solid, continuous structure of wax, the foundation of which is the support material. The very first layer of wax must be well fused to the support, penetrating into the surface and thereby anchoring the art firmly to it. Without this important physical attachment of wax to the support, the art is at risk of separating from its base, which can occur if the work is jarred or result from temperature changes that cause the base material to expand or contract. This is much less likely to happen if the wax is locked into the substance of the base material.

Once cooled, the encaustic structure is fairly rigid itself, but a rigid support provides additional strength. Although paper can be used as a support for encaustic, any movement or flexion of the paper may cause cracking or chipping of the painting, unless the wax is applied in very thin coats or the paper is mounted to panel. If you use a nonrigid supports, you must protect the art from flexion to avoid damage.

Which kind support and ground you choose ultimately depends on what you wish to express with your art. Because his process requires complex underpainting directly on a white ground, Timothy McDowell chooses to paint on rabbit-skin glue gesso–coated linen mounted on wood panel to achieve his signature surfaces. Because I layer more than a dozen coats of encaustic on my paintings before scraping them back, I don't need a special ground and choose to paint directly on the cradled birch panel, using the panel as both my support and my ground. Theodora Varnay Jones paints directly on handmade paper, while Lorrie Fredette uses her fabric sculptures as both ground and support. Let your mind explore possible grounds and supports, allowing your creativity to run wild. But keep in mind the best-practice principles set forth in this chapter.

TYPES OF **SUPPORTS**

While the majority of artists I interviewed paint on cradled wood panel, other supports— paper, cardboard, fabric, unglazed ceramic, wood sculpture, plaster, stone, and wire mesh—may be used. Applying the best-practice principles, an ideal support will be both rigid and absorbent, but artists have broken these principles with lasting and luminous results. My aim is to educate artists about the principles, so that they can be well informed if their creative juices lead them to experiment.

A Rodney Thompson birch panel.
Courtesy of Rodney Thompson.

WOOD PANELS

Most artists working in encaustic use wood or wood-based panels as supports for their artworks. Plywood is a common choice because its layers of thin wood veneer (with alternating grain orientation) provide stability. Other wood-based options include untempered hardboard and medium-density fiberboard (MDF). Both of these products are made of wood particles compressed into a binding medium. Because it is less absorbent than untempered hardboard, tempered hardboard does not work as well with encaustic. MDF absorbs well, but it tends to be much heavier than plywood. High-quality plywood with a birch, maple, or luan veneer surface is rigid, relatively lightweight, and very absorbent, making it a very good support material for encaustic.

While small panels may be used without further structural support, most panels need reinforcement to prevent flexion that could damage a painting. "Cradling" the panel—bracing it with wood strips on the back—provides the extra stiffness needed to keep the panel rigid. Thinner panels (such as those made from ¼-inch plywood) need bracing at a smaller dimension than thicker, heavier, more rigid panels (such as ¾-inch plywood panels).

CREATING A CRADLED PANEL

Rodney Thompson shares the following step-by-step tips for creating professional-quality cradled panels:

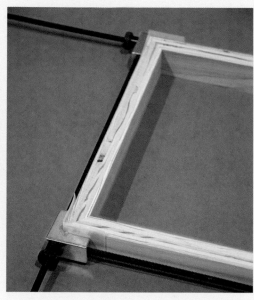

STEP 1 For the cradle, use 1 x 2–inch solid pine or fir or 1-inch-wide strips of plywood. Using wood glue (such as Titebound woodworking glue), glue the edges of the cradle together and, using a frame clamp with threaded rods and corners, squeeze the miters together. Use small folded pieces of waxed paper to keep the glued corners from sticking to the frame clamp.

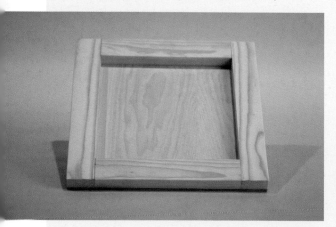

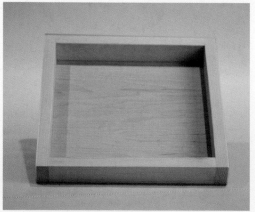

STEP 2 To brace the panel, glue the cradle onto the perimeter of the back side of the panel. Although you can glue the flat sides of the braces to the panel, as in the photo at the left, they provide more rigid support if glued on their edges, as shown in the photo at right. (This is less important with smaller panels.) The braces can be butt-jointed at the corners or mitered for a more refined appearance.

LEFT Pine 1 x 2–inch braces, glued flat, butt joints.
ABOVE Pine 1 x 2–inch braces, glued on edge, butt joints.

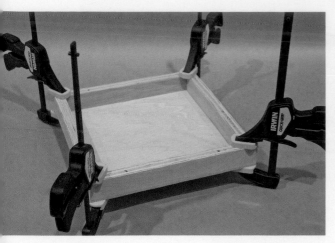

Birch panel, clamped.

Cross-bracing on the back of a 24 x 48–inch panel. Note that the bracing strips are recessed from the frame's edges to allow room for hanging wire.

STEP 3 After gluing the strips of wood to the back of the panel, use frame clamps to hold them tightly in place until the glue dries.

Note that with a panel larger than 24 inches in either length or width, you will need to add cross braces as well. They can be placed at 90-degree angles to the perimeter braces (the cradle) for strength, but braces angled across the corners resist twisting and warping better. The larger the panel, the more important it is to brace it. To determine whether a panel needs additional bracing, hold the panel by its edges and try to flex the panel from corner to corner. If you can twist the panel, it needs bracing.

STEP 4 You can give a floating appearance to the finished work by recessing the cradle frame from the edge of the panel.

ABOVE LEFT Recessed frame cradle.

ABOVE Floating panel.
Photos courtesy of Rodney Thompson.

CARDBOARD

Relatively rigid and very absorbent, cardboard can be an environmentally friendly support on which to paint. With so many chunks of cardboard lying in most recycle bins, opportunity for creativity abounds.

For the past few years, Gail Gregg has been playing with a variety of supports—cardboard packing forms, wine-box dividers, loom cards from a nineteenth-century fabric mill, and plastic packaging—pushing her paintings toward relief sculpture. She is fascinated by the beautiful forms inherent to these industrial materials, which we typically experience as annoyances, things to be discarded or recycled. Using the plastic properties of encaustic, she transforms these eccentric, throwaway objects into beautiful, color-infused forms and patterns. For example, the form in Gregg's work *One Way*, originally the protective packaging inside a box that a radio was shipped in, becomes an iconic piece of design, familiar yet unfamiliar. It asks the viewer to ask whether the form is an object itself or the cast of an object. In an *ARTnews* review of Gregg's 2007 exhibit at Luise Ross Gallery in New York, Ann Landy wrote that "recycling hasn't looked this good since Rauschenberg's *Cardboards*."

Gail Gregg, *One Way*. Encaustic on cardboard (in two sections), 14 x 13 x 1 inches (35.6 x 33 x 2.5 cm), 2006. Collection of Mary Graham. Photo courtesy of Steven Tucker Photography.

FABRIC

Wax on fabric can produce glowing, translucent, light-catching effects. If the fabric is unsupported by panel, the key to success is limiting the amount of wax you use while saturating the flexible fabric with wax. In this way, the mesh of wax and fibers you create will retain some flexibility without losing wax from the surface when movement occurs. Lorrie Fredette creates sculptures made primarily of fabric, which she coats with wax to provide both translucence and support. The inspiration for *Not Knot Dress I* came when Fredette, browsing at a flea market, found a pattern for the same child's dress her grandmother had made for her. Using this pattern, she sewed a series of dresses. *Not Knot Dress I* has more than a thousand hand-tied knots, all based on an intricately intertwined knot known as the love knot.

SCULPTURAL SUBSTRATES

In ancient art, wax was often used to accent sculptures, and artists today are exploring many three-dimensional applications. Unglazed ceramic, cement, wood, and stone sculptures can all be coated with wax. In Robin Hill's *Sideslip,* the base is constructed from wood, wire mesh, and concrete.

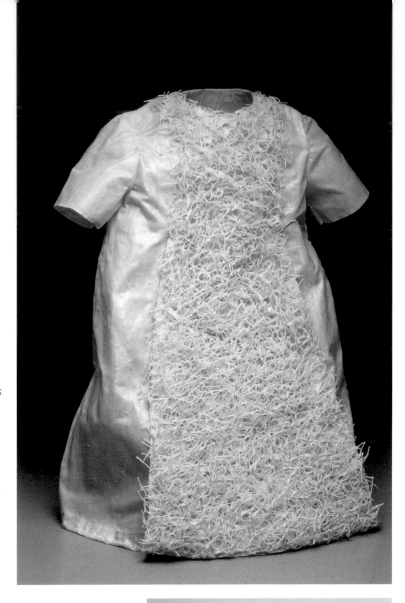

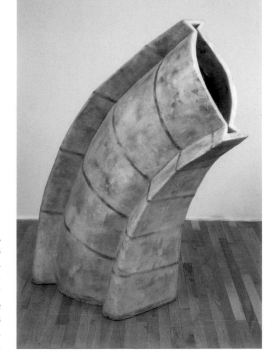

ABOVE Lorrie Fredette, *Not Knot Dress I.* Encaustic, muslin, and waxed linen, 23 x 18 x 18 inches (58.4 x 45.7 x 45.7 cm), 2002. Collection of Lissa Rankin and Matt Klein. Photo courtesy of John Lenz.

RIGHT Robin Hill, *Sideslip.* Beeswax, wood, wire mesh, concrete, 60 x 47 x 18 inches (152.4 x 119.4 x 45.7 cm), 1986. Photo courtesy of Lennon, Weinberg, Inc., and the artist.

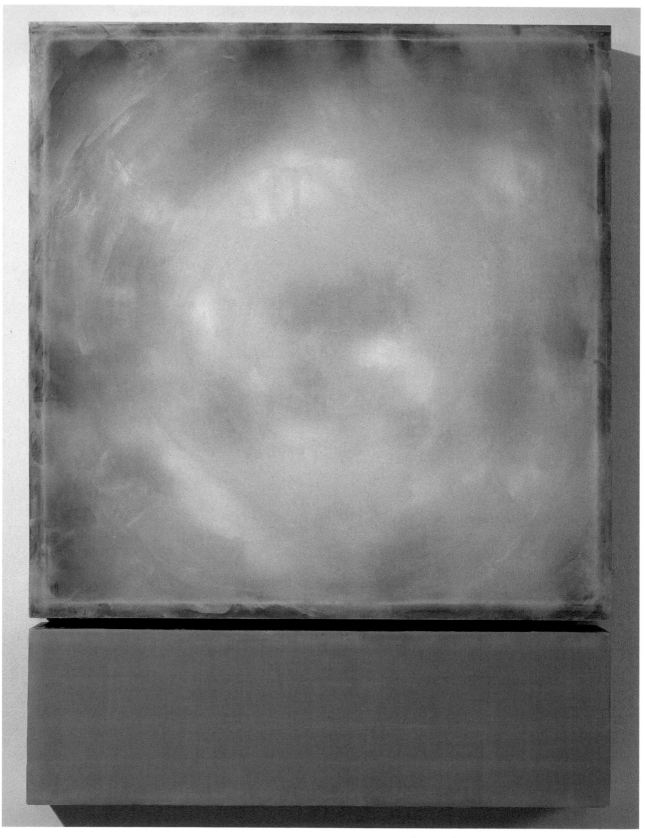

Heather Hutchison, *In Time*. Beeswax, Plexiglas, birch, and pigment, 36 x 28 x 4 inches (91.4 x 71.1 x 10.2 cm), 1995.
Photo courtesy of Peter Muscato.

PLEXIGLAS AND GLASS

Even Plexiglas and glass have been used as supports for encaustic painting. The idea of painting with a translucent medium over a transparent substrate appeals to some artists who want light to play an important role in their art. From an artistic standpoint, Plexiglas and wax are a perfect marriage. As ambient light shines through a painting on Plexiglas, the painting takes on great luminosity, appearing to glow.

Heather Hutchison, who has worked with wax on Plexiglas for decades, reports that she has had no problems beyond the usual wear and tear that encaustic works are prone to (and that all the artists in this book have experienced). Dusty Griffith also paints on Plexiglas, building cradled panels from modular pieces of 2 x 2–inch lumber and then screwing plates of Plexiglas to the large wooden cradle. By painting the back side of the Plexiglas and coating the front side with beeswax, Griffith creates visual depth and luminous color. Because the wax cannot penetrate into the substrate, painting on Plexiglas or glass relies on the limited adhesive qualities of encaustic. Roughening the surfaces with sandpaper can provide some textural "tooth," which may allow the encaustic to bind better.

In her work, Hutchison makes sure that the substrate is rigidly supported to avoid any flexion. Her process has been very success-ful. If you want to use a clear support, Plexiglas is probably preferable to glass, because the dramatic temperature changes to which glass is subject (from very hot to very cold) put the wax at greater risk of cracking. Hutchison encourages those who are drawn to Plexiglas or glass to seek ways of making these materials work for them. To artists who want to explore alternative grounds and supports, Hutchison of-fers this advice: "Experiment with materials that resonate with you or that you discover in your immediate surroundings. Be inventive about finding solutions when working with nonabsorbent grounds."

Of her art, Hutchison says, "I am engaged in a responsive art form, in which color luminosity registers for the viewer the changing natural light specific to any moment of a given day. This work is purely phenomenological and is best considered experientially. In my work, I explore, in a very real sense, the scientific truism that the only con-stant is change. Specifically, I utilize my medium's literal transparency to then amplify and inflect its ability to self-illuminate. It is my pursuit in my work to maximize the physicality of the material while minimiz-ing the resultant imagery."

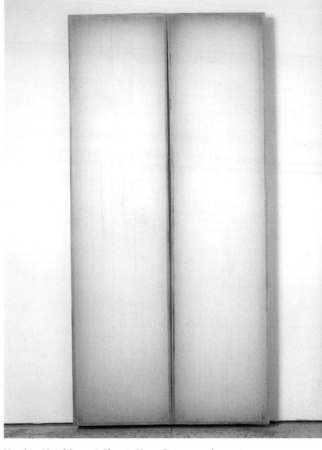

Heather Hutchison, *A Place to Hang*. Beeswax, pigment, acrylic, Plexiglas, wood, 96 x 45 x 4 inches (243.8 x 114.3 x 10.2 cm), 1997.
Photo courtesy of Peter Muscato.

TYPES OF GROUNDS

Ideally, the ground for encaustic—the surface onto which you actually paint—should be absorbent. Many artists prefer to work on a white ground to enhance reflectivity and color brilliance, although wood panels can be painted directly with wax, with no other ground necessary. Do note that acrylic gesso, which is used on most prestretched canvases and which is an appropriate ground for other media, is not absorbent and is therefore not a suitable ground for encaustic.

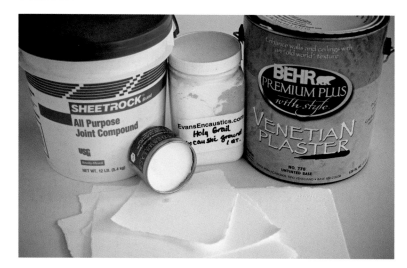

Types of grounds. *Clockwise from top left:* Sheetrock joint compound, white encaustic paint, Evans Encaustic Holy Grail encaustic ground, Behr Venetian Plaster, watercolor paper.
Photo by Monique Feil.

WHITE ENCAUSTIC PAINT

The quickest and simplest way to create a white ground is to paint the support with white encaustic paint. To prepare the surface, size the support with a layer of beeswax or encaustic medium, then follow with a layer of white encaustic paint. The disadvantage to this simple technique is that, if the paint that is applied on top of this ground is completely liquefied, the white pigment may mix with paint laid down on this surface. Titanium white is a particularly strong pigment and can seep through other pigments when liquefied. Putting a few coats of clear medium on the white ground may help separate the ground from the colored layers that will be laid on top of it and help buffer the surface from interference from the white pigment beneath.

RABBIT-SKIN GLUE GESSO

Many encaustic artists swear by the time-honored rabbit-skin glue (or hide glue) gesso ground. Time-consuming and laborious to make, rabbit-skin glue gesso is the traditional method for preparing a white ground that is both velvety smooth and highly absorbent, brilliantly

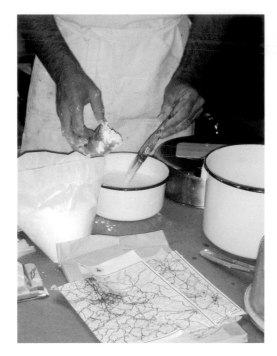

ABOVE R&F Handmade Paints Encaustic Gesso.
Photo courtesy of R&F Handmade Paints.

LEFT Chester Arnold demonstrating the preparation of rabbit-skin glue gesso at the International Encaustic Artists retreat in Carmel Valley, Calif.
Photo courtesy of Paula Fava.

white, and unbeatably luminous. Tina Vietmeier, Adele Shaw, and Timothy McDowell all use a rabbit-skin glue gesso ground and then employ a variety of painting and drawing techniques directly on the surface before applying wax.

OTHER GESSOES

For those seeking a less laborious process, there are alternatives to rabbit-skin glue gesso. Fredrix Gesso Ground Dry Mix, which contains crushed marble, titanium white, and animal glue, is easier to prepare than traditional rabbit-skin glue gesso. Evans Encaustics' Holy Grail ground, a nonacrylic product created specifically for encaustic, provides a ready-made, easy-to-apply, absorbent white ground for encaustic painting. R&F Encaustic Gesso is a brushable white ground that dries to an absorbent, ready-to-paint surface. This gesso functions like an acrylic gesso but has a lower ratio of binder to solid, which makes it remain highly absorbent.

CANVAS STRETCHED OVER PANEL

You can stretch canvas over a cradled panel, eliminating the flexion that causes problems when encaustic is used on canvas stretched over a frame. It helps to first apply beeswax, microcrystalline wax, or encaustic medium to the panel. Then stretch the canvas tightly across and around the panel, securing it onto the back of the cradle of the panel. Apply a coat of beeswax, microcrystalline wax, or encaustic medium and fuse it to the canvas to create a continuous surface of

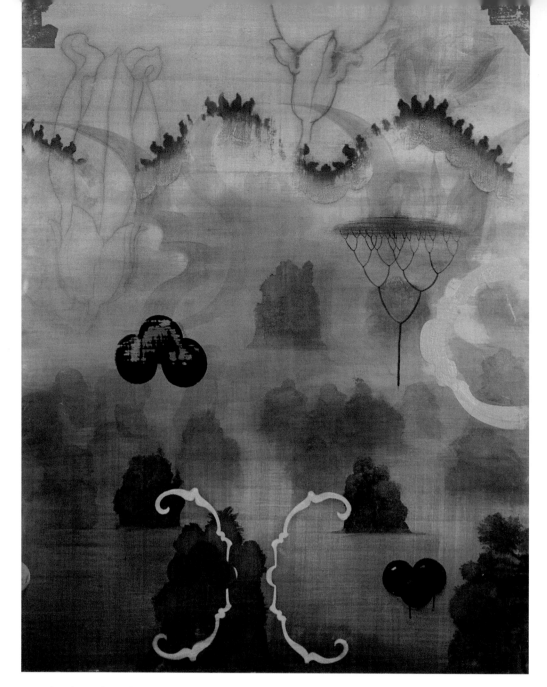

wax that is anchored in the wood and that encases the fibers of the canvas. This eliminates any potential movement of the canvas.

Some artists work on linen rather than cotton duck canvas. Timothy McDowell paints on linen that he mounts on panels and then coats with rabbit-skin glue gesso. His paintings embrace the texture provided by the linen, which remains visible through the translucent layers of wax.

WHITE PAPER MOUNTED ON PANEL

Paper mounted on a wood panel can also provide a good ground for encaustic. For best results, use a thicker paper, such as heavy watercolor or printmaking paper or white, all-rag, museum matboard. Lay the paper on a flat surface, with the side you will be painting on

facing down. Spread an even coat of PVA glue or acrylic gel medium on the panel's surface, then invert the panel onto the paper and weight the panel, allowing it to dry overnight. It helps to use an oversize sheet of paper and then to trim the paper to the panel's edges after it is dry. In this case, the acrylic medium does not present a problem because the absorbency is provided by the paper, and the wax does not come into direct contact with the acrylic.

VENETIAN PLASTER

While laborious to mix and apply, traditional Venetian plaster, which is made with slaked lime, sifted river sand, and marble dust, creates a lush, absorbent ground that binds well to wax. A contractor cautions that Venetian plaster works best when applied over a roll-on adhesive. Without the adhesive, the plaster has a tendency to chip off.

Mark Rediske prefers to use a synthetic product created by Behr, called Premium Plus With Style Venetian Plaster. Easy to apply in thin layers, velvety smooth, white, absorbent, and readily available at hardware stores Behr Venetian Plaster offers yet another way to prepare a white ground.

CLAYBOARD

Clayboard, a hardboard panel coated with ground, is readily available from art-supp[ly] use. Clayboard comes in both cradled an[d] the cradle limits flexion, cradled clayboa[rd] tic. Some artists have admitted to me th[at] with chipping when using clayboard, bu[t] swear by it.

OTHER GROUNDS

You can experiment with other mater[ials] ground variations. Some artists use o[ther] other casting plasters, or cement mi[x] to adhere well to a panel may requi[re] wood first or using a special adhes[ive]

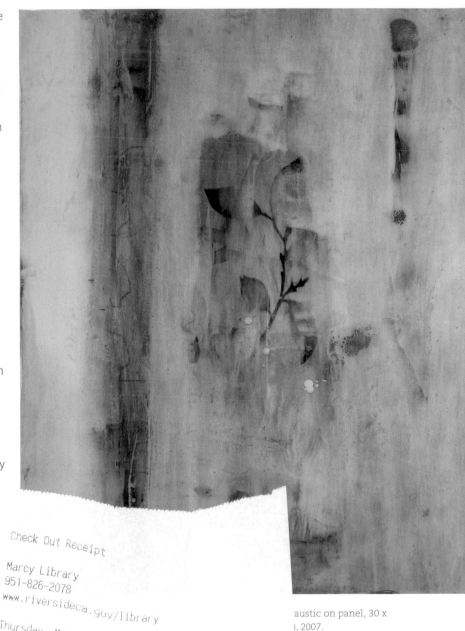

austic on panel, 30 x
), 2007.

t House. Beeswax,
60 x 46 inches (152.4

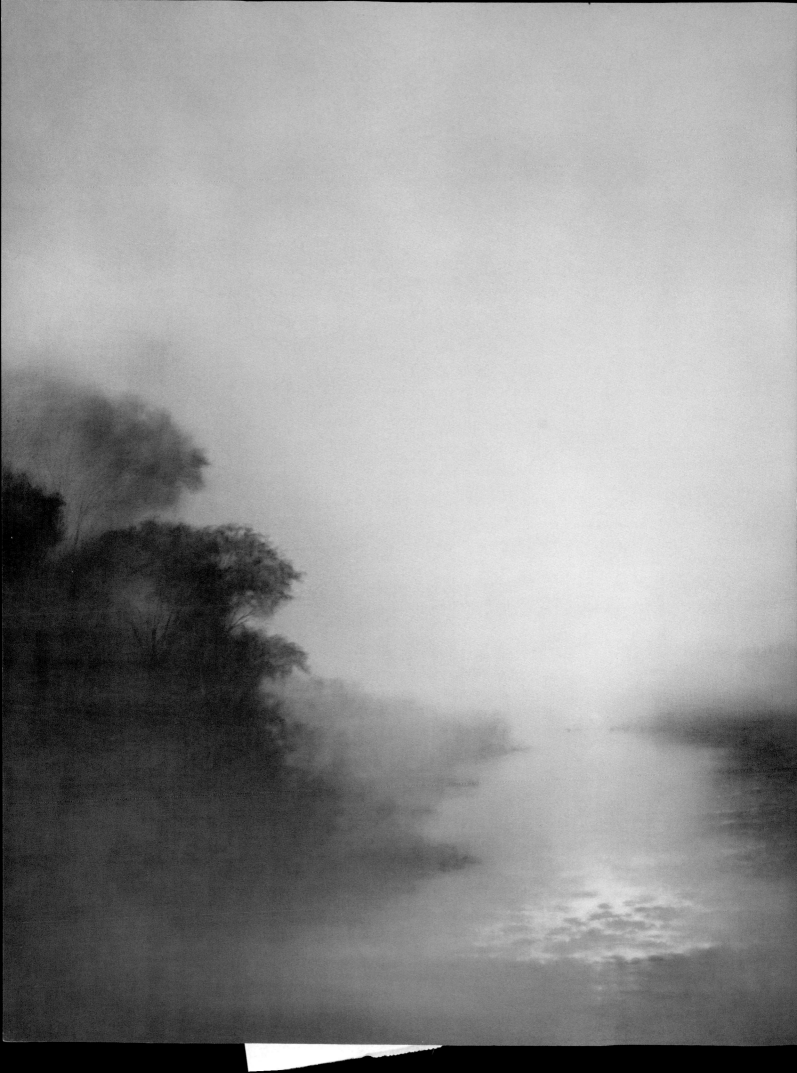

Encaustic Painting Techniques: SMOOTH

Many consider a perfectly smooth surface the holy grail of encaustic. With buffing and proper care, a smooth encaustic surface will retain its color, luminosity, and finish indefinitely. Artists use a variety of techniques to achieve a smooth surface, and each has its unique characteristics and beauty. In different hands, even the same technique can yield different effects.

Students often ask me how they can create a perfectly transparent surface with encaustic, and I have experimented with many techniques. In general, the finest quality of mechanically bleached white beeswax will yield a semitransparent surface. It's nearly clear, but not quite, because encaustic always has a bit of milky opacity as one of its inherent qualities. The thinner the application of wax, the more transparent it will be. If you are seeking a thick, perfectly clear surface, you are working with the wrong medium and would be better served with other materials.

Hiro Yokose, *Untitled #4923* (detail). Oil and wax on canvas, 54 x 48 inches (137.2 x 121.9 cm), 2007. Courtesy of Winston Wächter Fine Art.

USING A BRUSH

The most common technique for achieving a smooth surface is to brush wax on a surface and then fuse the layers with a heat gun or blowtorch to eliminate the brushstrokes. This technique works best when the ambient temperature is neither too hot nor too cold. Preheating the surface on which you are applying the wax helps to limit the texture the brush leaves behind.

Tracey Adams applies the technique described opposite to achieve her works' smooth surfaces.

Tracey Adams, *Untitled*. Encaustic on panel, 42 x 40
inches (106.7 x 101.6 cm), 2005.
Collection of David and Helen Milgrom.

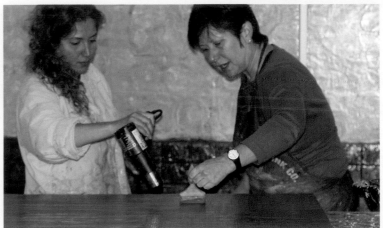

STEP 1 Adams applies beeswax as her initial layer. For her white ground, she mounts paper to panel, but any smooth ground may be used for this initial coat. Using a heat gun or blowtorch, she fuses the beeswax to the ground, chasing away the bubbles that tend to form on the surface. When you do this yourself, stand at an angle to the surface so that you can see, by the light reflected from the surface, when the wax is just beginning to liquefy. Manipulate your heat source in small movements, starting in one corner and working across the surface, pushing the bubbles away from the starting point until the bubbles and brushstrokes disappear. If you keep the heat source in one spot too long, a "bald spot" may occur where too much melted wax has moved away from that area. If this happens, allow the surface to cool completely, add more wax, and fuse again.

STEP 2 When the initial layer has been fused, begin applying encaustic paint. When covering large areas, Adams is helped by her studio assistant, Hoda Caracalla (at left), who holds a heat gun over the surface to keep it warm as Adams paints.

STEP 3 When applying paint, Adams divides her panel into four quadrants, brushing from the edges of the panel toward the center. She applies two thin layers at 90-degree angles to one another to create a cross-hatched effect.

Photos by the author.

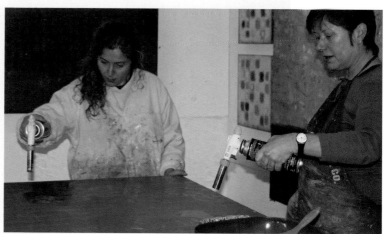

STEP 4 After applying the paint, Adams scrapes the surface with a single-edge razor blade to smooth it. (You can also use a ceramic loop tool, cabinet scraper, or other straightedge).

STEP 5 Now, using either a heat gun or blowtorch, Adams and her assistant fuse the surface, then repeat the process of laying down paint, scraping, and fusing for up to sixteen layers, until Adams achieves the desired effect.

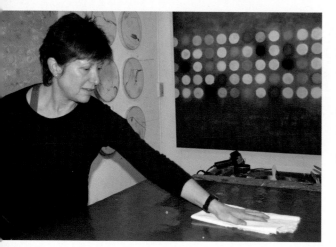

STEP 6 When the painting is cool, Adams buffs the surface of the painting with a clean, smooth cloth, which elevates the shine to a polished finish. As the painting cools, the surface will become harder and more translucent. Over time, the surface may lose its shine, but the luster can be renewed with simple buffing.

Photos by the author.

Bubbles and pinholes appearing on an encaustic surface painted on birch panel as it is fused. Photo by the author.

Preventing and Eliminating Bubbles

The appearance of bubbles or pinholes on a smooth encaustic surface can be extremely frustrating. These bubbles, which are caused by air in the support migrating up through the wax, can usually be prevented by careful technique. Start with high-quality materials. Cabinet-grade birch plywood contains less air than less expensive plywood, which tends to cause more pinholes. Also, reheating can cause bubbles to appear, so avoid backtracking with the heat source over an already bubble-free area.

The key to a smooth, bubble-free surface is to keep the leading edge of the liquefied wax moving continuously across the surface until the opposite edge is reached.

Complete each layer of fusing, and avoid stopping halfway. If an area persistently continues to retain bubbles, the layer of paint may be too thin in that section; to get rid of the bubbles, try adding another layer of paint and fusing again. Sometimes bubbles persist no matter what you do for the simple reason that absorbent supports are porous and air will continue, despite your best efforts, to migrate upward through the wax. If you find it impossible to remove all the bubbles, relax, embrace the spontaneity of the medium, and allow it to lead you. If, however, the bubbles are just too frustrating, try filling the pinholes with an oil stick to achieve a different effect—or start over with a new panel!

POURING **WAX**

Betsy Eby creates luminous, smooth surfaces in her work. To achieve this, she paints an initial underpainting on a gessoed cradled panel using a mixture of oil paint and a homemade cold wax medium (a combination of beeswax and damar varnish). This cools into a workable, paste-like consistency, similar to the commercially available Dorland's wax medium or Gamblin's Cold Wax Medium. She then pours her version of encaustic medium over the painting, spreading the liquefied wax across her surface before fusing with two blowtorches. The particular mixture she uses allows the wax to remain liquid for a longer time, making pouring over a large surface more manageable.

To achieve his smooth surfaces, Howard Hersh pours encaustic medium or paint over a painting's surface in one swift pour. Hersh layers these pours of wax to create his complex paintings. About his paintings, Hersh says, "While I seek to depict the Oneness and refute the illusion of separation people feel, I also strive to reveal layers of reality through the translucency of paint, particularly wax." Here are the steps Hersh follows:

STEP 1 Hersh first uses masking tape to build a dam around the edges of a cradled plywood panel. He makes this dam high enough to contain all the wax he'll pour onto the surface. (Alternately, if he wants the wax to spill over the edges, he leaves the edges untapped.)

STEP 2 To make the ground more receptive to pouring, Hersh preheats the surface with a heat source.

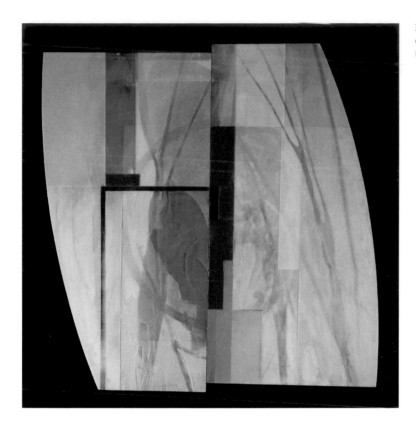

Howard Hersh, *Straight Forward Curves 05-3*. Encaustic on panels, 62 x 60 inches (157.5 x 152.4 cm), 2005. Photo courtesy of the artist.

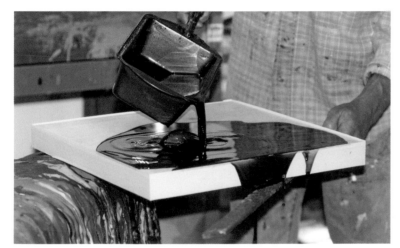

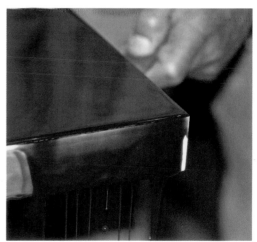

STEP 3 Making sure he has mixed enough paint to cover the surface, Hersh pours the wax with a steady, swift hand. Hersh balances the panel on a sawhorse and a piece of wood to achieve the perfect angle for his pours—perfectly flat if he desires or barely tilted to allow wax to spill off a corner.

Photos by the author.

Michael David Talks about His *Jackies* Series

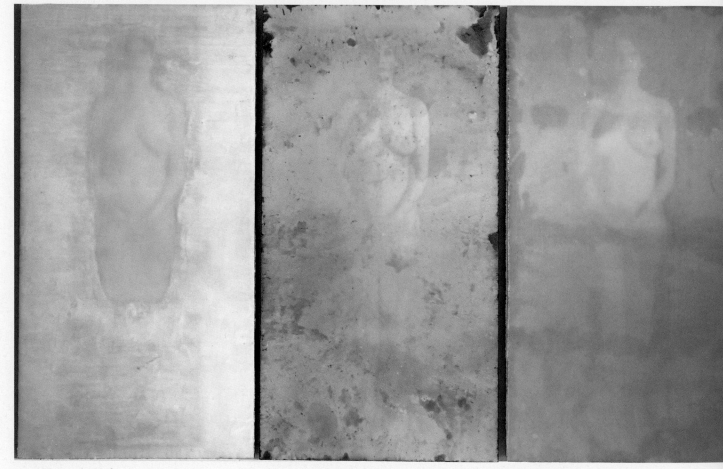

Michael David, *Three Jackies*. Oil and wax on wood,
88 x 132 inches (223.5 x 335.3 cm), 1993.
Collection of the Singer family. Photo courtesy of Oren Slor.

Lissa Rankin: Your celebrated *Jackie* paintings, which appeared at the Aspen Art Museum and in the Montclair Museum of Art's Waxing Poetic show, demonstrated a sublime example of pouring wax on a painting. How did you achieve that effect?

Michael David: All the *Jackies* were poured in tandem with my assistant, John McCafferty, who was Jackie's husband. We would take four cooking pots and mix white bees-wax, oil paint, and damar varnish in each pot and melt it until it was boiling hot. Then we would wrap our gloved hands in paper towels, so as not to burn our hands, and walk over to the panel, which was 88 x 44 inches. John would go to the top vertical end and I to the bottom. He was at her head, and I was at her feet.

Next, we would lean over with twenty pounds of molten wax and meet over the middle of the painting, pouring the wax

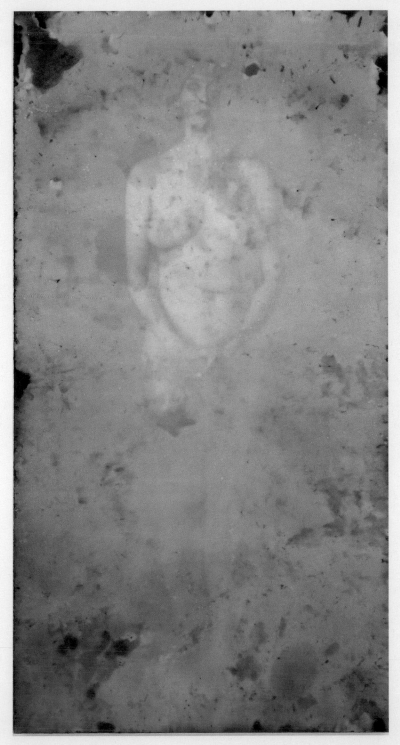

in a mimicked S pattern, a form of some erotic snake dance. It was akin, I guess, to Yves Klein's event paintings, but way more dangerous.

John, the more meticulous of us, would try to make the painting level before we poured. He would place the painting on two sets of sawhorses about four feet high and then shim the corners with cut cardboard. Still, the wax was so hot that it would run off the edges onto the drop cloth below. After the painting cooled and set, we would take a knife and shave the nipples of wax that collected on the undersides of the supports. We would repeat this dance six times, until the painting weighed 120 pounds, the same weight as Jackie herself. After pouring the painting, the oil-painted image underneath would disappear. We wouldn't know what we had until it slowly cooled. And then she, Jackie, would reappear like a ghost developing in a photo in a darkroom. It was some of the most dangerous, thrilling painting I have ever done. Like Iggy Pop stage-diving or cutting himself with razor blades, a merger of painting and performance art, with a dash of sadomasochism.

Michael David, *Blue Jackie*. Oil, wax, and wood, 84 x 44 inches (213.4 x 111.8 cm), 1993. Collection of the Singer family. Photo courtesy of Oren Slor.

USING AN **IRON**

You can use a tacking iron to create a variety of different effects. Cari Hernandez uses a tacking iron to achieve a glossy surface that appears as if the wax were applied with a hot palette knife. Gay Patterson uses a tacking iron, combined with other techniques, to achieve a pristine, perfectly smooth surface.

Cari Hernandez recommends the following technique for achieving a luminous, smooth surface. She prefers the Hobbico tacking iron and recommends using medium that has a high ratio of damar resin to beeswax because it holds up better to the high heat generated by the process. About her work, Hernandez says, "*Oh* is a lively series that has been described as visceral. It was developed while on a quest to explore jubilant emotion. I seek to create a sense of movement and spontaneity in form." Here's how her technique works:

STEP 1 Start with a white ground, which will give a greater depth to the painting as light passes through the wax and bounces back. Apply several layers of encaustic medium before applying any paint, using the iron to fuse each layer.

STEP 2 Gently pass the iron over the surface, smoothing brushstrokes and creating an even surface, eliminating divots and ridges. Have folded paper towels ready, and wipe the surface of the iron after each pass.

STEP 3 Apply one or two layers of encaustic paint, then add a layer of encaustic medium.

STEP 4 If you wish to blend colors together, pass the iron back and forth over the area where you want the blending to take place, and let the layer beneath mingle with the top layer. Be sure to use enough medium in the layering process to act as a buffer between layers that you don't wish to blend. The more layers of medium you use, the more depth and translucency you will achieve.

STEP 5 Repeat this process until you have added the desired number of layers. As you start to build layers of paint, be aware of the amount of heat that the iron is creating and the amount of pressure you are applying to the surface of the painting, as you can easily melt through to underlying layers. Let the surface cool if hot spots develop.

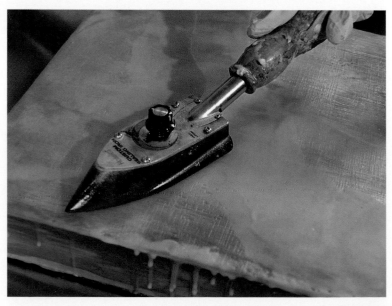

Cari Hernandez with tacking iron in her studio in San Anselmo, Calif.
Photo by the author.

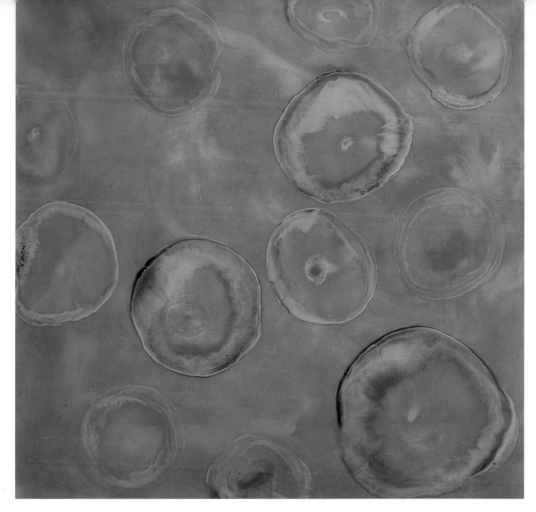

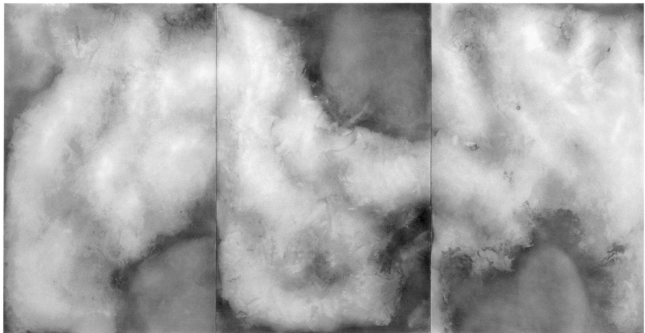

TOP Cari Hernandez, *Oh . . . Luscious.* Beeswax, damar resin, and pigment. 24 x 24 x 6 inches (61 x 61 x 15.2 cm), 2007.
Photo courtesy of the artist.

ABOVE Gay Patterson, *Far from Equilibrium* (triptych). Encaustic on wood, 54 x 108 inches (137.2 x 274.3 cm), 2002–2005.
Photo courtesy of the artist.

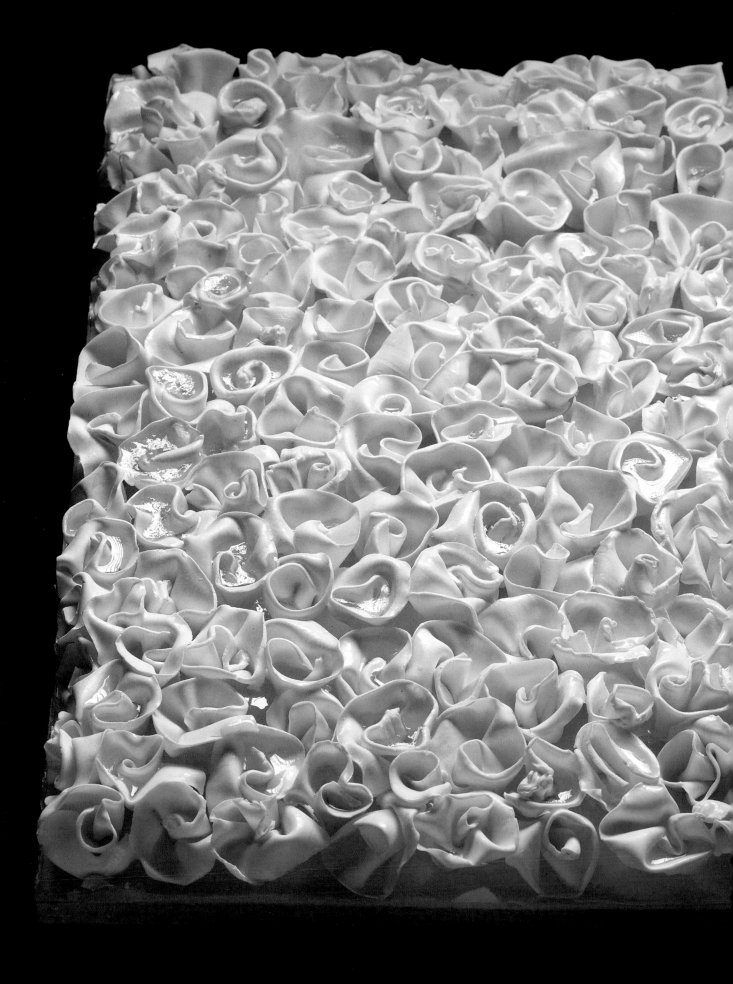

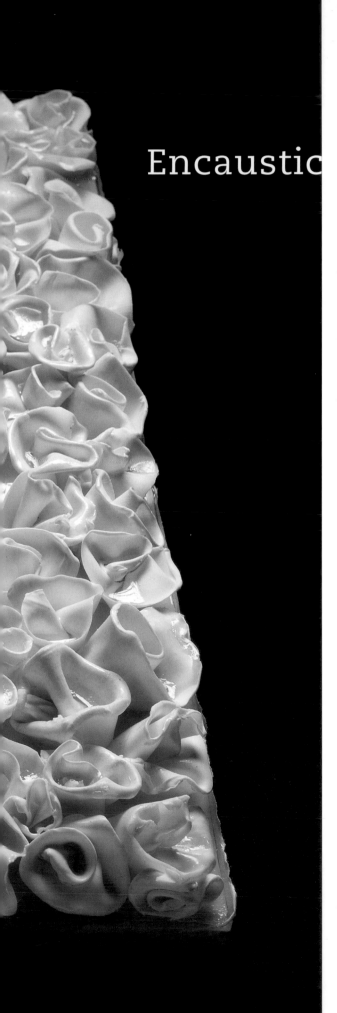

Encaustic Painting Techniques:
TEXTURED

While smooth surfaces require fighting wax's tendency to build texture, textured effects capitalize on wax's tendency to quickly become sculptural. Because fusing the surface tends to smooth the paint, many techniques for creating a textured surface require less heat. The following techniques all begin with a smooth surface but become very textural with the application of these dimensional effects.

Cari Hernandez, *Lovely Bed*. Encaustic and resin on panel, 18 by 24 inches (45.7 x 61 inches), 2009.
Photo courtesy of University Communications at Appalachian State University. Photograph by Troy Tuttle and Marie Freeman.

CAVO-RILIEVEO RELIEF IMPRINTS

By placing a flat object on a warm, smooth wax surface, you can create a relief impression, or imprint, of the object. For this technique, known as *cavo-rilievo* (Italian for "hollow relief"), you can use natural objects such as leaves and flowers, textured fabrics such as lace or burlap, or meshes such as the screening material used for window screens.

Anna Gagne utilizes this technique to create embossed reliefs of organic elements in her botanical paintings. She recommends choosing objects that are flat, sturdy, and filled with detail. Gagne says, "I use leaves that I gather from my yard, on walks through the woods, in a park, anywhere I happen to find them. I'm intrigued with the way the wax fossilizes the leaf's impression. What's most frustrating is that I can't do this kind of work through the winter."

Anna Gagne, *Ginko's Descent*. Encaustic, pigment stick, and gold leaf, 24 x 12 inches (61 x 30.5 cm), 2007. Photo courtesy of the artist.

CAVO-RILIEVEO TECHNIQUE

Any textured flat object will work for this technique. Here are the steps:

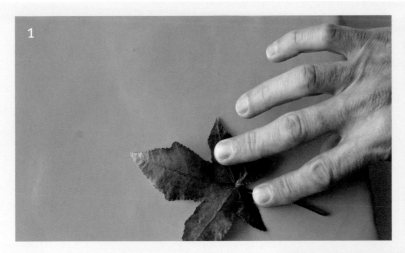

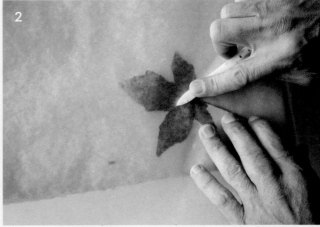

STEP 1 Prepare a smooth encaustic surface in the color you wish the background to be. (This will become the color of the object.) Lay the object flat upon the surface while the wax is still warm but not too soft.

STEP 2 Cover the object with wax paper and burnish the object with a burnishing tool.

STEP 3 Remove the wax paper and paint over the object, then fuse.

STEP 4 While the overlying layer of paint is still warm, gently remove the object.

STEP 5 If you wish, use an oil stick to accentuate the detail of the object's imprint, then fuse.

Photos by Monique Feil.

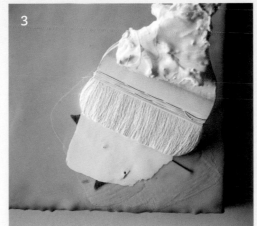

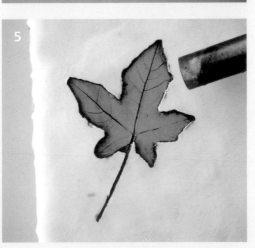

DRIPPING

You can apply paint to a brush and drip it across the painting's surface to create a polka-dot effect. The width and height of the dots will depend on the amount of paint on your brush and the temperature of the paint when applied. Cooler paint creates smaller, taller dots, while warmer paint makes wider, flatter dots. Drips can be more precisely applied with a small round detail brush. For an interesting effect, drip dots on the painting's surface, cover with medium, then fuse the surface to make the underlying drips melt.

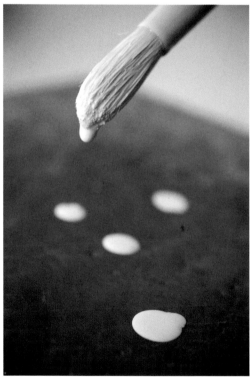

Photo by Monique Feil.

RIGHT Sue Katz, *Decades*. Encaustic on wood with copper and pencil, 24 x 6 inches (61 x 15.2 cm), 2009.
Photo courtesy of the artist.

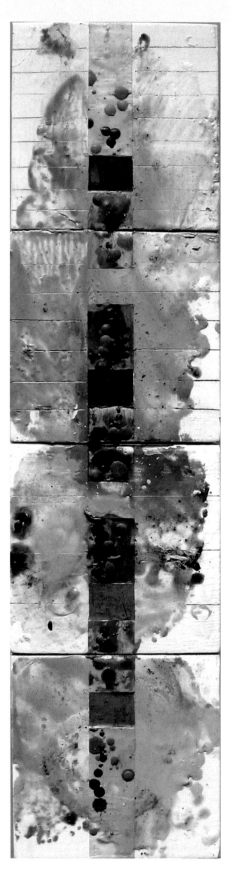

SPLATTERING

Splattering encaustic paint across a wax surface adds exciting and unpredictable spontaneity to a painting. To create a splattered effect, dip a brush in paint, then hold the brush vertically with the bristles up, angling the brush toward you. Flick the brush forward, flexing at the wrist or hitting the handle of the brush against your other hand. Experiment with splattering, varying the effect by changing the size of the brush, the amount of paint on the brush, the force of the flicking motion, and the temperature of the paint. Bigger brushes create bigger splatters because they hold more paint; smaller brushes create a more controlled effect. If you allow much of the paint to drain from the brush before splattering, the size of each individual splatter mark will be smaller.

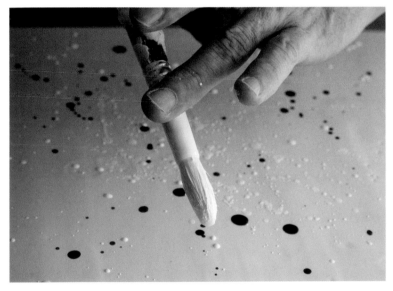

Photo by Monique Feil.

Laura Moriarty, of R&F Handmade Paints, describes the following splattering technique, which employs a wire mesh:

STEP 1 Prop a fine wire-mesh screen above the surface of a painting.

STEP 2 Paint hot wax onto the screen, allowing the paint to splatter through the mesh onto the painting. The hotter the wax, the more it will splatter.

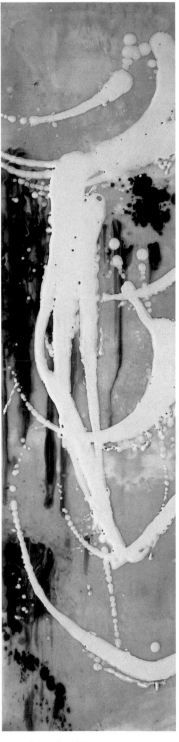

Matt Klein, *Mixed Messages.*
Encaustic on panel,
36 x 9 inches (91.4 x 22.9 cm), 2007.
Photo courtesy of the artisit.

ACCRETION

Accretion capitalizes on the textural properties of wax and can be achieved by building up the wax with repetitive brushstrokes to create a textured surface.

Using a variation of the accretion technique, Michael David creates his famed *Chortens* by frenetically applying hot wax to supports made of wood or fiberglass. "What I love about working with wax," he says, "is that the wax leaves a history of every brushstroke, every movement of the artist, every drip, every gesture frozen."

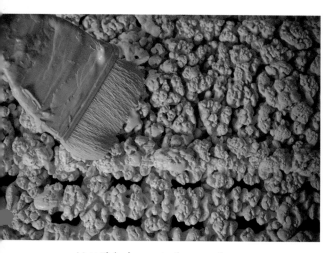

Matt Klein demonstrating accretion.
Photo by the author.

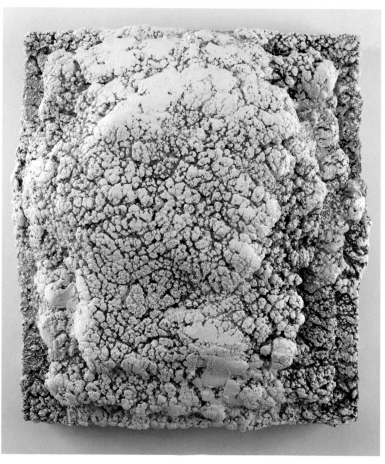

Michael David, *Population Whites/Greens/Yellows*. Oil, wax, wood, 26 x 30 x 10 inches (66 x 76.2 x 25.4 cm), 2001–2002.
Photo courtesy of Oren Slor.

David describes his painting process as a "physical attack" in which he builds up patterns based on the rhythm of his actions "like a boxer." He moves around vigorously, wielding the brush in a dancelike fashion and allowing his physical gestures to manifest themselves in the art as the wax builds up with each stroke of the brush. Noting that his work is not technically encaustic, he chooses not to fuse between layers, wishing to preserve every gesture in his painting dance. "It's all there," he says. "Art is the only real truth. Everything you feel, every-

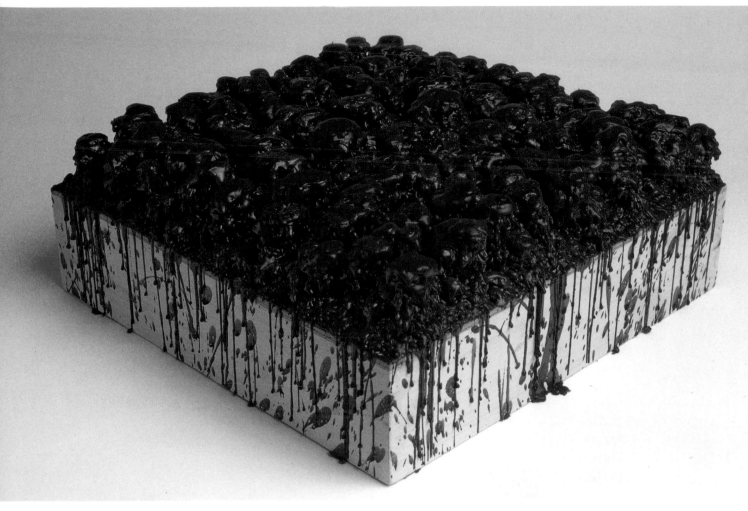

Martin Kline, *Conundrum (for Roberta Smith)*. Sculpture wax on panel, 1999.
Private collection, France. Photo by Kevin Noble.

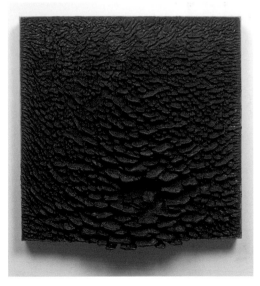

Martin Kline, *Threshold*. Sculpture wax on linen on stretcher, 27 x 26 x 4 inches (68.6 x 66 x 10.2 cm), 1999. (This painting was cast in bronze in 2004.)
Photo by Kevin Noble.

thing you do, every lie, every bit of passion, it's in there."

David views the fragility of these pieces as part of their legacy. A longtime admirer of Buddhist philosophy, he believes that a change that occurs to the art because of this fragility is merely a mutation that enhances the life of the art. David was delighted to discover that, in Buddhist teachings, wax is a sacred material, "a metaphor for compassion, fragility, and change."

Martin Kline uses an accretion technique to create paintings that emphasize every brushstroke in a manner that reveals his process. With his process, he hopes to maintain the integrity and honesty of his art. "You can detect how each painting is made," he says, "by studying the work. The brushstrokes tell the history, and each stroke is evident. When people ask how these effects were created, I tell them, first of all, with a paintbrush, because they are so built up that many people initially think they are hand formed. Secondly, you can see the direction the brushstroke traveled, from bottom to top to create a hanging growth, or in a spiral where the motion of my arm sweeps

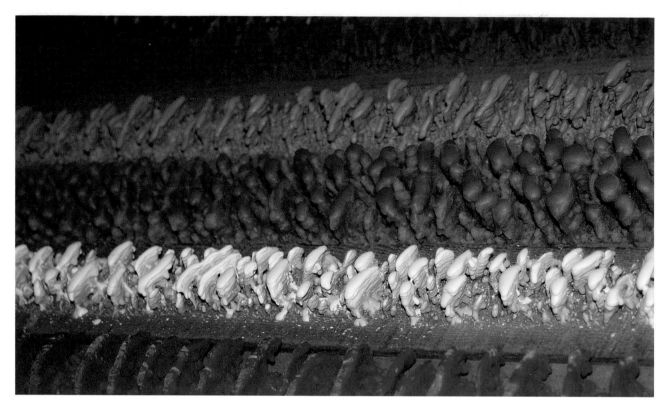

in a path to the center of the painting, from the outside in or inside out, creating a bloom. An all-over flat effect where the encaustic paint grows straight out from the panel is achieved by painting equally and evenly in all directions."

Kline uses a variety of types of wax, including pure beeswax, microcrystalline mixes, and sculpture wax. Visiting his studio, I discovered that, in addition to creating paintings that blur the line between painting and sculpture, Kline employs this technique to anything in his environment—a baseball bat, a fallen tree, a chair. His enthusiasm for the process is evident in both the artworks and the ordinary objects that surround him.

"Candy Drawer" containing studies for larger works, in Martin Kline's studio in Rhinebeck, N.Y.
Photo by the author.

Kline's studio in Rhinebeck.
Photo courtesy of Kevin Noble.

LAYERING AND SCRAPING

Working with wax is so playful and rewarding in large part because you can both build up and scrape down a surface. You can create surfaces that are both smooth and textured, then scrape the surfaces using a single-edge razor blade, a ceramic loop tool or rib tool, or any tool with a straight, rigid edge. Repeating this process through intentional manipulation or spontaneous performance (and the resulting "controlled accidents") can yield extremely complex and interesting surfaces.

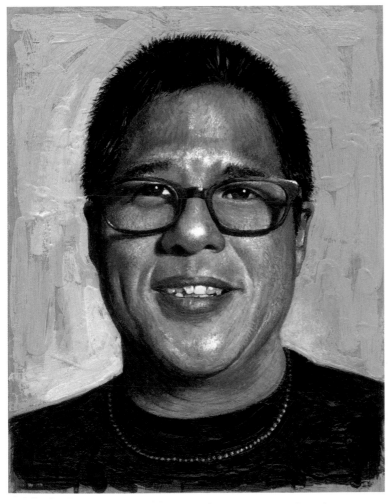

Kevin Frank, *Paul H-O*. Wax on wood panel, 14 x 11 inches (35.6 x 27.9 cm), 2000.
From the collection of GalleryBeat TV. Photo courtesy of the artist.

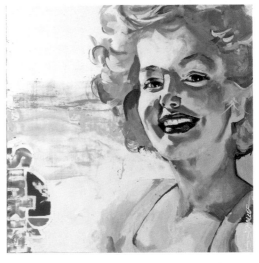

TOP Eileen Goldenberg, *Tea House #154*. Encaustic on wood panel, 12 x 12 inches (30.5 x 30.5 cm), 2007.
Photo courtesy of the artist.

ABOVE Jeff Schaller, *Sunkist*. Encaustic on panel, 24 x 24 inches (61 x 61 cm), 2007.
Courtesy of Gallery I.D., Geneva, Switzerland. Courtesy of Adler & Co.

Mark Perlman, who often uses a layering-and-scraping process, says that he often ends up with more wax dripped around the studio than painted onto his panels. Gay Patterson creates beautifully smooth but expertly manipulated surfaces using this technique. To achieve her effects, she applies paint, fuses, and scrapes through to reveal underlying layers, ending up with an essentially level surface. She then uses the iron to smooth the surface, moving the iron in a back-and-forth motion to make the surface minutely faceted.

Kevin Frank and Jeff Schaller both utilize this technique to achieve variations in flesh tones in their portraits, while Alexandre Masino uses a similar process when shading his still lifes. The process of adding and then subtracting paint creates complexity, and most of the artists I interviewed incorporate such techniques into their work to some degree. Eileen Goldenberg employs a process of building up layers and then scraping the surface with a clay loop tool, selectively revealing the circular forms she meticulously builds up beneath.

LAYERING-AND-SCRAPING TECHNIQUE

While there are many variations on the layering-and-scraping process, the following step-by-step instruction explains one such technique:

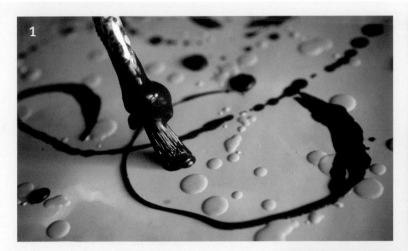

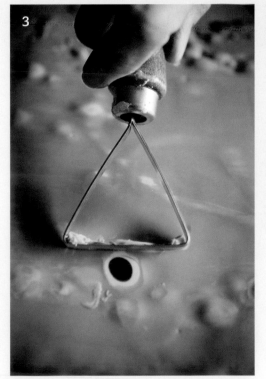

STEP 1 Over a fused, smooth encaustic surface, build up a textured background with drips, dribbles, stencils, accretion techniques, or any other textured technique you want to use. Keep in mind that this background will be completely covered over but later revealed.

STEP 2 Cover the textured background with encaustic paint, in layers, fusing lightly between layers. (For my paintings, I add five to ten layers of encaustic paint, fusing each layer in turn, before I scrape.)

STEP 3 Using a tool with a flat surface, such as a ceramic loop tool or single-edge razor blade, scrape back the surface to selectively reveal what lies beneath. Be careful not to scrape when the surface is too warm, or you may scrape all the way down to the support—but also keep in mind that if the paint gets too cold, it will be difficult to scrape. (When I employ this technique, I scrape small sections that I know I can start and complete in a relatively short period of time. If you stop layering and scraping before you're done, you may find it impossible to scrape, even if you reheat the surface.)

Photos by Monique Feil.

STEP 4 When the scraped surface has cooled, paint a layer of encaustic medium over the revealed surface to protect it from bleeding when fused, then fuse it.

Creating Special Effects
WITH ENCAUSTIC

Once you've mastered the basics of creating smooth, textured, and layered surfaces, the real fun begins. You can employ a variety of techniques to achieve special effects that serve your own artistic vision. In my body of work, I have used almost every one of these techniques, depending on the message I've sought to put forth and the aesthetic I've wished to achieve. Let your imagination run wild—and light your creative spark—as you experiment with inscribing techniques, masking off lines and shapes, using stencils, pouring shapes, and combining encaustic with graphite and underpainting techniques.

Lissa Rankin, *All of Us* (detail). Encaustic on panel, 48 x 36 inches (122 x 91.5 cm), 2008.
Photo by Matt Klein.

INSCRIBING ENCAUSTIC PAINTINGS

You can achieve unique effects by etching a wax surface—scratching lines, drawings, or words into a wax surface and combining these techniques with a variety of others. You can modify the effect by altering the tool, the temperature of the surface, and the pressure you exert when inscribing. If you work on a warm, still-soft surface, the etched lines will be deeper and wider. Cooler surfaces yield more discreet, thinner lines. For etching, you can use any pointed tool: dental instruments, kitchen utensils, bookbinding tools, awls, sculpting and printmaking tools, or woodcarving equipment. Oil sticks are an ideal complement to etching techniques because they can be used to highlight marks made on the surface.

Etching an encaustic surface with a book-binding awl.
Photo by Monique Feil.

ETCHING

The simplest inscribing technique, etching involves scratching a smooth encaustic surface with a tool that makes a mark. To etch the surface, use any pointed or sharp tool, such as an awl, single-edge razor blade, or dental tool. Depending on the size of the tool's tip, the etched mark will be fine or thick. The temperature of the encaustic surface will determine the depth of the etched marks: A warm surface yields a deeper etching; a cool surface works better for fine detail.

SGRAFFITO

The term *sgraffito*, derived from an Italian word meaning "to scratch," refers to the technique of scratching through a surface to reveal the underlying layer. It is often used in ceramics but is also applicable to encaustic. You can achieve a sgraffito effect by painting a base layer in one color and then covering it with a second color; when you scratch through the layer on top, the base layer is revealed.

Engraving an encaustic surface with an awl.

Filling the engraved line with an oil stick.
Photos by the author.

Richard Purdy, 104. Encaustic on wood, 12 x 12 inches (30.5 x 30.5 cm), 2005.
Courtesy of Nancy Hoffman Gallery.

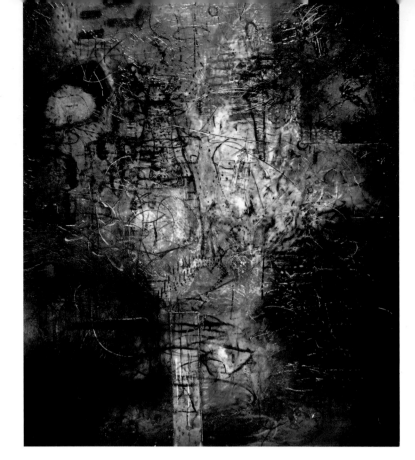

LEFT Mark Perlman, *Burst.* Encaustic on panel, 72 x 60 inches (182.9 x 152.4 cm), 2006.
Courtesy of Bill Lowe Gallery. Photo courtesy of the artist.

INTAGLIO

Intaglio, derived from the Italian "to cut," is a printmaking technique in which a surface is etched or engraved and then filled with ink to create a print. With wax, etching the surface with a pointed tool creates a burr, or ridge, of wax on the borders of the etched line. You can cut off the burr, fuse it in, or leave it as is to enhance texture. Alternatively, you can use a tool with a loop at the end, which removes the burr as you etch. You can then fill the etched line with an oil stick and use a rag to wipe away the excess oil stick, leaving a clean line. Mark Perlman digs deep trenches in his layered encaustic paintings, leaving the burrs as texture on his surfaces. The technique is one of many he uses to achieve what he hopes to communicate. Perlman says, "Like decaying walls or the dried skin of some mythical beast, my paintings attempt to bear the physical evidence of their own history."

INTARSIA (INLAY)

Intarsia—from the Italian "to inlay"—is usually thought of as a woodworking technique in which carved-out areas of wood are inlaid with smaller pieces of wood. With encaustic, you can create a channel by inscribing and then inlay wax paint into the channel, using a single-edge razor blade, clay loop tool, or other scraping tool to clean off any excess paint around the channel. This technique creates a beautiful, clean line.

Kim Bernard utilizes this technique in her paintings, digging out a line with a ceramics tool, filling in the line with colored paint, and then scraping back the paint to leave the line. Of her painting *Splash Red*, Bernard says, "The irony of this piece is that even though I try to make the splash appear fluid and gestural, it's anything but. It's a tedious process to make that spontaneous-looking line. [Robert] Motherwell's *Elegy to the Spanish Republic* was the initial inspiration for this body of work."

Richard Purdy, whose work *104* appears on page 99, takes the technique even further, meticulously carving out geometric shapes, brushing or pouring wax into the carved areas, and then scraping back the surface with a flat, heavy-gauge cabinet scraper. Because he works with wax at higher temperatures, the poured wax automatically fuses and does not need additional fusing after he has scraped it back.

Kim Bernard, *Splash Red*. Encaustic, pigment stick, and collage, 24 x 24 inches (61 x 61 cm), 2008.
Courtesy of Arden Gallery. Photo courtesy of the artist.

INTARSIA TECHNIQUE

Here are the steps to follow for an intarsia effect:

STEP 1 Etch a line with a pointed tool or carve a shape into the wax.

STEP 2 Paint over the line or shape with encaustic paint.

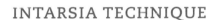

STEP 3 Scrape away excess paint with a scraping tool. Then fuse gently to prevent the inlayed line from bleeding, or, if you wish, leave the line unfused. You may paint a layer of encaustic medium over the line to protect it from bleeding when you fuse.

Photos by the author.

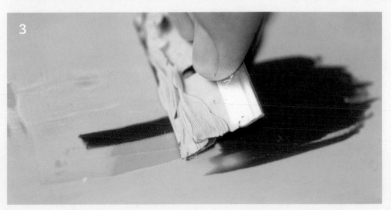

MASKING STRAIGHT LINES WITH TAPE

One way to control your line making is to mask off lines with tape. To make a straight line, you can apply masking tape or drafting tape to a surface, using a straight-edge ruler to ensure that the line is straight. Here are the subsequent steps:

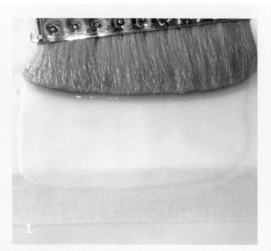

STEP 1 Paint medium over the masking tape to prevent paint from bleeding under the tape.

Photos by the author.

STEP 2 Paint with encaustic paint over the tape and fuse.

STEP 3 Allow the paint to partially cool before removing the tape, since the tape may lift the wax beneath it if that wax is too warm. But don't wait until the wax has cooled completely: If the line you've just created with wax grows too cold, it will crack when you lift the tape. If paint does seep under the tape, use a spatula to clean up any imperfections in the line, then fuse again. Take care not to leave tape on a wax surface too long, and, insofar as is possible, avoid fusing directly over the tape, since the tape can leave adhesive material behind after it is removed. Use a crème brûlée torch to fuse the edge when you're done cleaning it up.

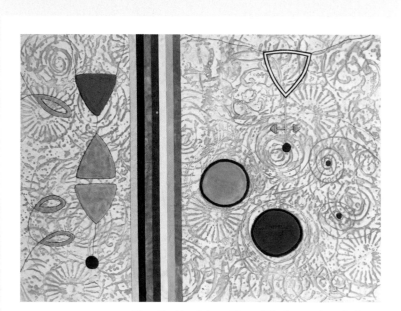

Lissa Rankin, *Between You and Me*. Encaustic and oil stick on panel, 48 x 36 inches (122 x 91.5 cm), 2009. Photo by Matt Klein.

MASKING OFF SHAPES WITH TAPE

Using a technique similar to the one just described, you can tape off shapes, using the taped area as a stencil:

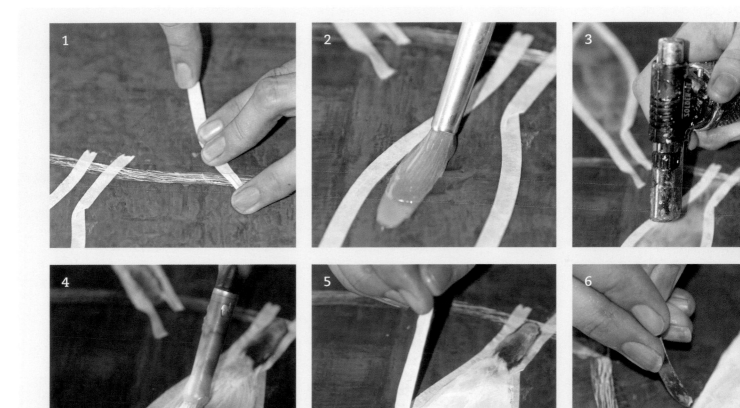

STEP 1 Tape off a shape on a smooth surface, using ¼-inch masking tape, which is more flexible than drafting tape or artist's tape.

STEP 2 Paint encaustic medium around the inside edges of the taped shape, allowing the brushstroke to overlap onto the tape itself.

STEP 3 Fuse with a crème brûlée torch, which provides a focused heat source.

STEP 4 Using a brush, fill in with encaustic paint and fuse again.

STEP 5 Lift off the tape.

STEP 6 If necessary, clean up the edges with a spatula, then fuse.

Photos by the author.

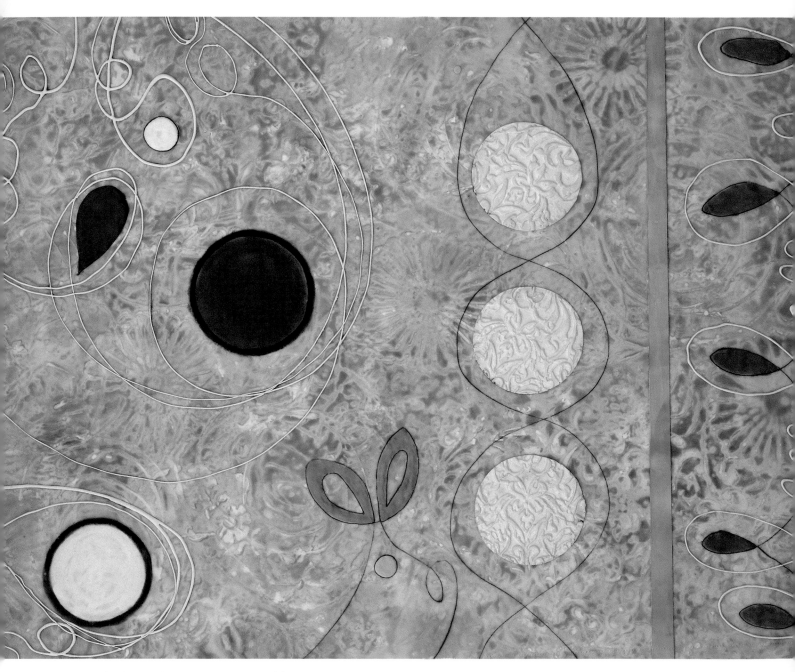

In *All You Need,* I taped strips of 2-inch masking tape to the painting's surface and cut out the circle shapes with an X-Acto knife. Then I lifted out the centers of the circles and used the tape as a stencil to create the three white circles, which represent the interconnectedness of me, my husband, and my daughter.

Lissa Rankin, *All You Need.* Encaustic and oil stick on panel, 48 x 36 inches (121.9 x 91.4 cm), 2009. Photo by Matt Klein.

USING STENCILS

You can use stencils in a variety of ways to help control your line work, and many of the artists I interviewed utilize variations of this technique. Timothy McDowell embellishes his smooth wax surfaces with stencils that he creates by cutting craft paper or stencil paper with fine-tipped Japanese scissors. He adheres the stencil to the painting surface using spray-mount adhesive, paints over the stencil with wax paint, and then removes the stencil. For additional effects, McDowell uses the inside cutout of the stencil to embellish the borders of the stenciled shape. Of his paintings, McDowell says, "My work explores images and systems within nature, portraying nature in an expansive, all-inclusive manner by incorporating the scientific as well as the idyllic associations regarding nature and our world."

Here's the technique McDowell uses for his stencils:

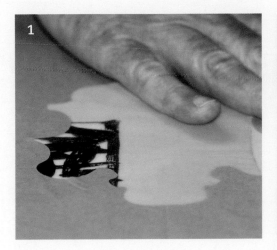
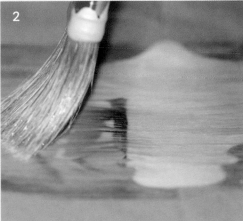
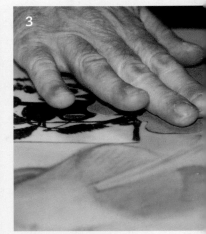

STEP 1 Apply spray-mount adhesive to the hand-cut stencil and apply the stencil to a smooth encaustic surface.

STEP 2 Paint encaustic paint over the hand-cut stencil, then lift off the stencil.

STEP 3 Using the inside cutout of the stencil, place the cut-out over the stenciled shape. It should be exactly the same size and should cover it completely. Paint a border around the stenciled shape.

STEP 4 Lift off the cutout and embellish the border as you wish. You can paint with a small brush or use a scraping tool to carve the paint and create detail.

Photos by the author.

LEFT Timothy McDowell, *Earthen Vessel.* Encaustic on linen, 60 x 46 inches (152.4 x 116.8 cm), 2006.
Courtesy of Marcia Wood Gallery. Photo courtesy of the artist.

ABOVE Stencils in Timothy McDowell's studio in Noank, Conn.
Photo courtesy of the artist.

Elise Wagner uses a similar technique, cutting paper stencils to assist with detailed line work. Mark Rediske applies graphite powder and chalk pastels over stencils, directly onto the ground, before coating the stenciled image with encaustic medium.

Paula Roland recommends cutting stencils out of wax paper, which naturally adheres slightly to a wax surface. She also uses Frisket film, a type of vinyl masking film with an adhesive backing paper. I make stencils out of Mylar or overhead-projector transparency film, using a heated stencil cutter or an X-Acto knife. To clean and reuse a Mylar stencil, place the waxed-over stencil in a bag in the freezer; the wax will fall off easily when you flex the frozen stencil.

A stencil in Mark Rediske's studio in Seattle.
Photo by the author.

Mark Rediske, *Articles of Faith*. Encaustic on panel, 56 x 64 inches (142.2 x 162.6 cm), 2007.
Courtesy of Foster/White Gallery. Photo courtesy of the artist.

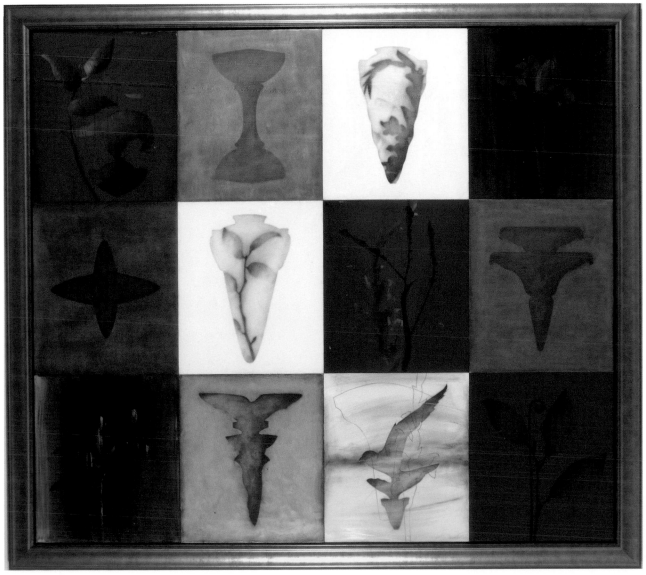

USING A MYLAR STENCIL

Here are the steps for using a Mylar stencil:

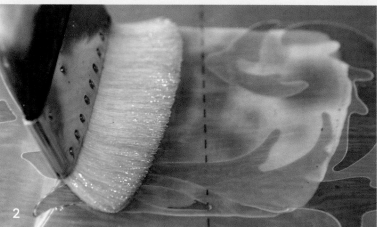

STEP 1 Cut out the stencil.

STEP 2 Place the stencil over a smooth, recently fused (still warm) encaustic surface. Paint medium over the stencil, being certain to keep the stencil flat. (You can use spray-mount adhesive to help flatten and adhere the stencil, if you wish.) The layer of medium helps prevent colored paint from bleeding under the stencil. Fuse gently with a heat gun.

STEP 3 Now paint encaustic paint over the stencil, then fuse.

STEP 4 Remove the stencil while the paint is still warm but not so hot that it will bleed into the area beneath the stencil.

STEP 5 Use a spatula to clean medium or paint that may have seeped under the stencil, then fuse the edges gently to avoid bleeding.

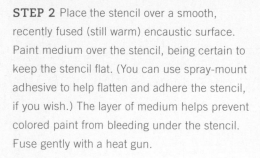

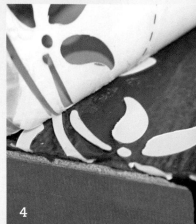

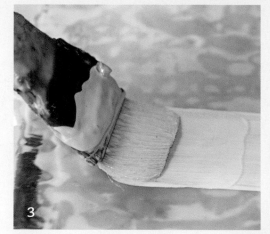

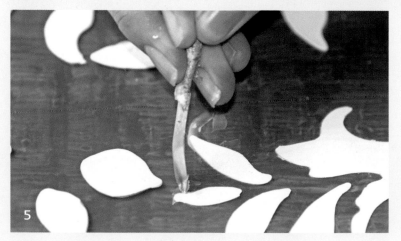

Photos by the author.

POURING SHAPES

By hollowing out a shape on a painting and filling the hollow with paint, you can achieve a smooth-surfaced shape. For *Every Fairytale Comes True* (next page), I carved out shapes and filled them with wax. Here's how:

STEP 1 Etch the outline of a shape onto a smooth wax surface, using any etching tool.

STEP 2 Dig out the wax within the perimeter of the shape down to the surface of the panel using a dental spatula, a cake-icing utensil, or a paint scraper. Fuse the edges of this hollowed-out "vessel" with a heat gun or blowtorch.

STEP 3 To make sure your surface is level, pour water into the shape, filling it to the edge. If the water spills over in one direction, prop up the edge and retest until the water completely fills the hollow without spilling. Dry thoroughly before proceeding to the next step.

STEP 4 Transfer molten paint into a container with a spout. Pour the wax into the hollowed-out shape. If small amounts of paint spill over the edges, clean off the excess wax with a spatula.

Photos by the author.

Lissa Rankin, *Every Fairytale Comes True.* Encaustic on panel, 36 x 30 inches (91.4 x 76.2 cm), 2008.
Collection of Edward and Christine Steinborn. Courtesy of Lanoue Fine Art. Photo by Matt Klein.

COMBINING GRAPHITE WITH WAX

Mari Marks mixes powdered graphite with denatured alcohol, creating a suspension that she brushes onto her encaustic paintings. She then uses a heat lamp to vaporize the alcohol, causing the wax to react with the graphite to produce a granular effect. Ed Angell uses a similar technique with Chromacoal powdered pigments, which come in a variety of colors.

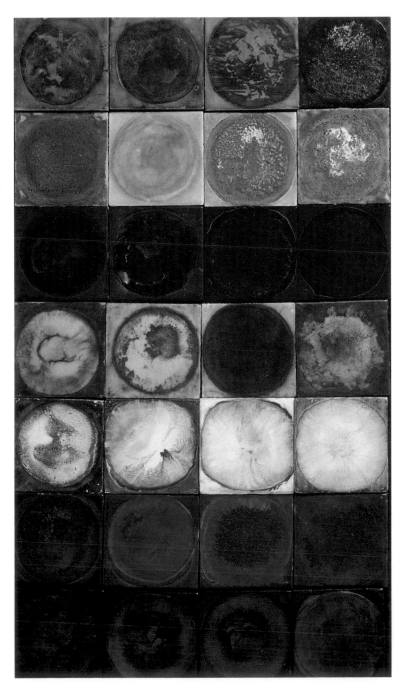

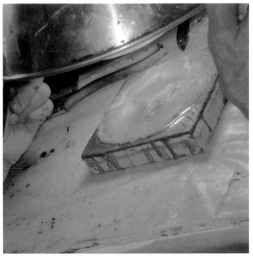

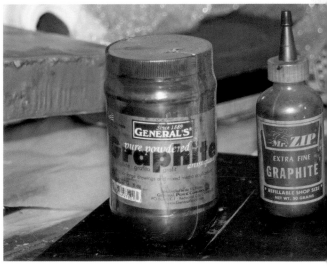

TOP Mari Marks demonstrating her graphite/alcohol/ heat lamp technique.
Photo courtesy of Paula Fava.

ABOVE Graphite in Marks's studio in Berkeley, Calif.
Photo by the author.

LEFT Mari Marks, *Sediments & Circles*. Beeswax, pigment, and graphite on panel, 35 x 20 x 2 inches (88.9 x 50.8 x 5.1 cm), 2005.
Photo courtesy of Kim Harrington.

Shawna Moore draws with graphite powder, applying it to a wax surface with her finger or a Q-tip and using vegetable oil to remove excess graphite. She fuses the graphite and then layers encaustic medium over it. Her paintings evolve directly from her practices of journaling, freeform painting, and drawing on brown craft paper or newsprint, which she does as a daily ritual. These disposable ideas and images reappear in the finished encaustic paintings. Interspersing elements of landscape among the writing and other marks, she slowly builds up thin wax layers, like washes, between etched surfaces, sweeps of color, and the spontaneously written marks. The paintings deal with themes of landscape, mark making, and cryptic attempts at written communication.

Mark Rediske also uses graphite powder to achieve a variety of effects. Rediske applies graphite and chalk pastel with his fingers, both freehand and using stencils, juxtaposing the two techniques to create his botanical imagery directly onto the ground. He then applies layers of encaustic medium, accenting the wax with oil stick mixed with powdered graphite or with thin layers of pure oil stick.

Shawna Moore, *Memory Place*. Graphite and encaustic on panel, 20 x 20 inches (50.8 x 50.8 cm), 2007. Photo courtesy of Heath Korvola Photographic.

Stencils in Mark Rediske's studio in Seattle. Photo by the author.

Mark Rediske, *Reprieve*. Encaustic on panel, 23½ x 42½ inches (59.7 x 108 cm), 2007. Courtesy of Foster/White Gallery. Photo courtesy of the artist.

USING **WAX LIKE WATERCOLOR**

James Meyer, who has worked as Jasper Johns's studio assistant for more than 25 years, initially shied away from creating his own paintings using the medium for which his mentor is well recognized. Over time, he found himself repeatedly drawn to working with wax, as he had done with Johns for so many years. Because he employed watercolor in his earlier paintings, he sought to create a type of wax paint that resembled watercolor, allowing him to incorporate the techniques he had developed with earlier paintings while using encaustic, which he knew so well. He now creates his paintings using both mediums, sometimes even combining the two. To mix his wax paint, Meyer thins his pigmented beeswax with turpentine or mineral spirits, creating a very thin wax, which he then applies to stretched canvas in washes that imply watercolor but that, when studied closely, reveal the mark of the wax. Because he paints in such thin layers, his paintings on canvas can easily be rolled for shipping.

James Meyer, *Atlas*. Encaustic on canvas, 72 x 36 inches (182.9 x 91.4 cm), 2002.
Photo courtesy of Michael Fredericks.

CREATING AN **UNDERPAINTING** DIRECTLY ON THE GROUND

Certain grounds lend themselves to painting directly on the ground and then using transparent layers of wax on top. Artists are using a variety of grounds with this technique, including rabbit-skin glue gesso, watercolor paper mounted to panel, and Venetian plaster.

Timothy McDowell underpainting with India ink on silver leaf.

McDowell underpainting with watercolors.

Timothy McDowell, who is very painterly in his approach, creates complex underpaintings (mixed with drawing) before he applies the first layer of wax. Using watercolor, distemper, graphite, India ink, and other drawing materials, he begins his paintings by working directly on the rabbit-skin glue, which he applies over linen.

Howard Hersh paints directly on wood panel, using oil paint for his signature tendrils—long curved lines that loop and curl like spring leaves. Hersh layers transparent encaustic paint over these lines, allowing the painted lines and wood grain to show through.

McDowell underpainting with distemper.
Photos by the author.

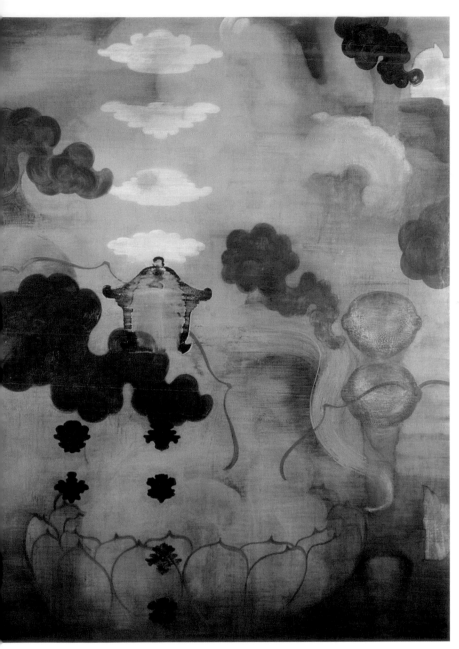

LEFT Timothy McDowell, *Gaia Dharma*. Beeswax, pigment, and hide glue on linen, 60 x 46 inches (152.4 x 116.8 cm), 2007.
Photo courtesy of the artist.

ABOVE Howard Hersh, *Bridging 06-3*. Encaustic on panels, 84 x 95 inches (213.4 x 241.3 cm), 2006.
Photo courtesy of the artist.

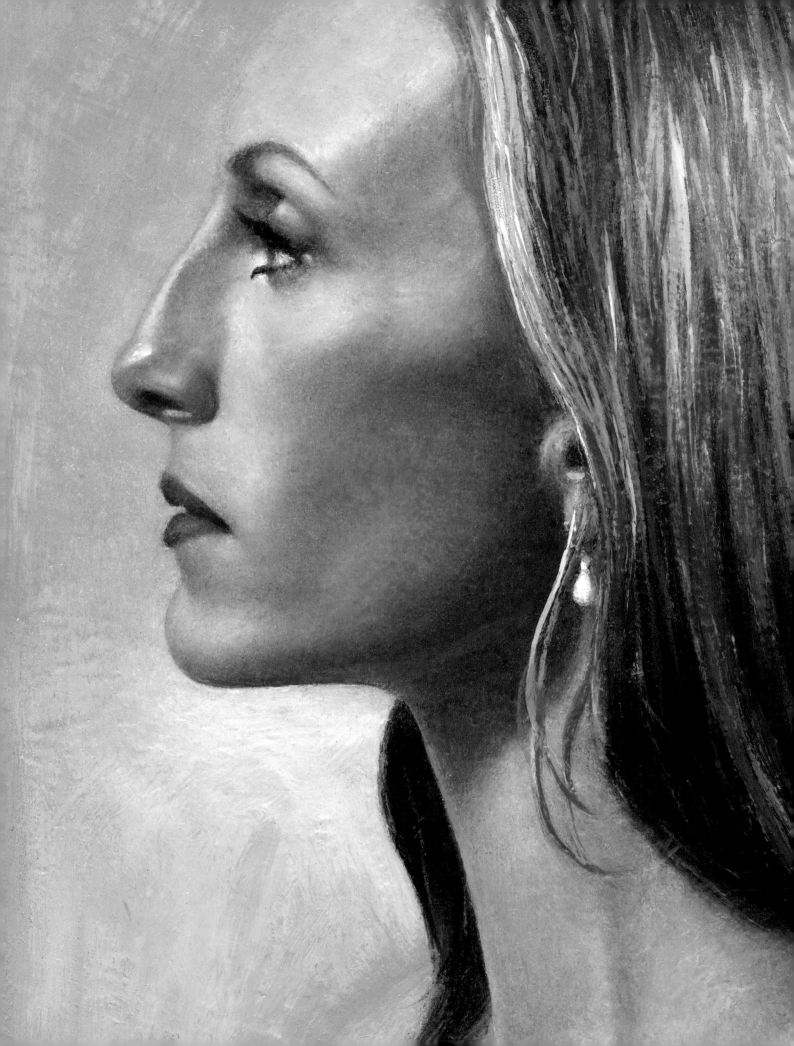

Creating Representational Work WITH ENCAUSTIC

Controlling wax to create representational art requires a high level of skill. Going with the flow of encaustic requires little technical ability, which makes it such an appealing medium for fledgling artists trying to own their creativity and find their artistic voice. With encaustic, you can paint a surface, fuse liberally, and let the colors meld together spontaneously, staying open to the art angels and waiting to see what might emerge. But if you wish to create the image of an apple, rather than a swirl of red paint, you must do one of two things: (1) create an underpainting of an apple on a white ground, using media such as watercolor, ink, or colored pencil, and then coat your painting with thin layers of encaustic, or (2) learn to master the use of encaustic, painting the apple directly with encaustic paint. That second route is the one that the gifted artists in this chapter have taken.

Kevin Frank, *Wendy Whelan* (detail). Wax on wood panel, 14 x 11 inches (35.6 x 27.9 cm), 2001–2008.
Photo courtesy of the artist.

Painting in progress with stereo photographs at Kevin Frank's studio in Brooklyn, N.Y.

Heated palette and cart in Frank's studio.
Photos by the author.

Painting still lifes, portraits, and landscapes, Kevin Frank applies to encaustic the skills he learned when working with oil paints. Some of his portraits show the subject directly facing the viewer in a style similar to the Fayum portraits, which Frank has studied extensively. When he can, he prefers to paint from life, as he does with his still lifes. But the cumbersome nature of encaustic painting makes plein air landscape painting difficult, and the amount of materials and gear involved make it impossible for him to travel to a subject's home for a portrait sitting. So for his landscapes and portraits, Frank works from stereo photographs, which he takes using an old Kodak stereo camera. The resulting stereo views help him visualize his subject in three dimensions even when he is alone in his studio.

For some of his paintings, Frank limits his palette to the pigments available to the ancient Greeks, using only Mars red, Mars yellow, titanium white, and Mars black. For fine lines and small details, he uses a no. 1 or no. 2 sable brush. He mixes his paint directly on his anodized aluminum palette, typically working in the range of 170° to 180°F (76°–82°C) but boosting the heat to about 210°F (99°C) when he wants to achieve a finer line.

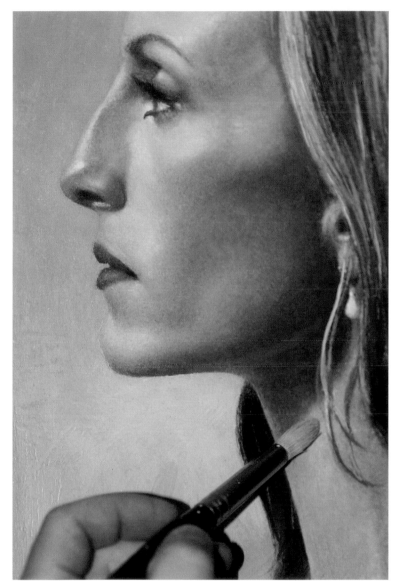

Kevin Frank's encaustic paints, pigmented with traditional pigments.

ABOVE Frank with cuticle tool, which he heats and uses as a spatula.

LEFT Frank painting *Wendy Whelan.*
Photos by the author.

To begin, Frank lightly sketches the outline of his subject. Next, he coats a wood panel with a layer of slightly tinted beeswax, which he fuses with a heat gun. Then, painting on an easel and working from the outside edges inward, he blocks in the painting loosely, building up the tone and working more tightly as he approaches the center. He lays in the general mass tones with fluid strokes. Then, to further model and define the form, he picks up the middle tones and applies the paint in a thin layer with a mostly dry brush. To blend from light to dark, he uses a hog-bristle brush, either a filbert or a round, dipping the brush in the paint, then wiping it until very little paint remains on the brush and dry-brushing thin layers, which he fuses with a heat gun. When the wax is still warm, he further blends the paint with his

Hiro Yokose, *Untitled #4922*. Oil and wax on canvas,
44 x 70 inches (111.8 x 177.8 cm), 2007.
Courtesy of Winston Wächter Fine Art.

fingers. Frank applies many layers very thinly, blending and painting,
fusing intermittently with a small, heated metal spatula (a cuticle tool
he took from his wife's bathroom). Using the spatula, he grazes the
surface of his painting, sometimes picking up color from the palette
and applying it with the tip. He recommends trying to be intuitive with
the paint, getting acquainted with its character. "It can act almost like
clay when your working environment is warm," he says. "So think of
blending as you would when sculpting."

Hiro Yokose, who paints lush landscapes, applies several layers of
pigment and wax with chisels, palette knives, and brushes. Fusing be-
tween layers with an electric heater, hair dryer, or blowtorch, he then
coats the entire painting with a layer of beeswax. Intermixing layers
of oil paint with layers of wax, he creates details with oil paint applied
directly to the wax surface.

When first developing his technique, Alexandre Masino created
large-scale watercolors on paper, which he then mounted to panel
and coated with layers of transparent wax before painting them with
encaustic. This method allowed him to establish his composition.
Scraping back the encaustic paint as he went, he was able to selec-
tively reveal the underpainting. Over time, he discovered that he was
painting over the entire surface, leaving none of the original watercolor
visible. Since then, his process has evolved.

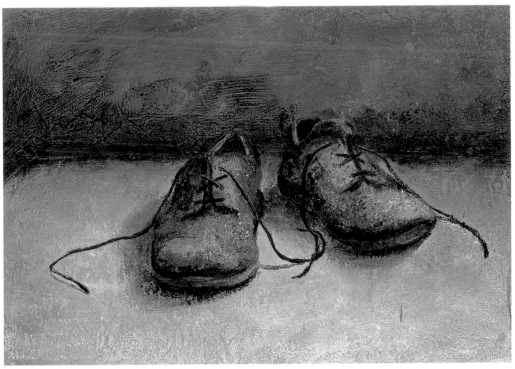

ABOVE Alexandre Masino, *Pèlerinage (les souliers)*.
Encaustic on panel, 16 x 23 inches (40.6 x 58.4 cm), 2007.
Photo courtesy of Richard-Max Tremblay.

RIGHT Alexandre Masino, *Sanctuaire*. Encaustic on
board, 84 x 63 inches (213.4 x 160 cm), 2003.
Photo courtesy of Richard-Max Tremblay.

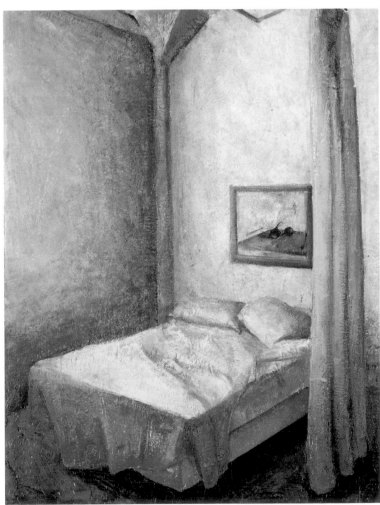

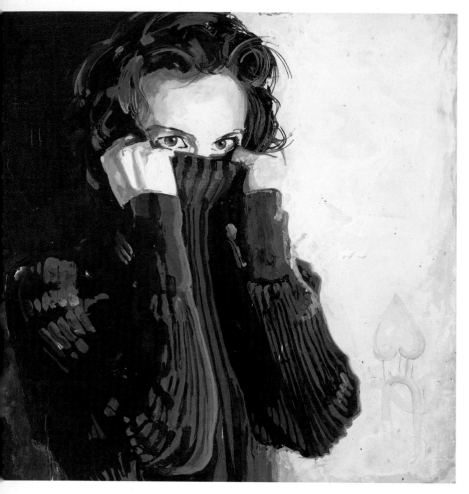

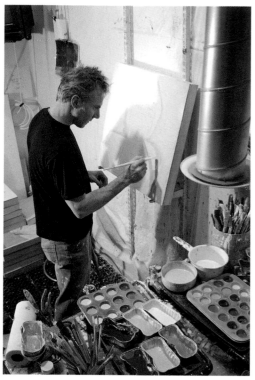

LEFT Jeff Schaller, *Queen of Hearts*. Encaustic on panel, 36 x 36 inches (91.4 x 91.4 cm), 2007. Courtesy of Gallery I.D.

ABOVE Jeff Schaller in his Downington, Penn., studio. Photo courtesy of the artist.

Now, Masino quickly sketches what he intends to paint and then paints the background textures and the large objects with encaustic paint, fusing with a heat gun. Like Frank, he primarily works vertically, on an easel, but he rests his paintings horizontally on sawhorses to fuse. He builds up his surface, scraping back with plaster knives as he goes. After painting the background surfaces, he paints the graphic shapes and then builds up the shadows, progressively adding detail. He frequently utilizes a fan brush for shading, using both opaque and translucent wax.

Jeff Schaller employs a variety of different techniques to create his pop art–style portraits. Preparing his panels with rabbit-skin glue gesso, he first sketches in pencil, filling in the background and then fusing. He then works with his figures, painting, engraving, and filling in with wax. To create flesh tones, he paints layers, starting with a medium flesh tone and then gradually darkening the tone to bring up the shadows and painting the highlights in thin transparent glazes. He then scrapes the surface to reveal the varying shades. Of his paintings, Schaller says, "I paint things that already exist. This is what feels true to me. I reflect on culture, past and present, as an arbiter of interpretation. I then explore the subtle nuances of language and life. It is my intent to propel the viewer into scenes of seemingly unrelated

subjects, contained within captivating and complex sonatas. The simultaneous expressions are pop and edgy, esoteric and direct, unrelated and curiously similar, creating a visual language of paradox and juxtaposition."

For her painting *Abandoned Hatchery #1,* Chris McCauley painted multiple layers of encaustic, fusing each layer. She painted the seaweed in the background with a mixture of oil paint and turpentine, using a watercolor brush, then allowed the detail work to dry before fusing lightly with a blowtorch and adding yet more layers of wax, repeating the process over and over. To achieve the outline of the lily pads, she cut stencils out of Rives BFK paper (a paper usually used for fine-art printmaking), using both the positive and the negative of the stencils and filling in color details with a watercolor brush. To create the red stems, she gouged into the thick layers of wax, filled the etched lines with red encaustic paint, and then scraped back the excess paint. For the reflective surface that appears on the water, she used a stencil brush with a broad, even surface to gently tap the dry pigment (interference blue pigment, in this case) onto the warmed surface of the painting so that it would stick to the painting without being pushed below the surface of the wax. For further detail work, she used both oil pastel and thinned oil paint, allowing these to dry before adding wax on top of them.

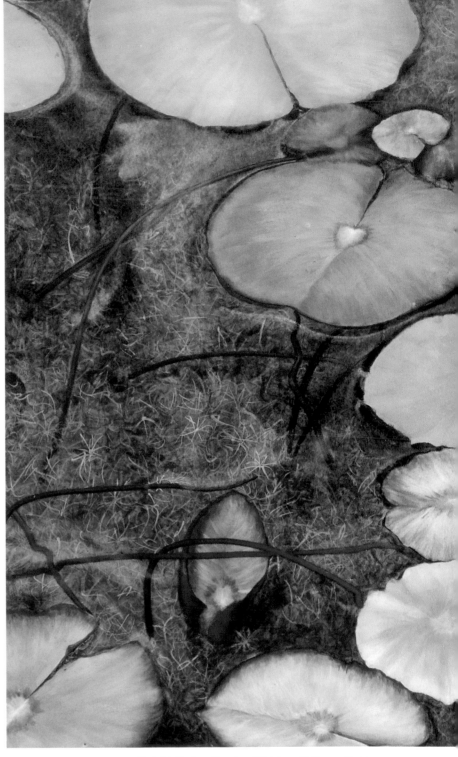

Chris McCauley, *Abandoned Hatchery* #1. Encaustic on wood panel, 23 x 33 inches (58.4 x 83.8 cm), 2004. Courtesy of Michelle Cooney.

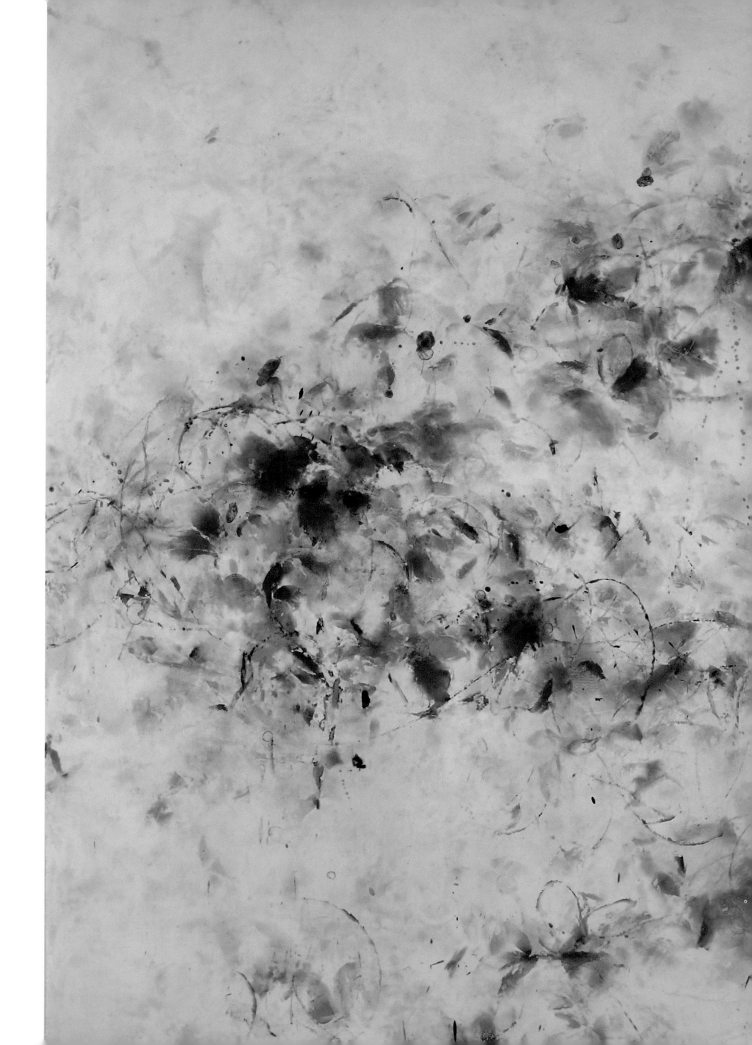

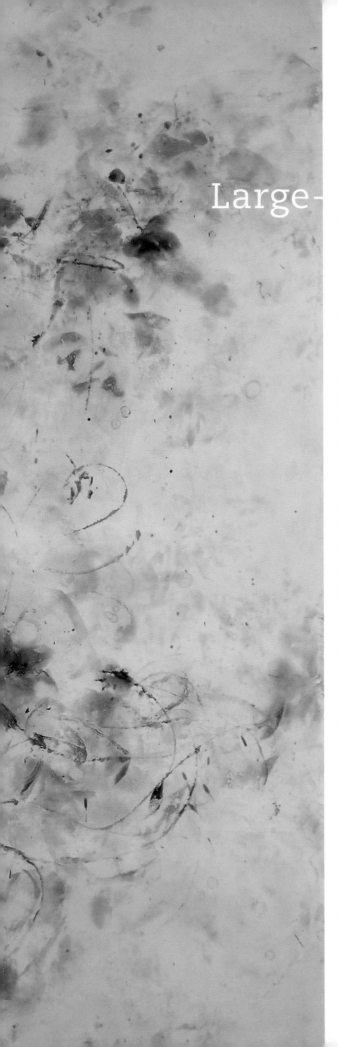

Large-Format Encaustic Painting

Working with encaustic on large panels involves significant challenges. Because most artists using the medium work horizontally, with panels lying flat on a table, the length of the artist's arm limits how far he or she can comfortably reach with a paintbrush or heat source. One way around this limitation is to paint vertically, with the panel hung on a wall, but many techniques cannot be performed vertically. Heat inevitably leads to drips, and it can be difficult to fuse properly when a panel is upright. Most artists who create large paintings with wax therefore combine the two modes of working, transferring the painting between horizontal and vertical positions. I talked to many artists working in large format, and all agreed that the work is physically demanding, requiring both strength and flexibility.

Betsy Eby creates works as large as 76 x 114 inches using well-constructed panels built by her father. When composing a work, she paints vertically, hanging the panel on the wall so that she can stand back to achieve a better perspective. But for pouring and fusing, she works horizontally, and she continues to shift the work from the horizontal to the vertical position as she paints.

Betsy Eby, *Ferdinand*. Encaustic on canvas on panel, 68 x 68 inches (172.7 x 172.7 cm), 2009. Photo by Richard Nicol.

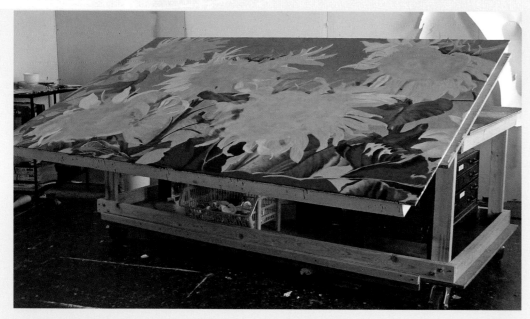

Chris McCauley's work table, custom-designed in 2003, in her Pontiac, Mich., studio.
Photo courtesy of Chris McCauley.

A Custom-Built Worktable

After winning a grant to create large-scale (up to 5 x 10 feet) encaustic landscapes, Chris McCauley had to solve the problems that working in such a large format entailed. To do so, she created two work tables with hinged tops and frames heavy enough to securely support panels weighing up to 300 pounds, a design she has patented. Each table is constructed of two-by-fours and three full sheets of ¾-inch plywood. By using an extra-long piano hinge and offsetting the tabletop on the base table, she is able to counterbalance the panels, raising them from the horizontal painting position to the vertical viewing position and lowering them back down again with very little effort.

Howard Hersh, who creates paintings as large as 6 x 16 feet, also alternates between working vertically and horizontally. While some of his large pieces are painted on single panels, most consist of smaller panels bolted together. Because Hersh pours wax over each panel to create layered color fields of wax, each panel becomes quite heavy, making it all the more important that he work in modules. Although Hersh usually attaches his panels to each other prior to shipping, modular art can also be shipped in separate modules and then assembled for exhibition.

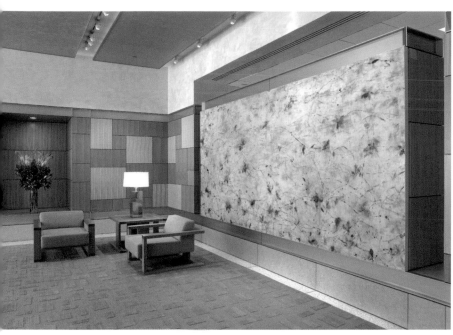

LEFT Betsy Eby, *Cielo* (installation view). Encaustic on panel, 76 x 114 inches (193 x 289.6 cm), 2005. Collection of Cielo, New York. Photo courtesy of Bryan Whitney.

BELOW Howard Hersh in his San Francisco studio, working on *Straight Forward Curves,* a 6 x 16–foot painting. Photo courtesy of Joyce Polish.

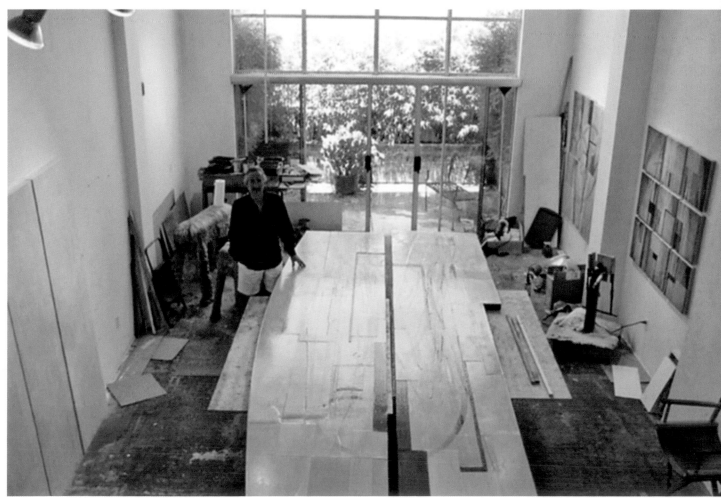

Mark Perlman, *Forward*. Encaustic on panel, 72 x 60
inches (182.9 x 152.4 cm), 2006.
Courtesy of Bill Lowe Gallery. Photo courtesy of the artist.

Mark Perlman, whose largest single panel is 84 x 96 inches and
whose largest diptych is 72 x 120 inches, moves his large panels back
and forth between a vertical wall, where he paints, and a horizontal
surface, where he both paints and fuses.

Gay Patterson creates large encaustic paintings in two differ-
ent ways—by working on single large panels and also by combining

ABOVE Gay Patterson's work table in her studio in Santa Fe, N.M.
Photo by the author.

LEFT Gay Patterson, *Ephemera*. Encaustic on wood panel, 60 x 54 inches (152.4 x 137.2 cm), 2002.
Collection of Katherine and Fritz Holland. Photo courtesy of the artist.

multiple smaller panels to form larger works. Because she always works horizontally, her largest single panels are 60 x 72 inches, which is the limit of her reach. She braces the panels, resting their edges on two stainless steel chef's tables, which can be repositioned to accommodate panels of different sizes. She keeps her encaustic palette on a rolling table attached to an extension cord so that she can move the paint around the painting rather than trying to work on the whole panel from just one side. When making large works from smaller panels, she connects the panels and frames them together, creating works as large as 9 feet long.

Patterson admits that it's challenging to manage the large panels: After all, it's not easy to lift a 5 x 6–foot panel coated with pounds of wax. But the scale makes the effect all the more glorious and sublime. To prevent torque and to protect the edges, she frames her paintings in welded aluminum frames, which are bolted to the panels. About

her work, Patterson says, "I do believe that a large scale transforms a painting into a psychic space that can be entered into, allowing a viewer to step out of their known world into one that can open them up, which makes painting large well worth the hassle."

Working in large format requires physical strength to handle the panels; it requires a workspace generous enough to accommodate them; and it requires that the supports be expertly built to withstand the stresses and strains imposed by pounds and pounds of wax. And when the time comes to exhibit the work, large panels require professional shipping. To avoid these problems, Sierra Jolie works in a modular way, painting on 12 x 12–inch panels. These smaller modules can easily be boxed and shipped and then hung together to create the illusion of a larger work after they've arrived at the exhibition space. To create *Autumn,* Jolie composed each individual component as a separate painting, utilizing techniques including intaglio, stencils, layering and scraping, poured shapes, relief imprints, dripping, and splattering.

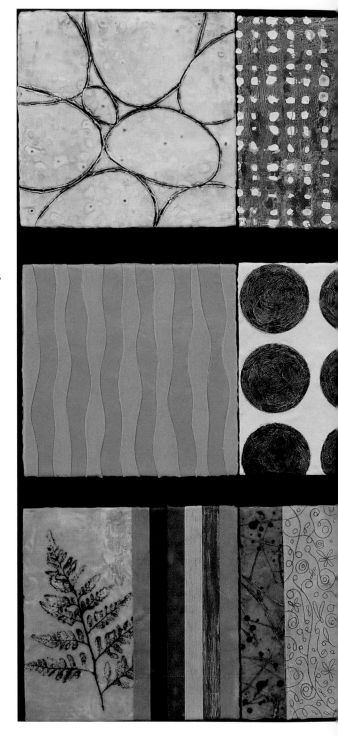

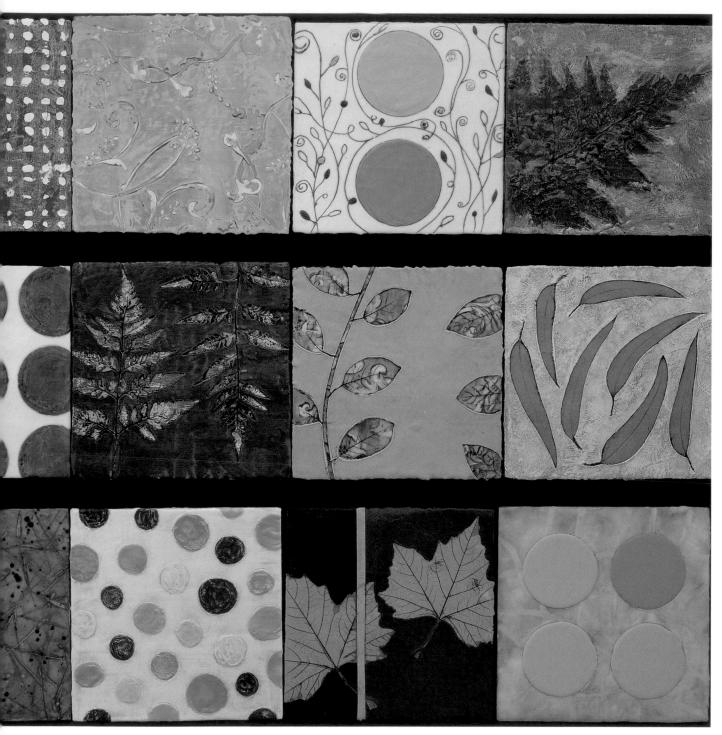

Sierra Jolie, *Autumn*. Encaustic on panel, installation of fifteen 12 x 12 inch (30.5 x 30.5 cm) panels, 2007. Photo by Matt Klein.

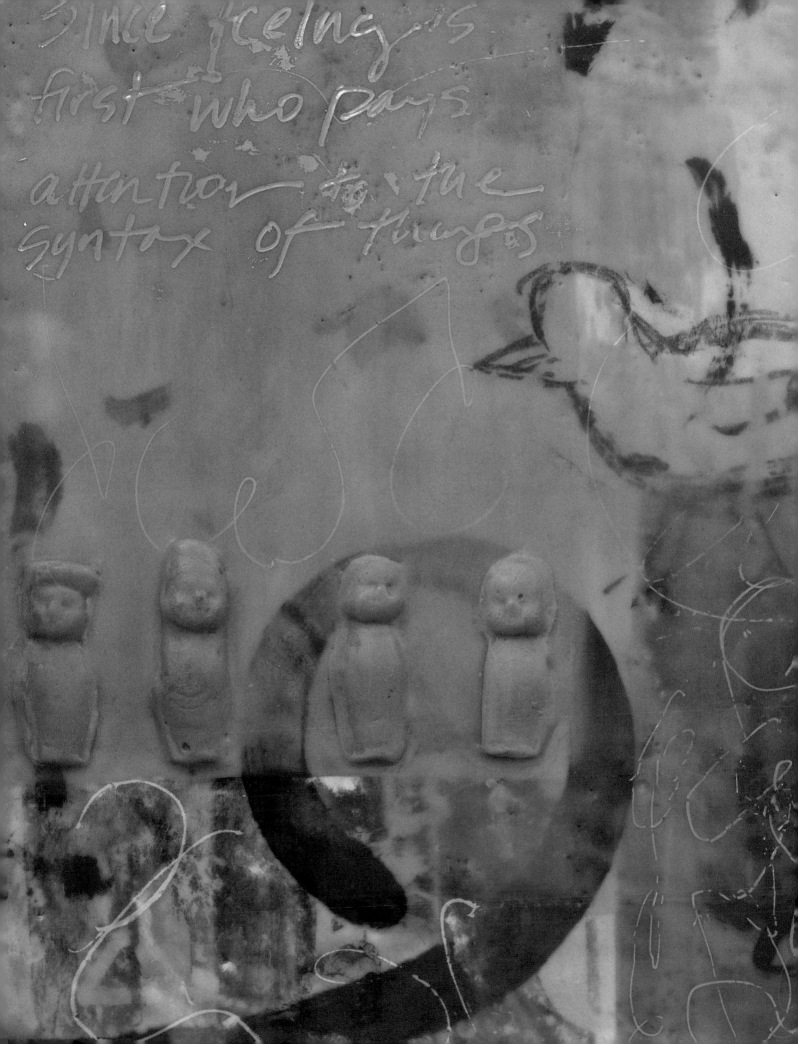

Using Drawings and Transfers
WITH ENCAUSTIC

Encaustic invites a variety of drawing techniques. Many products can be used for drawing directly on a smooth encaustic surface: graphite, charcoal, India ink, oil pastels, Stabilo pencils, litho pencils, and water-soluble crayons such as Caran d'Ache or Lyra Aquacolor. Simply draw the image, fuse lightly, and then cover with a fused layer of encaustic medium to protect the marks.

Lissa Rankin, *Sitting Duck* (detail). Encaustic, charcoal, book foil, and cast wax on panel, 12 x 12 inches (30.5 x 30.5 cm), 2004.
Photo by Matt Klein.

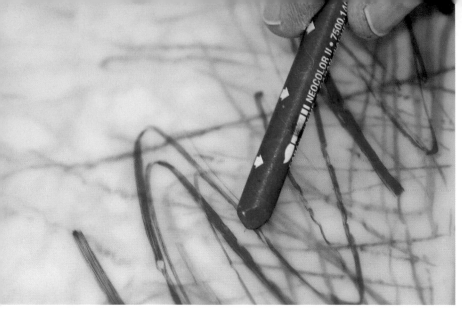

Rodney Thompson drawing directly onto wax with
Caran d'Ache Neocolor II, a water-soluble artist
crayon.
Photo by the author.

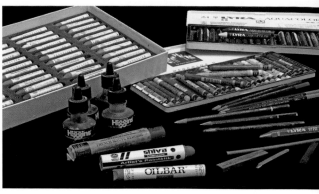

Drawing tools: Sennelier oil pastels, Caran d'Ache cray-
ons, Lyra Aquacolor crayons, Higgins drawing ink, R&F
Pigment Stick, Shiva Artist's Paintstik, Windsor Newton
Oilbar, Derwent colored pencils, Derwent water-soluble
graphite pencil, Derwin graphite pencil, Pentalic wood-
less graphite pencil, Lyra graphite stick, vine charcoal,
Kimberly graphite sticks, compressed charcoal.
Photo courtesy of Rodney Thompson.

Betsy Eby employs this technique, along with
several others, when creating her *Tablets*.
About this series, Eby says, "I approach my
Tablets similarly, in that they are my own
drawing solution. The *Tablets* reference the
repetitive patterns found micro- and macro-
scopically, from sound waves, star nebula,
and flight patterns to musical rhythms. It is
always my intention to conceal the tool. I am
constantly interpreting objects or implements
as potential tools that might transfer materials
with somewhat mysterious results. Since it is
difficult to directly deposit wax traditionally
with a brush, I draw and paint with anything
from grass to extra-long razor blades, edges
of glass, knives, ribbon, Mylar, and thread,
fusing and laminating to bear veiled results
of a kind of contemporary reinvention of
sfumato."

Betsy Eby, *Tablet XIV.* Mixed media on paper, 7½ x 7½
inches (19.1 x 19.1 cm), 2007.
Photo courtesy of Charles Backus.

DRAWING AND PAINTING
DIRECTLY ON THE GROUND

Both Timothy McDowell and Tina Vietmeier compose their paint-
ings by drawing directly on traditional rabbit-skin glue gesso ground.
McDowell draws with Conte pencil, Litho pencil, or graphite before
adding wax to his paintings; Vietmeier draws with graphite before
painting in thinly pigmented, transparent layers that allow her de-
tailed drawings to show through. By drawing directly on the ground
rather than on an encaustic surface, you avoid the problems that can
occur when heat is added. The wax you use to paint over your draw-
ing must be very minimally pigmented in order not to obscure the
details of the drawing.

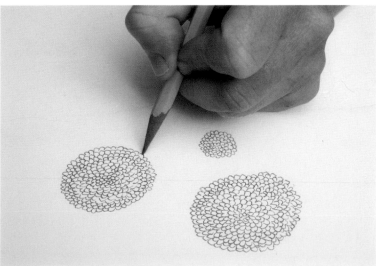

ABOVE LEFT AND RIGHT Timothy McDowell demon-
strating drawing directly onto rabbit-skin glue gesso.
Photos by the author.

LEFT Tina Vietmeier drawing on the rabbit-skin glue
gesso ground.
Photo courtesy of J. W. Diehl.

DRAWING ON PAPER

You can take advantage of the transparency of rice or tissue paper by drawing on the paper and then collaging the drawing into a painting. The edges of the paper will disappear, and the drawing will appear to be floating in the wax. This technique works well if you want to incorporate a drawing as a surface element, because you do not have to worry about heat dispersing the drawing, as you do when drawing on wax and then fusing.

LEFT Tina Vietmeier drawing with graphite on tissue paper.

ABOVE Vietmeier applying drawn element to wax surface.
Photos courtesy of J. W. Diehl.

OPPOSITE Tina Vietmeier, *Nothing That We Are Not Study #1*. Encaustic with mixed media on panel, 16 x 12 inches (40.6 x 30.5 cm), 2005.
Courtesy of Andrea Schwartz Gallery. Photo courtesy of J. W. Diehl.

Many artists prefer this method because it allows them to focus on the drawing separately from the painting. If Vietmeier wants a drawing to reside subtly in a painting's background, she draws directly on the gesso; if she wants it to appear more prominently in the foreground, she draws on transparent paper and collages the drawing into the wax. She also combines drawings on paper with drawings made directly on the gesso ground—the resulting layers of drawings give depth and complexity to the finished work. Vietmeier paints with very thin layers of encaustic, building the painting up slowly and then scraping away. Of her painting process, which is influenced by traditional oil-painting techniques as well as drawing and collage, she says, "My motivation is in living, imagining, and connecting. In the process, I use up a lot of paint. The act of painting and sculpting for me is elemental, an intuitive yet deliberate response, a result of being in the world. Through the particulars of my daily life, my work becomes a distillation of my visual and emotional experience, practice, thought, and influences."

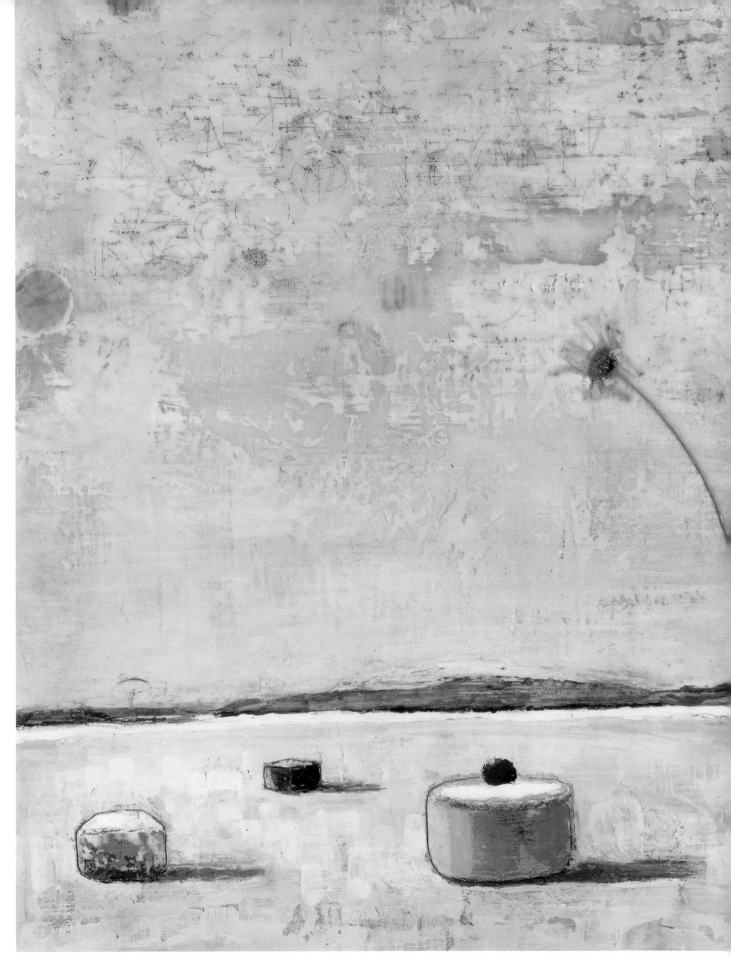

IMAGE TRANSFERS

In image-transfer techniques, a printed or drawn image is transferred, in reverse, onto a smooth wax surface. Wax provides an excellent surface for transferring images. You can transfer photocopied or laser prints as well as graphite, charcoal, colored pencil, or pastel drawings. For any type of transfer, start with a slightly warm (but not soft) smooth wax surface; if the surface is too cold, the image may not transfer as readily. For direct transfers and photocopy or laser-print transfer, you will need a burnishing tool (a metal spoon may be used in a pinch).

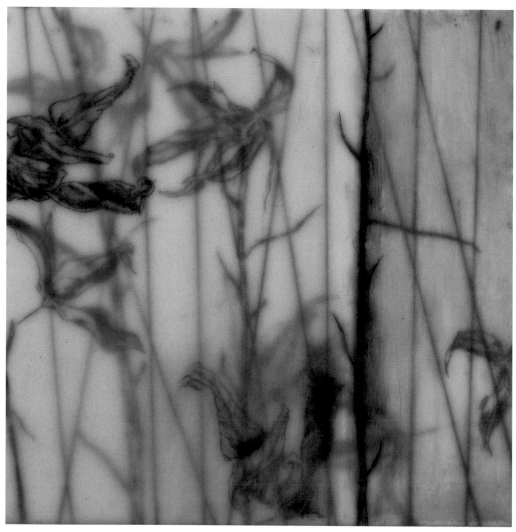

Jhina Alvarado, *Fail the Fallen*. Encaustic, oil, and graphite on panel, 12 x 12 inches (30.5 x 30.5 cm), 2007. Collection of Lissa Rankin and Matt Klein. Photo courtesy of the artist.

DIRECT TRANSFERS OF DRAWINGS

You can draw with charcoal, pastel, graphite, or colored pencil and transfer the image to a wax surface. Images transfer most easily if drawn on paper that's not designed for drawing. For instance, copy paper and laser-print paper work well because they resist absorbing the charcoal or graphite; by contrast, papers designed for charcoal and other drawing media absorb the media and transfer less readily. Jhina Alvarado prefers to draw with graphite watercolor pencil on tracing paper, which she then lays face down on an encaustic surface and burnishes to transfer the image. By coating each image with multiple layers of wax, she makes her drawings look as if they are suspended in the wax.

To transfer a drawing to an encaustic surface, follow these steps:

STEP 1 Draw the image. (Here, the drawing is being made with charcoal on cheap copy paper.)

STEP 2 Cut out the drawing, trimming the paper very close to the edges of the image.

STEP 3 Lay the paper image-side down on a recently fused—warm, but not soft—encaustic surface. Burnish over the image, being careful not to miss any spots.

STEP 4 Remove the paper. Fuse the transferred image gently. When the wax has cooled, you may cover the transferred drawing with a layer of medium to protect the image, if you wish.

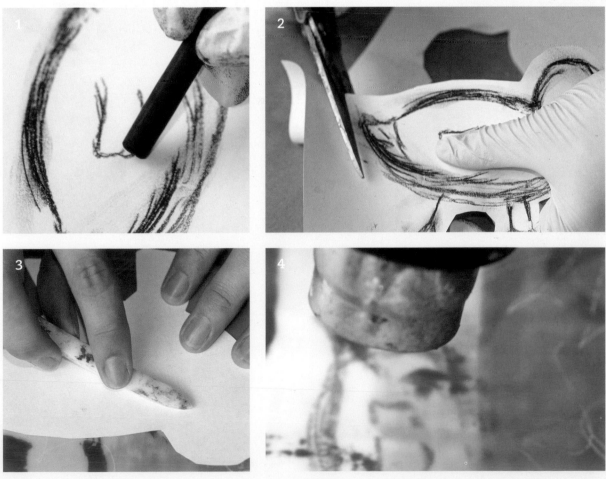

Photos by Matt Klein.

BOOK FOIL AND TRANSFER PAPER

You can also use book foil or transfer paper to draw or write on a wax surface. Book foil (designed for stamping letters into book covers) and transfer paper are sold at sewing and craft stores. Available in a variety of colors, book foil has a transferable chalky side and a nontransferable shiny side. By laying the foil chalky-side down on a wax surface and writing or drawing on the shiny side, you transfer the marks to the wax. The same procedure is used for transfer paper. Like book foil, transfer paper has two sides—one chalky and transferable and the other not transferable. Both book foil and transfer paper are available in rolls.

Shawna Moore uses Seral transfer paper to make looping, textlike marks. When she works large, she makes her own transfer paper out of wax paper covered with oil stick, using the wax paper as if it were a plate for monotype images transferred directly onto the wax. I used this transfer technique to make marks on the piece *Sitting Duck*, which incorporates book-foil transfers, charcoal transfers, and photocopy transfers as well as casting with clay.

Here are the steps to follow when transferring from book foil or transfer paper:

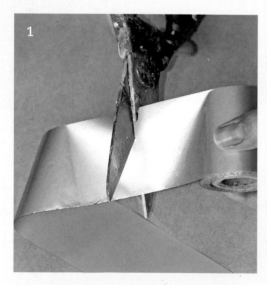

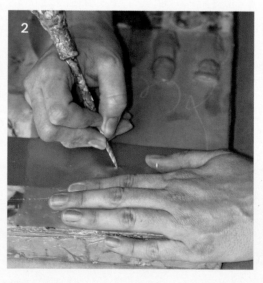

Photos by Matt Klein.

STEP 1 Cut the desired length of book foil or transfer paper. Place the foil or transfer paper chalky-side down on a recently fused—warm but not soft—encaustic surface.

STEP 2 Holding the foil down securely, use any pointed tool (such as an awl) to create marks on the foil.

STEP 3 Remove the foil, and fuse the transferred marks gently. When cool, cover with a layer of medium if you wish.

PHOTOCOPY AND LASER-PRINT TRANSFERS

Eve-Marie Bergren collected fingerprints from volunteers, enlarged the fingerprints on a photocopier, and then transferred the enlarged fingerprints onto a wax surface. Of her work, Bergren says, "I have chosen the finger, foot, or palm print as a meditation and a question, engaging my audience in a broader range of ideas relating to identity, such as the issues of nature versus nurture, Internet identity theft, retinal scans, DNA and genetics, formation of identity, landscape, topography, body, and language."

For her piece *Kristin's Geode,* Laura Moriarty transferred an illustration onto a base layer of clear wax and then buried it under layers of color. Later, she carefully scraped up all of the layers of encaustic and flipped the scraped layers, so that the image would appear on the top of the geode.

When transferring photocopied or laser-printed images, be sure to use only images that are not protected by copyright. Also, because some toners transfer more readily than others, you may want to experiment with a variety of photocopiers/laser printers to make sure that the images you copy or print will easily transfer to wax.

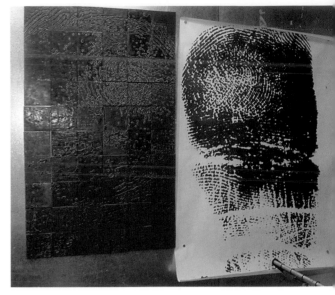

ABOVE Eve-Marie Bergren, *Archipelaga Finola.* Encaustic on birch plywood, magnets, and steel panel, 24 x 38 inches (61 x 96.5 cm), 2005. (The large fingerprint on paper, to the right of the finished piece, shows a step in Bergren's process.)
Photo courtesy of the artist.

BELOW Laura Moriarty, *Kristin's Geode.* Beeswax, tree resin, pigments, and photocopied illustration, 9¾ x 11 x 8 inches (24.8 x 27.9 x 20.3 cm; sliced in two, lengthwise), 2006.
Photo courtesy of the artist.

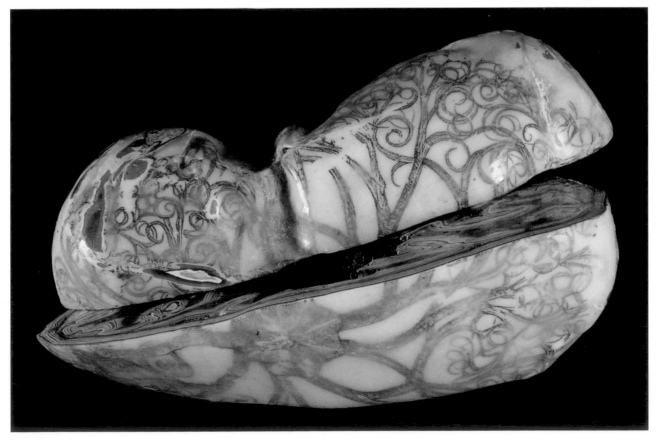

TRANSFERRING A LASER PRINT

Here are the steps for the laser-print transfer process:

STEP 1 Copy the image you want to use on a photocopier or scan or download it onto your computer and then print on a laser printer. Trim the image, leaving an approximately ½-inch edge of blank white paper around the image. (Well-defined, high-contrast images on a white background work best. Images with a gray background must be trimmed very closely to avoid transferring a gray shadow around the image.)

STEP 2 Place the image face down on a warm, smooth wax surface. Rub carefully over the image with a burnishing tool to make the toner adhere to the surface.

STEP 3 Now pour a small amount of water over the paper, rubbing it into the paper with your fingertips. If the image is large, pour the water over small sections at a time, as the paper may disintegrate if it stays wet too long.

STEP 4 Quickly burnish the wet paper, rubbing in overlapping circles and covering every bit of the image. Avoid tearing the paper or digging the tip of the burnishing tool into the wax. The paper will begin to roll up in pieces as the image transfers.

STEP 5 Using your fingertips, gently roll up the paper, leaving the transferred image. Do not roll too aggressively or the image will roll up with the paper. If you notice that an area is not transferred, try burnishing again over that area.

STEP 6 When you have rolled up and removed as much of the paper as possible, blot dry with paper towels.

STEP 7 Fuse gently with a heat gun set on low, taking care not to apply too much heat, which might disperse the image. As the image begins to fuse, it will first turn white, indicating that the water is evaporating out of the remaining paper fragments. It will then become transparent as the ink or toner is encapsulated in the wax. Heat just until the white color disappears. Small areas that remain white will not be a problem, as they will disappear when covered with medium. Do not use a blowtorch for fusing in this step, as the paper may ignite. Allow the surface to cool before proceeding; if the surface is too warm, the image may smear. When cool, paint encaustic medium over the image to preserve it and to encapsulate any remaining paper particles. Fuse gently with a heat gun.

Photos by Matt Klein.

Encaustic and Collage/Assemblage

Encaustic is an ideal medium for collage because wax has both adhesive and preservative properties. When it comes to the things that can be embedded/collaged in wax, the possibilities are endless: paper, dried flowers and leaves, tea bags, beads, photographs, coffee filters, lace, fabric, and so on and on. When embedding thick, heavy, and/or nonabsorbent objects in an encaustic collage, it helps to attach the object directly to the support, gluing it to the panel with an adhesive such as acrylic gel medium, PVA glue, or Super Glue.

If, however, the objects being collaged are lightweight and highly porous—thin cloth, tissue paper, rice paper—the wax makes a wonderful adhesive all by itself. When using wax as an adhesive for thin materials, use a tacking iron for fusing: The iron will smooth the object into the wax and fuse it thoroughly without scorching. A collaged object can be completely covered with medium or paint and then excavated using a heat gun or scraping tool to selectively reveal parts of the object.

Lorraine Glessner, *Aggregate* (detail). Beeswax, encaustic, digital prints, photographs, paper, and oil paint on rusted, composted, and burned silk, 42 x 24 inches (106.7 x 61 cm), 2006.
Photo courtesy of the artist.

COLLAGING **PAPER**

Lorraine Glessner creates her layered collage pieces using transparent papers as well as other lightweight materials such as fabric and photographs. About her work, she says, "My pieces begin with layers of fabric that have been subjected to burning, rusting, decomposition, burying, or exposure to the elements. I also collage images of consumer goods, combined with my own images taken at trade shows, interior design centers, botanical shows, and gardens."

To create her artworks, Glessner applies a thin layer of encaustic medium to the surface and, while it is still warm, applies the paper, lightly pressing out any air bubbles. She then fuses the paper into the medium with a tacking iron. If air bubbles appear, she uses an X-Acto knife to prick the center of the air bubble and then lightly fuses with the iron. She applies layers of photographs in a similar fashion. She

says, "Rubbings, drawings, and images taken from billboards, buildings, streets, and sidewalks of the city are merged together with the stained materials along with my own intuitive responses to them in paint. In a continuous process of accumulation, concealment, and removal, the layers of material create new narratives, which look through and into time, thus reminding us of perpetuation, death, and regeneration. My intent is to follow and record these marks as evidence of the spectacle and complexity of human activity and the poetic violence that is life."

To create her works *I Know Where I'm going* and *Styx,* Barbara Kerwin cut individual components of cardboard and wood blocks, which she painted with microcrystalline wax in multiple millimeter-thick, high-melt layers. She then assembled these painted components, gluing each piece to panel and coating the entire surface with a unifying glaze of thin, high-melt paraffin. (She wore a respirator while working at such high temperatures.) Of her art, Kerwin says, "My work is a repository of my feelings placed into geometric formats—fields of large rectangles, squares within squares, grids, and stacked or aligned rectangles—which act as containers for these feelings."

ABOVE Barbara Kerwin, Styx. Oil and wax over paper on panel, 20 x 32 inches (50.8 x 81.3 cm), 2001. Collection Lissa Rankin and Matt Klein. Photo by Matt Klein.

OPPOSITE Barbara Kerwin, *I Know Where I'm Going.* Oil and wax over paper on canvas, 37 x 37 x 2 inches (94 x 94 x 5.1 cm), 1999. Photo courtesy of the artist.

EMBEDDING OBJECTS IN WAX

When embedding thick items, such as the sewn eucalyptus leaves she incorporates into her paintings, Daniella Woolf paints on specially designed recessed panels, which have a built-in lip. For collages, Woolf recommends using absorbent elements and making sure the embedded objects are fully saturated with wax. Of *Beauty at My Feet* and other works from the same series, Woolf says, "These works with eucalyptus are inspired by walking my dogs. It puts me into a relaxed state that almost always transforms into creativity. I like the simplicity of leaving the color to nature. My unending love of repetition creates patterns with the leaves."

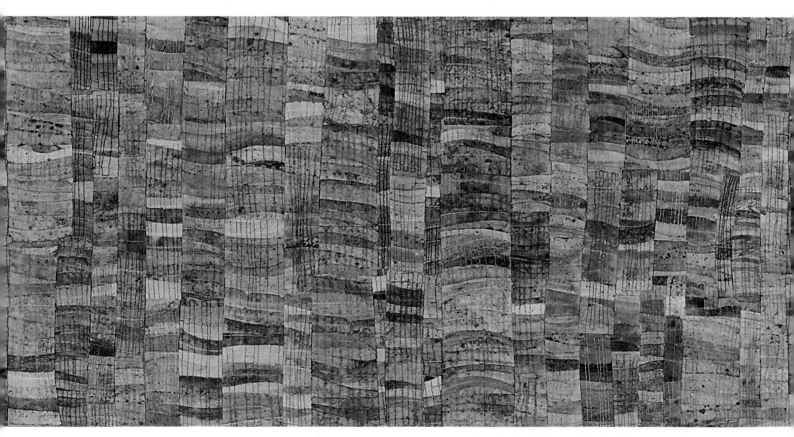

Daniella Woolf, *Beauty at My Feet*. Encaustic and euca-
lyptus leaves on panel, 24 x 48 inches (61 x 121.9 cm),
2006.
Collection of Juana and Craig Meyer. Photo courtesy of rr jones.

EMBEDDING TECHNIQUE

To make *Beauty at My Feet,* Woolf used the following process:

STEP 1 First, Woolf sewed the eucalyptus leaves together.

STEP 2 She then dipped the sewn leaves into encaustic medium.

STEP 3 Using an X-Acto knife, she cut the waxed leaves into strips.

STEP 4 Next, she made sure her panel was resting on a level surface and then poured melted beeswax over the panel.

STEP 5 Heating the wax surface to make it receptive to embedding, Woolf pressed the leaves into the warm wax. She shimmed off excess wax while flattening and pushing the objects into the beeswax surface. When all of the objects were in place, she brushed encaustic medium over the entire surface and fused.

Photos courtesy of Kim Tyler.

In my own *Bijou* series, I used a similar technique, working with recessed panels built specifically for this purpose. (Note, however, that you can make a lip of blue painter's tape to achieve a similar result.) Embedding objects such as clay, silk cord, jewels, and vintage buttons in the wax, I created compositions that suggest interpersonal relationships, conflict and resolution, birth and death, and family structures. Because some of the objects I used were nonabsorbent, I glued each element to the panel with a dab of Super Glue before pouring encaustic medium over the entire composition.

LEFT Gluing collage elements to the recessed panel.
ABOVE Pouring the encaustic medium.

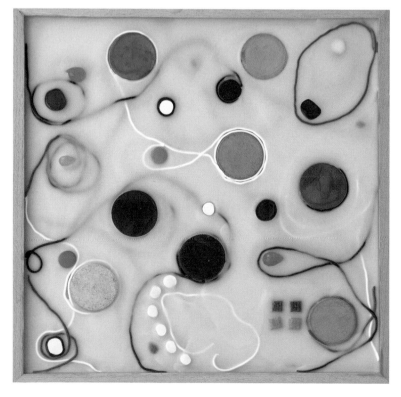

Lissa Rankin, *All Bets Are Off.* Clay, jewels, glass, and encaustic on recessed panel, 12 x 12 inches (30.5 x 30.5 cm), 2008.
Photos by Matt Klein.

USING RECYCLED OBJECTS

Christel Dillbohner's *Zeitmesser* (Timekeeper) pieces measure time by how many tea bags she consumes. Wax is her binder, connecting the tea bags to the wooden frame that surrounds them. Of her work, Dillbohner says, "Investigating events and concepts through uncommon viewpoints and tools, then transforming ideas and material into visual catalysts, offers me a perpetual challenge, the basis for my creative process and the means for a nonverbal communication with others."

Rodney Thompson collages remnants of used tea bags and coffee filters in his *T&C* series. Thompson says, "This series explores my fascination with the beauty of the overlooked materials and objects of our daily lives. Drinking tea and coffee is a calming and soothing meditation. The simple objects used in these works are like prayer flags, marking a moment spent quietly and peacefully."

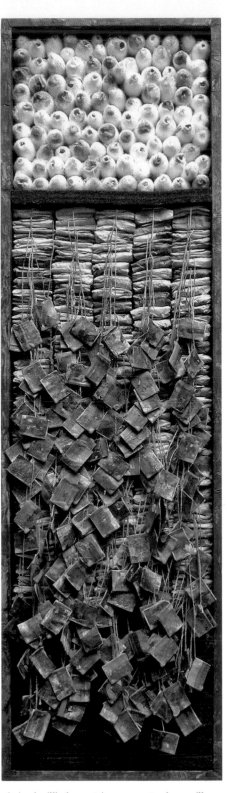

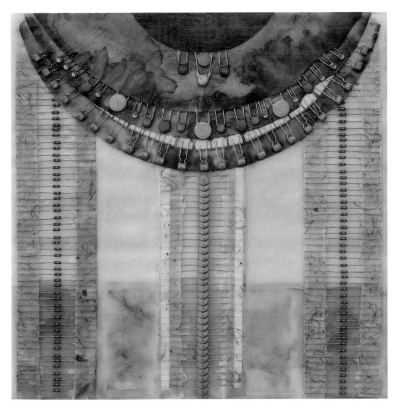

Rodney Thompson. *Collar Piece #2.* Encaustic, electronic parts, tea bag paper, coffee filters, and paper, 12½ x 12¼ inches (31.8 x 31.1 cm), 2006.
Photo courtesy of the artist.

Christel Dillbohner, *Zeitmesser* X. Tea bags, silk co-coons, felt, and wax in wooden box, 32 x 9 x 2 inches (81.3 x 22.9 x 5.1 cm), 2007.
Courtesy of Don Soker Gallery.

Another artist drawn to working with tea bags, Theodora Varnay Jones incorporates them into some of her works on paper, as in *Surface 154 Tea Bags*. Varnay Jones says, "I regard the little organic bags as ready-made units, forming ongoing lines in a field of handmade paper stained with persimmon tannin and beeswax."

In her art, Donna Sharrett combines rose petals, synthetic hair, the ball ends of guitar strings, rings, bone beads, and handmade rose beads, all of which she hand-sews to encaustic-covered boxes drilled to accommodate stitching. She attaches ribbons—each embroidered with the title of the work and the artist's name—to the sides of the wax boxes with small, carefully hammered straight pins. She uses variety of needlework techniques, including crochet, embroidery, and needlelace.

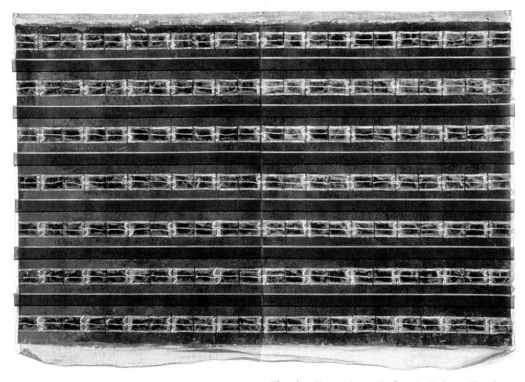

Theodora Varnay Jones, *Surface 154 Teabags*. Fiberglass, tea bags, cheesecloth, wax, and persimmon tannin on handmade paper, 44 x 58 inches (111.8 x 147.3 cm), 1996.
Courtesy of Don Soker Gallery. Photo courtesy of Kaz Tsuruta.

She chooses her materials, titles, and forms for their symbolic significance: The guitar-string ball ends are a tribute to her late brother Scot, a musician who had amassed a collection of hundreds of these little beads. The song titles she chooses to name the works also serve as a dedication to Scot. The circular shapes enveloped by square backgrounds of the creations that Sharrett calls "arrangements" mirror the Buddhist mandala form, speaking of the infinite within the finite. About her pieces, Sharrett says, "Using symbolically significant materials, my work addresses cultural traditions and objects associated with remembrance. The circular forms and compositions reflect the seamless continuum of rituals developed over time to satisfy the human need to mark important passages."

Donna Sharrett, *Long May You Run*. Rose petals, synthetic hair, handmade rose beads, guitar-string ball ends, bone beads, rings, synthetic beads, and glass beads sewn to a hand-tinted wax-covered box, with an embroidered ribbon attached with hammered pins, 8 x 8 x 1¼ inches (20.3 x 20.3 x 3.2 cm), 2005. Courtesy of Pavel Zoubok Gallery. Photo courtesy of Margaret Fox.

USING CONSUMER PRODUCTS

Everyday consumer products find new life in the hands of Miles Conrad, who recycles socks, latex gloves, sponges, Ace bandages, rubber bands, drinking straws, masking tape, string, paper towels, wire, and found objects in sculptures and paintings that reference organic forms. He transforms the objects by dipping them into an absorbent ground and then coating them with encaustic. Using kitchen utensils, dental instruments, and other tools, he shapes the objects so that they lose all evidence of their origin. Interspersing painting techniques with sculpting and utilizing such diverse processes as silicone casting, working with high-nap fabrics, and creating texture with cornstarch, Conrad constantly experiments with the materials he encounters.

ABOVE Latex gloves transformed with wax, waiting to be assembled by Miles Conrad in his studio at Conrad Wilde Gallery in Tucson, Ariz.
Photo by the author.

LEFT Miles Conrad, *Extraction Series* (installation view). Mixed media and encaustic on set of nine panels, each 8 x 8 inches (20.3 x 20.3 cm), 2007.
Courtesy of Conrad Wilde Gallery. Collection of Flynn/Peterson.

He says, "I transform recycled industrial [materials], mundane materials, and found objects into relief-based encaustic forms evocative of shapes and patterns found in the body and in nature. 'The body as microcosm' metaphor holds renewed currency as we face epidemics and weather changes that are global in their scope. As an artist working in the desert environment of Tucson, I am surrounded by this territory of harsh extremes, where there is morbidity, decay, and the constant risk of encroachment by forces both natural and industrial. Individual lives and the survival of whole species hang in the balance."

USING ORGANIC MATERIALS

Debra Ramsay employs a variation of the Japanese eggshell-inlay technique called *tamago-ji,* which was widely practiced during the Meiji era. Ramsay says, "I first encountered an example of this in a museum collection. I learned the traditional technique, using lacquer, from the teachings of a Japanese master. The process became my own through continued exploration and bringing in wax in place of lacquer." The eggshells require three days of preparation to thin the shells before they can be placed on the wood panels. Ramsay carefully glues individual pieces of eggshell into place, giving attention to spacing and each piece's effect on the overall pattern. Layers of purified beeswax protect the finished surface.

Debra Ramsay, *New Blue Moon.* Encaustic and eggshell on wood panel, 40 x 20 x 1½ inches (101.6 x 50.8 x 3.8 cm), 2007. Photo courtesy of the artist.

Tracey Adams began gathering kelp she found in large piles along the beaches in her hometown of Carmel, California. "I was feeling that I needed a break from working within the confines of geometric form and structure. One day I was struck that these huge, smelly masses of kelp, complete with buzzing flies, could possess some of the most delicate and intricate plant life. Collecting these not-yet-realized treasures became a fun and engaging enterprise. The choices of available kelp change with the seasons, oftentimes making for a challenging compositional experience."

Adams dissects the pieces of kelp and then rinses, dries, and presses them before embedding them in layers of wax. In addition to embedding the kelp in the wax, she also presses pieces of kelp into the warm surface of the wax and then removes them to leave an imprint that unearths many layers of colors. She then uses various tools to carve a counterpoint of lines into the existing linear surface. Although her work typically adheres to a more geometric and grid-like form, Adams has found herself drawn to the irregular, organic lines of the kelp.

Tracey Adams, *Saccharina 1*. Encaustic, kelp, and oil on three panels, 15 x 45 inches (38.1 x 114.3 cm), 2007. Courtesy of Bryant Street Gallery. Collection of Carol Boyden. Photo courtesy of Renee Balducci.

USING FABRIC

In my own art, I sometimes incorporate fragments of garments that I cut up and reassemble to create the likeness of a new garment. In *Something from Nothing,* I sacrificed the wedding dress I wore when I married my ex-husband to imbue the once-important but later meaningless object with fresh, new life. The process of ripping, tearing, and cutting the garment provided welcome catharsis, and the act of rebuilding the garment—just as I have since rebuilt my life—offered solace. Because thin silk is so porous, I allowed wax to act as the adhesive. Preparing a smooth encaustic background, I layered encaustic medium over the garment fragments and fused with a heat gun.

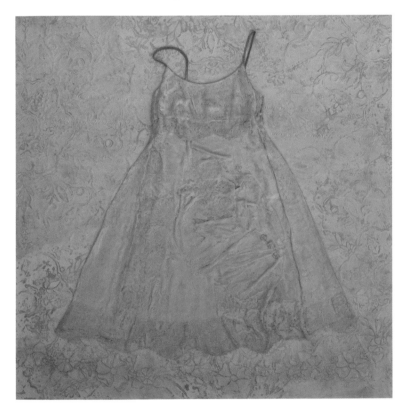

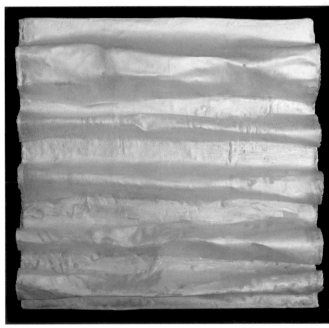

LEFT: Lissa Rankin, *Something from Nothing.* Encaustic, silk, and oil stick on panel, 48 x 48 inches (121.9 x 121.9 cm), 2007.
Photo by Matt Klein.

ABOVE: Cari Hernandez, *Kira: 5 Channel.* Beeswax, damar resin, pigment, and silk fiber, 12 x 12 inches (30.5 x 30.5 cm), 2007.
Photo courtesy of the artist.

Cari Hernandez layers silk fiber over her encaustic paintings and coats the silk with wax, letting it undulate in waves—fluid like water yet supported by the structure of the wax. About her *Kira* series, Hernandez says, "Kira is the name of my daughter and also the Greek word for light. Both are the meaning and inspiration for this work, my pursuit to create a flow of light and movement while working silk fiber lightly in wax. It requires a gentle balance, using just enough wax to create a structure of permanence while still maintaining translucency."

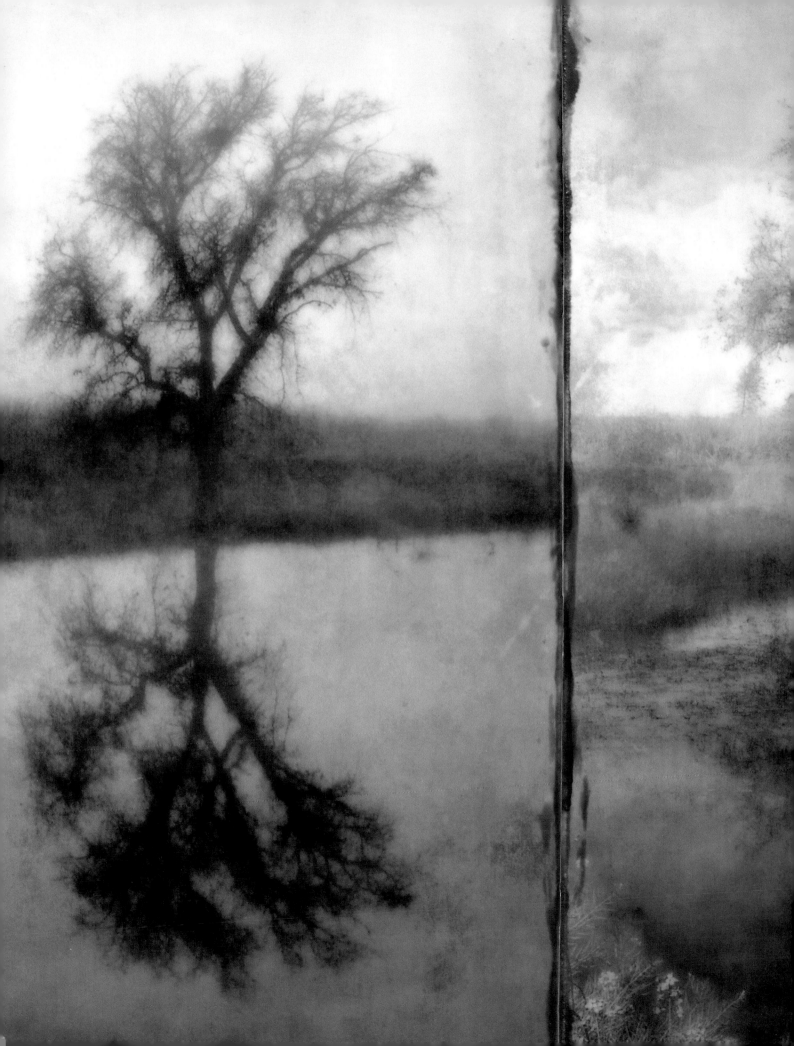

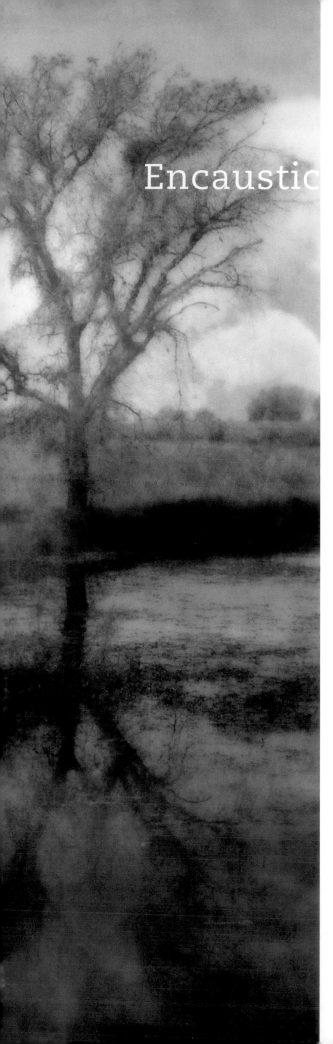

Encaustic and Photography

Photographers are increasingly discovering the potential of combining photography and wax. Given the importance of light in photography, it seems a natural marriage, since wax refracts light in unique ways and can add an otherworldly quality to photographs.

Thea Schrack, *Winter/Spring* (detail). Photograph with encaustic wax painting (two panels), 18 x 25 inches (45.7 x 63.5 cm), 2004.
Courtesy of I. Wolk Gallery.

GLAZING PHOTOGRAPHS WITH WAX

Thea Schrack prints her digital photographs on absorbent paper with archival ink and then mounts them to panel. She coats the photographs with layers of encaustic medium and fuses them with a heat gun, using a small amount of encaustic paint to accent the edges. This process gives Schrack's art an illusory, foglike aura that obscures some of the photographic detail and suggests the blurred edges of idyllic childhood memories or indistinct, half-remembered dreamscapes.

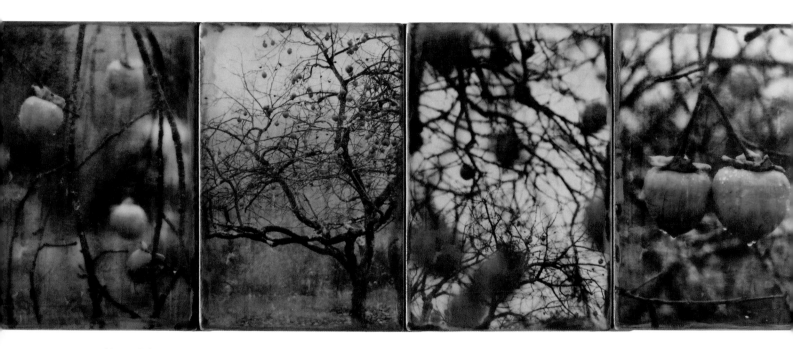

Katsy Johnson uses a similar technique, printing digital photographs on watercolor paper and mounting them with acrylic gel medium onto birch panel. After mounting her photographs to panel, Johnson glazes her photographs with a thin layer of encaustic medium and then uses encaustic paint to embellish the borders.

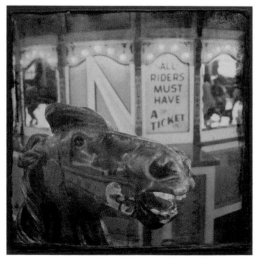

DIPPING PHOTOGRAPHS IN ENCAUSTIC

To create her beautiful, translucent art, Jeri Eisenberg photographs landscapes using either a pinhole camera or a radically defocused 35mm lens. After printing an image on handmade Japanese kozo paper, she lays the photograph on a heated griddle and brushes on encaustic medium with a hake brush. The heat from the skillet fuses the wax, causing the wax to become one with the paper and allowing light to diffuse through the photograph. To optimize the refraction of light through the image, Eisenberg suspends the waxed photograph from an acrylic bar, using magnets to attach the photograph to the bar. Eisenberg says, "I feel no need to seek out grand vistas or exotic locales, majestic mountain ranges or rushing rivers. It's the common wooded landscape of my day-to-day life that captures my attention. The images are firmly grounded in the natural world, a particular place, a particular season, a particular time. But by obscuring detail, only the strongest brushstrokes emerge: The images become sketches with light, literally and figuratively."

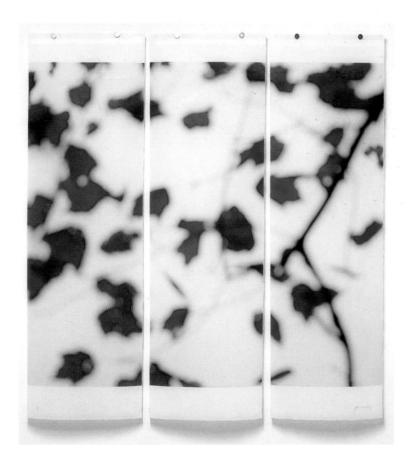

LEFT Jeri Eisenberg, *Sugar Maple Floaters (Red)*. Ink and encaustic on kozo paper, 36 x 34 inches (91.4 x 86.4 cm), 2006.
Courtesy of Lanoue Fine Art. Photo courtesy of the artist.

OPPOSITE TOP Thea Schrack, *Winter Fruit*. Photograph with encaustic wax painting (four panels), 18 x 50 inches (45.7 x 127 cm), 2005.
Courtesy of Julie Nester Gallery.

OPPOSITE BOTTOM Katsy Johnson, *Ticket to Ride*. Encaustic wax, photograph, and oil on panel, 16 x 16 inches (40.6 x 40.6 cm), 2008.
Photo courtesy of the artist.

PAINTING PHOTOGRAPHS WITH ENCAUSTIC

Fawn Potash takes a more painterly, multimedia approach to her photography. Of her piece *Monarda*, Potash says, "I created *Monarda* in the wintertime, while I was missing my garden. In February, the garden catalogs start showing up in the mail, making the contrast between the still-gray, white-brown landscape outside all the more poignant. I cut out the flowers I was missing, taped them onto the dead stalks in my yard, and took photographs of them using an old Polaroid camera from the 1970s. The film acted slowly in the winter cold and tended to develop only halfway, solarizing [reversing] the lightest tones. These dark, Victorian-looking landscapes came across as otherworldly, more like drawings of a place where summer and winter exist simultaneously, where twilight holds day and night in an odd balance, where water, sky, and earth trade places. I toned the prints in blue and sepia, playing up the confusion and harmony in the natural world. The photographs are toned, colored, mounted on wood, and then sealed in encaustic medium. I use etching tools to draw the verdant seasons on top of snowy landscapes, filling the etched lines with oil color. Several layers build an interpreted place, season, and time of day."

To create his lush photographic paintings, Chris Reilly first attaches a photograph printed with pigment inks on heavy hot-press watercolor paper, which he attaches to a birch panel. He coats the photograph with encaustic and then lays layers of cheesecloth over it, painting over the cheesecloth with an absorbent gesso mixture. After lifting up the cheesecloth, which leaves a textured print of the gesso

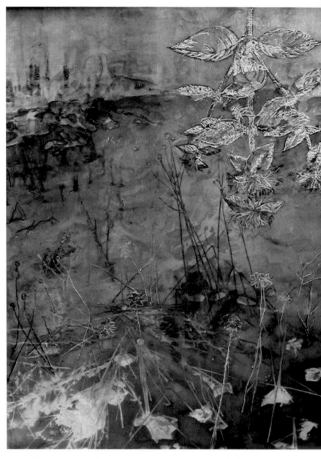

Fawn Potash, *Monarda*. Photograph, encaustic, and oil, 20 x 16 inches (50.8 x 40.6 cm), 2005.
Photo courtesy of the artist.

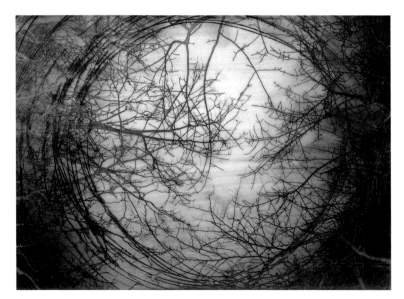

Fawn Potash, *Branches*. Photograph, encaustic, and oil, 16 x 20 inches (40.6 x 50.8 cm), 2005.
Photo courtesy of the artist.

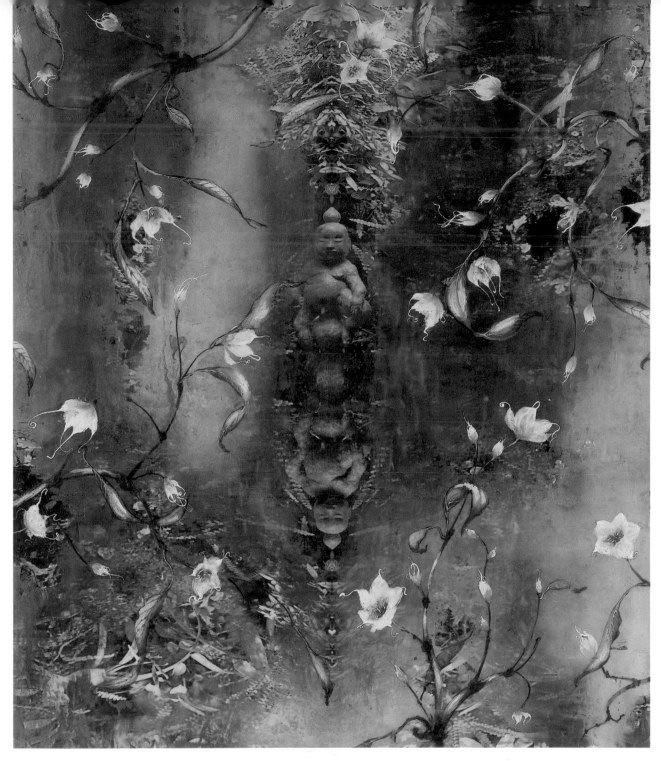

mixture, he applies ink, watercolor, and gouache to create atmospheric backgrounds he cannot achieve with encaustic alone. He then scrapes the surface to reveal variations in color and texture before coating it with yet more layers of encaustic. Using water-soluble inks mixed with denatured alcohol, Reilly uses Chinese brushes to apply inks to the surface. After applying the inks, Reilly paints with encaustic paint, using brushes and sometimes a heated wax pen. As a final coat, Reilly applies a mixture of alkyd oils and Dorland's Wax Medium to glaze his paintings, applying the mixture and then wiping it off to unify the surface and highlight textures.

Chris Reilly, *Buddhaboy Reflecting.* Encaustic, ink, and pigment print on paper mounted to birch plywood panel, 48 x 40 inches (121.9 x 101.6 cm), 2009. Photo courtesy of Jeff Lancaster.

About his paintings, Reilly says, "I enjoy painting creatures that go through metamorphosis, such as dragonflies, moths, frogs, and butterflies. I also paint the Buddhas, male and female, who have transformed through stillness. A painting is a still object that depends on the viewer for its meaning. The accretions and layers of paint scraped and preserved mimic the mind's layers of memory."

Monique Feil prints her photographs on watercolor paper and mounts them on panel using acrylic gel medium. She then glazes her photographs with encaustic medium, which she applies in thin layers, fusing in between layers. Using a variety of encaustic techniques to embellish her photography, she creates painterly borders for her photographic images.

To mount her photographs, Feil uses the following technique:

Monique Feil, *Enchanted Soul.* Photograph with encaustic on panel, 16 x 16 inches (40.6 x 40.6 cm), 2007. Photo courtesy of the artist.

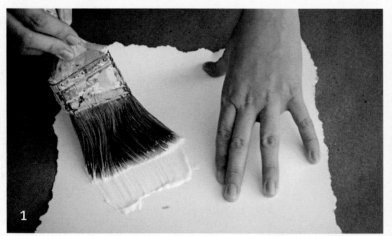
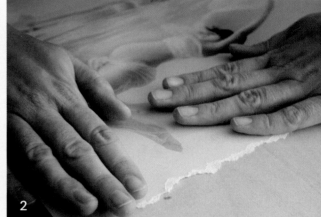

STEP 1 Print the photograph on heavy, cold-press watercolor paper and coat the back of the photograph with acrylic gel medium or other adhesive.

STEP 2 Mount the photograph to a wood panel, being careful to prevent any of the acrylic gel medium from oozing onto the surface that will be painted. Now, weight the panel with books or other heavy, flat objects. (You may wish to protect the surface with a sheet of newsprint.)

STEP 3 Paint a thin layer of encaustic medium over the photograph, and, if you wish, experiment with other techniques to enhance the borders of the photograph.

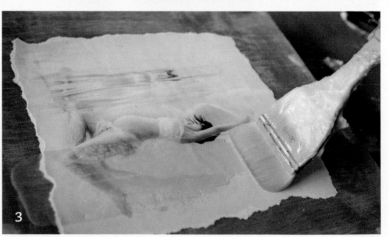

Photos by Monique Feil.

COLLAGING PHOTOGRAPHS INTO PAINTINGS

Gay Patterson creates smooth-surfaced abstract paintings onto which she collages digital photographs that she has printed on rice paper or silk. (Both DigiFab and Jacquard create products in which thin sheets of white silk fabric are attached to backing paper, making them easy to put through a printer.) The encaustic medium makes the rice paper or silk disappear, leaving the photographic image floating in the wax. Patterson recommends preheating the encaustic surface to more easily incorporate the rice paper or silk. To gently heat her large surfaces evenly, she uses a series of heat lamps suspended over her surface.

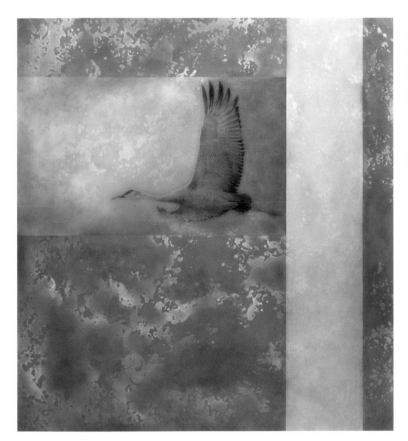

ABOVE Photographs printed on silk in Gay Patterson's studio in Santa Fe, N.M.
Photo by the author.

LEFT Gay Patterson, *Nightfall*. Encaustic on wood with pigment-ink print on silk, 48 x 44 inches (121.9 x 111.8 cm), 2007.
Photo courtesy of the artist.

About *Nightfall,* Patterson says, "One branch of an ongoing dialogue with myself involves the question of how our inner world of mind and emotion connects with the external world of our experience. Photos I had taken of patterns in nature—cranes in flight, ripples on the ocean—were made to act as surrogates for objective reality when embedded into the painted field I had created. When bonded, the digitally prepared and printed silk sheet had a transparency that allowed me to imagine a fusion of the two realms."

PHOTO TRANSFER

In her work, Danielle B. Correia begins with a warm white encaustic ground, followed by a layer of encaustic medium. Next, she prints color photographs on a toner-based laser printer and transfers them using a technique similar to the photocopy transfer technique described on pages 142–143. The photographic images serve as the inspiration for the rest of the piece.

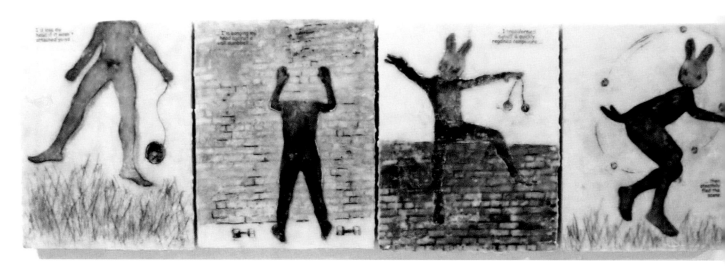

Correia says, "The bunny head in *I'd Lose My Head if It Wasn't Attached* is a metaphor for change or transformation. I photograph a model and make any necessary adjustments to the image in Photoshop. I then transfer the images onto the wax anywhere from three to ten times using an extremely thin layer of medium in between each transfer. This gives the illusion of depth or three-dimensionality in the figure. The text is only transferred once and is kept closer to the surface of the piece—it is the last step and is only figured out upon completion of the piece. I use drawings to further enhance the idea of transformation. These are hand-drawn using sculpture or dental tools and then filled in and wiped back with oil stick. The childlike objects and crude manual technique speaks to the idea that we are in constant change, both in our personal lives and in the bigger picture. The political unrest in this world and the constant turmoil on one hand juxtaposed with the beauty of the world or the curiosity of a child—I always come back to this duality."

Danielle B. Correia, *I'd Lose My Head if It Wasn't Attached* Comic strip, mixed media, 36 x 12 inches (91.4 x 30.5 cm), 2006.
Photo courtesy of the artist.

PHOTOGRAPHY, ENCAUSTIC AND **MIXED-MEDIA**

To create *Oneness,* Cari Hernandez mounted photographs printed on Awagami and Fabriano handmade paper to a cradled birch panel. She then layered encaustic medium and paint, silk fibers, oil paint, pigments, and writing inks over the photos before coating the mixed-media piece with a layer of epoxy resin. About *Oneness,* Hernandez says, "This work is about my journey toward courage. There is a duality in this piece. It is about both giving and receiving. The embedded silk fiber is symbolic of a tie or cord, a connection to something bigger."

Cari Hernandez, *Oneness.* Encaustic, photographs, handmade papers, silk fiber, oil paint, pigment, ink, and epoxy resin on birch panel, 32 x 24 inches (81.3 x 61 cm), 2009.
Photo courtesy of the artist.

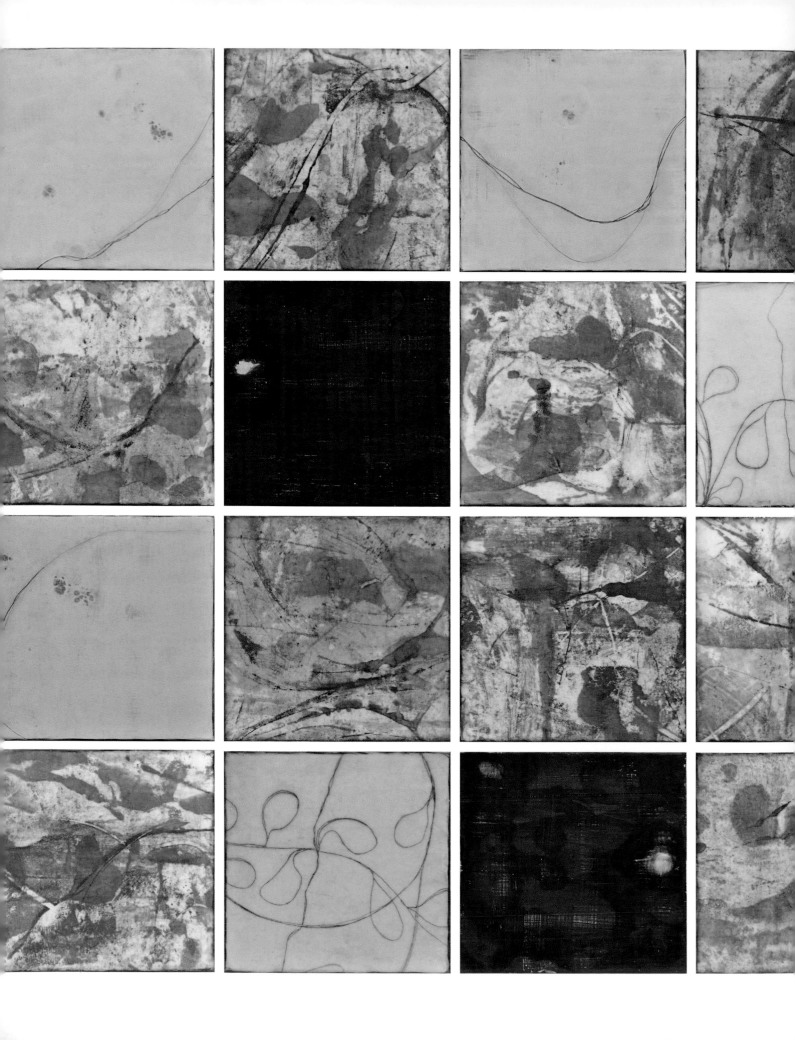

Encaustic and Printmaking

Like photography and encaustic, fine art printmaking and wax work well together. The process of painting or coating with wax transforms a fine art print into an original painting. Several artists I interviewed compared working with wax to printmaking, saying that the two provide similar elements of spontaneity, experimentation, and playfulness. The two pair beautifully, with wax adding dimension and luminosity to prints and printmaking techniques embellishing a piece of encaustic art. As long as the images are printed on absorbent paper, you can add encaustic paint or medium to prints, giving them a hand-painted appearance. You can collage prints into encaustic paintings, or you can mount a print to panel and paint over it with encaustic. Some printmaking techniques are even similar to techniques used in encaustic: For instance, the process of carving into a copper plate with an etching needle is similar to carving into a wax surface with carving tools.

Tracey Adams, *Hypnagogia 2*. Encaustic, encaustic monotype, and intaglio on twenty panels, each 48 x 60 inches (122 x 152.4 cm), 2009. Installation at the Santa Cruz (Calif.) Museum of Art and History.
Photo by Renee Balducci-Houston.

COLLAGRAPHS

In traditional printmaking, a collagraph is a type of print made from a collage of various materials, such as string, cardboard, or paper, glued together on a cardboard, metal, or Plexiglas plate to form a relief block with different surface levels and textures. The plate is coated with gel medium, allowed to harden, and then inked and printed. The plate can be printed with the ink in the recessed areas or as a relief plate, or as a combination of the two. It can also be printed without ink to create an embossed effect.

Elise Wagner uses the concept of collagraphy but applies it in a whole new way to encaustic, using the texture of her encaustic paintings on birch panel to make collagraph "plates" for monoprinting. She begins by painting encaustic on an uncradled ¼-inch wood panel, using encaustic paint with a slightly lower resin content than usual, which allows the wax to stay more pliable and reduces the risk of cracking when the panel is run through the press. She then incises the surface using a technique similar to that used for intaglio printing. Taking advantage of encaustic's natural texture, she builds and carves the wax and then spreads water-based Aqua Inks over the surface. She runs this wax-painted collagraph plate through a printing press, adjusting the press to allow the plate to pass under it. When the plate is run through the press, the ink bleeds into the incised lines of the wax surface, and the wax on the plate compresses. Wagner, who prints on Rives BFK, Stonehenge, or Arches 88 paper, recommends soaking the paper before printing for optimal absorption of the ink.

What emerges from this process is a monoprint that reflects the texture of the waxed plate; the wax-painted collagraph plate itself takes on properties suggestive of stone or marble. For some works, she uses the wax collagraph plate as the base for a painting—the painting itself goes through the printing press and then gets reworked.

Wagner says, "Painting has always been a good platform for me to negotiate the tensions between the real and the abstract, chaos and order, the unknown and the factual. The texture and complexity

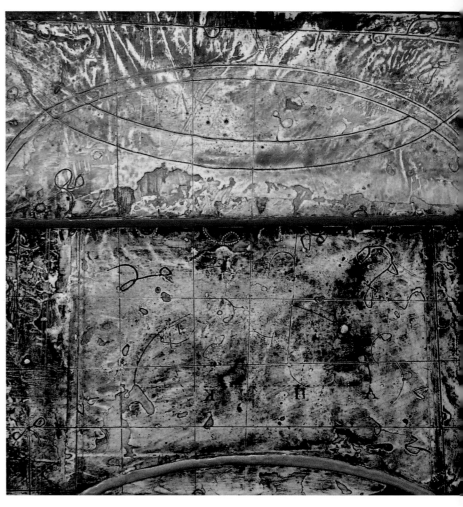

ABOVE Reworked collagraph plate: Elise Wagner, *Terra Reverse Plate*. Encaustic and shellac ink on birch panel, 10 x 10 inches (25.4 x 25.4 cm), 2007. Photo courtesy of Daniel Reid.

OPPOSITE Collagraph monoprint: Elise Wagner, *Terra Infinity*. Collagraph on paper, 10 x 10 inches (25.4 x 25.4 cm), 2007. Photo courtesy of Daniel Reid.

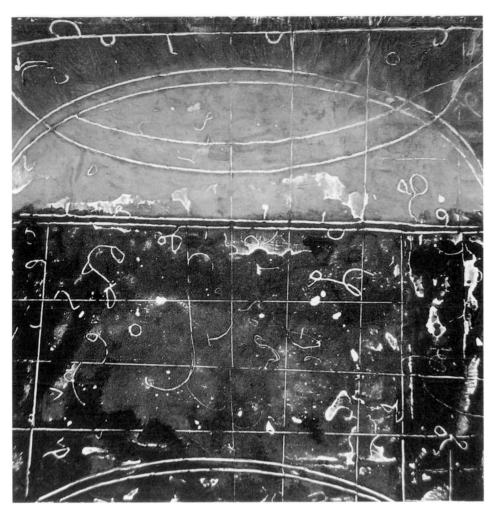

of the surfaces often represent the great unknown and celestial, while the scientific symbolism suggests the accurate and quantifiable. Daily studio practice and ritual become the narrative of the work—a process of making, reflecting, researching, and making again. Ultimately, though, my work draws from the more romantic notion of being among a lost series of maps whose places and origins are in the eye of those beholding them."

MONOPRINTS AND MONOTYPES

The meanings of the terms *monoprint* and *monotype* are very similar, because each technique yields one image (*mono* = one). Traditionally, an image is drawn or painted onto a plate with oil- or water-based ink or paint and then transferred to paper. But the terms are not equivalent, and the distinction deserves clarification. A monotype is a printed image from a plate containing no incising or matrix. It is therefore a singular image and cannot be replicated. A monoprint, on the other hand, is similar to the monotype with its drawing or painting, but, like an etching or collagraph, it has an additional matrix—something that can be replicated multiple times.

ENCAUSTIC MONOPRINTS

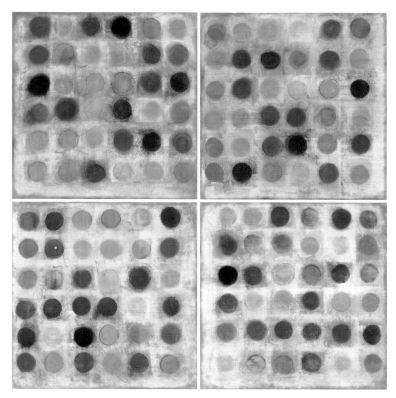

Tracey Adams, *Revolution* 5. Encaustic and monoprint on four panels, 36 x 36 inches (91.4 x 91.4 cm), 2006. Collection of Jennifer DeGolia. Photo courtesy of Renee Balducci.

In her work, Tracey Adams makes use of both printmaking techniques. Adams marries her structured, geometric sensibilities with her printmaking skills and the versatility of wax to create layered works on panel. While many of her paintings are created using a traditional encaustic painting process, some are created by mounting on panel her meticulously crafted fine art prints, which incorporate elements of monoprint, etching, monotype, and drawing. Once she mounts the prints, she layers them with encaustic medium, working back into the wax with oil sticks and an etching needle and finishing with more lay-

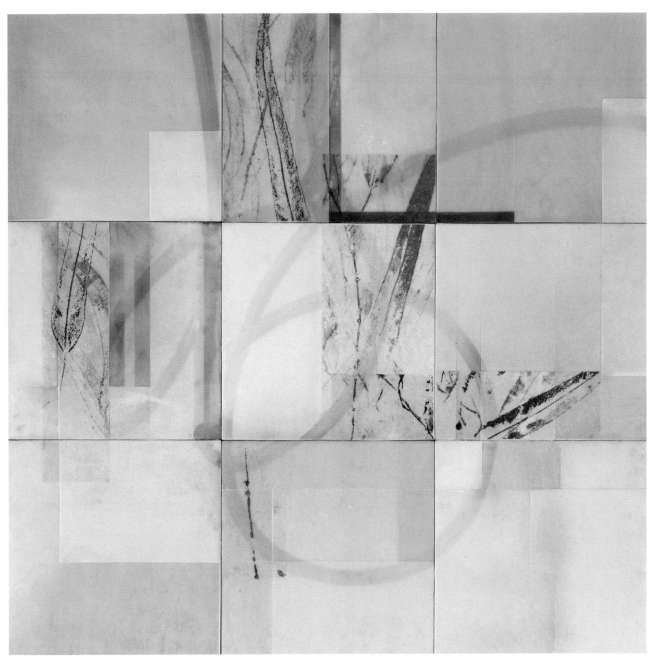

ers of wax. In other works, prints constitute only a fraction of the total composition, allowing her to explore other encaustic techniques.

Adams says, "A painter, printmaker, and musician, I consistently have been drawn to art forms that are sympathetic to geometric structure yet open to improvisation. Recent investigations into certain mathematical expressions and formulae have had an influence on my work, especially when they make their appearances in nature. These provide a means of recognizing and understanding the intricate connections between all things."

Howard Hersh, who trained as a printmaker, prints monotypes of botanical elements on rice paper, which he then collages into his paintings. About his work, Hersh says, "My interests and my work

Howard Hersh, *New Community 03-11*. Encaustic on panel, 48 x 48 inches (121.9 x 121.9 cm), 2003. Photo courtesy of the artist.

continue to explore interrelationships and connectivity in the universe. Especially interesting to me is the mimicking of manmade things of forms found in nature. Decorative elements on gates, doors, and facades come to mind. In addition to this mimicking, there is harmony in seemingly disparate things. Witness how easily the architecture-like grids exist within my paintings of plant forms. So nature informs art, and art edifies nature."

Paula Roland, *Scatter* (detail, lit from behind). Encaustic monotype on Rives BFK paper, 28 x 22 inches (71.1 x 55.9 cm), 2008.
Photo courtesy of the artist.

ENCAUSTIC MONOTYPES

Encaustic monotypes are created directly on a heated palette, without a printing press. To create her encaustic monotypes, Paula Roland, who teaches workshops on the technique, applies wax directly to a heated plate and manipulates it with brushes or other tools. Roland says, "Direct and freeing, the fluid nature of the wax tends toward abstraction and leads to serendipitous, magical discoveries. Encaustic monotypes may be one-pass prints, or they may consist of multilayered surfaces of depth, translucence, and blended color. They may be open and calligraphic or have an all-over surface texture. My approach is to honor the spontaneity of encaustic yet provide an element of predictability to the monotypes by modulating factors such as temperature, pigment, and the type of paper I use."

After learning the monotype process from New Orleans print-maker Dorothy Furlong Gardner, Roland waited many years before beginning to create her own monotypes. "The medium has its own charm, leading you to create effects you could never preconceive," she says. "I love how the possibilities continually unfold and how the process links with other media and combines with other encaustic techniques." The natural spontaneity inherent in encaustic monotype has led Roland to pursue a more experimental, experiential approach in both her teaching and her art. She believes that her personality fits well with the improvisational nature of encaustic monotype, which opens the door to creative exploration. About her art, Roland says, "An abstract narrative unfolds in the act of making each piece. The language of repetitive mark-making is a record of experience or at-titudes. These systems flow, disperse, gather, interact, and personify social interactions. Within their storied space, they suggest journeys, populations of species, climates, and interactions between humans and the natural world."

To make encaustic monotypes, Roland uses what she calls an "Encaustic HotBox." This device, which she designed, consists of an insulated wooden box fitted with four 100-watt light bulbs in porce-lain sockets, which are wired to a rheostat that controls the light and, secondarily, the heat. An anodized aluminum plate rests on top of the box; because there is no single, central heat source, heat is evenly distributed across the surface. For creating larger prints, several Hot-Boxes can be arranged together to create larger plates.

ABOVE LEFT Paula Roland, *Fragment II*. Encaustic monotype and graphite rubbing on kozo paper on panel, 14½ x 13 inches (36.8 x 33 cm), 2007. Photo courtesy of the artist.

ABOVE RIGHT Paula Roland, *Fragment III*. Encaustic monotype and graphite rubbing on kozo paper on panel, 14½ x 13 inches (36.8 x 33 cm), 2007. Photo courtesy of the artist.

MAKING AN ENCAUSTIC MONOTYPE

Paula Roland offers the following tip for creating encaustic monotypes: For more predictable results, choose absorbent paper. Roland primarily uses rice paper, but different effects can be achieved by using papers of varying thicknesses and absorbency. The thicker the paper, the more wax it can absorb. Less absorbent papers yield a waxier surface, which many artists also find desirable.

Here are the steps Roland follows when making a monotype:

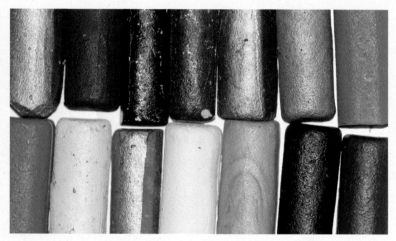

STEP 1 Roland draws or paints directly on the HotBox using her own encaustic paint sticks, which are heavily pigmented, cylindrical sticks of encaustic paint with squared edges. She creates the paint sticks in a cast-iron breadstick mold, using a formula of 50 percent pigment mixed with 50 percent encaustic medium. (Please consult the safety section of his book, pages 50–55, before contemplating doing anything similar on your own.) The sticks' shape allows Roland to create a fine line with a corner or a large swath of color using the long edge. To move paint on the surface, she uses a Bondo spreader (available in the paint departments of hardware stores). To control the line better, Roland recommends using a light touch when applying encaustic.

LEFT Paula Roland demonstrating encaustic monotype in her studio in Santa Fe, N.M.

ABOVE Roland's handmade encaustic paint sticks.

STEP 2 When she's ready for the first impression, Roland presses the paper gently against the surface of the HotBox. She backs the paper on which she is printing with a sheet of newsprint and uses a baren, a disc-shaped tool traditionally used in Japanese printmaking, to press the encaustic paint into the paper. The paint fuses to the paper when the paper is laid on the heated surface, and the print does not need additional fusing. "The image becomes one with the paper," says Roland. To clean her HotBox between paint applications, she sprays the box with water or uses paraffin as a cleaner.

Roland repeats the process as many times as she desires, layering colors and images. Do take note of the fact that the more layers of wax you apply, the more the underlying images will be obscured.

Photos by the author.

LEFT Encaustic monotype coming off the HotBox.

ABOVE The small heated plate Roland places on the surface of the HotBox to print an encaustic monotype with borders.

Wood blocks in Roland's studio.

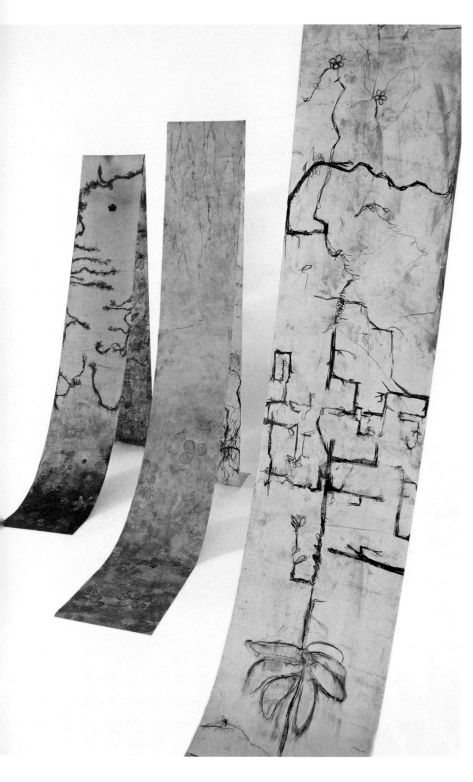

ABOVE Paula Roland with *Chant III*.
Photo by the author.

LEFT Paula Roland, *Chant* (installation view). Encaustic monotype with surface drawing in graphite and charcoal, each piece 25 feet x 18 inches (7.62 m x 45.7 cm), 2003.
Photo courtesy of Cliff Roland.

Roland also uses her HotBox for a technique in which she draws directly onto paper with encaustic paint. In this process, she places absorbent paper on a clean Hotbox. She then draws on the paper with one of her paint sticks, which melts as it comes into contact with the heated paper. The paint is absorbed into the paper automatically as she works. In these works, she lays down layers of wax, using a stick made of clear encaustic medium for blending.

In her workshops, Roland teaches variations on these techniques: surface drawing into encaustic monotype, combining monotype with other media, using wax-stamping and block-printing techniques, using stencils, adding texture to the paper's surface and to the HotBox surface, and using natural objects for printing and creating reliefs. In her work, Roland sometimes combines monotype with collage and other media and sometimes uses found and natural materials for printing.

Encaustic monotypes may be framed under glass or mounted to wood panel for display. If mounted on panel, monotypes may be coated with encaustic medium for additional depth, sheen, and protection. (Once the monotype has been mounted, you may also use it as an "informed" surface on which to work using traditional encaustic painting techniques.) Because unmounted encaustic prints may be rolled, folded, or saturated with wax medium, they are ideal for installation art, sculptural forms, and artists' books.

To mount encaustic monotypes to panel, Roland spreads a light layer of acrylic gel medium on both the back of the monotype and the front of the support and covers the print with a few sheets of newsprint to absorb moisture and any excess gel medium. She then uses a brayer—a small hand-roller usually used for spreading ink—to press the print and the support together. Next, she places weights over the print to ensure that it bonds completely to the underlying support. She has had success with this technique even when mounting waxier prints.

COMBINING ENCAUSTIC MONOTYPE WITH PAINTING OR SCULPTURE

Encaustic monotype can be combined with other techniques to amplify the effect of the monotype. In *Circle of Life, Series IV,* Ruth Gooch uses an encaustic monotype on rice paper as the centerpiece of the sculpture, combining metal, rust, and encaustic monotype with luminous results.

I sometimes collage encaustic monotypes into my paintings. For *Both Sides Now,* I started with an encaustic monotype that I had created on one large sheet of rice paper. I cut the monotype into squares, and then, working with encaustic paint on birch panel, I painted the background of *Both Sides Now.* On this painted encaustic background surface, I taped off rectangles with masking tape and painted a layer of encaustic medium inside the taped-off shapes. (See page 103 for step-by-step instructions on using masking tape to create shapes.) To collage the encaustic monotypes, I heated the surface of the painting to liquefy the wax and then placed the monotype cutouts on an R&F heated encaustic palette to liquefy the wax on the backs of the cutouts. I then placed the cutouts inside the taped-off rectangles, wet-to-wet, and covered the monotype cutouts with another layer of encaustic medium. Next, I fused the encaustic medium and pulled up the masking tape. After applying the cut-outs, I reworked the surface, adding compositional elements by painting on top of the monotypes.

Like other works from my *Delta* series, *Both Sides Now* references familial relationships and interpersonal dynamics. This piece demonstrates the push and pull I feel from trying to integrate the many facets of my life as a doctor, artist, writer, and mother. The visual elements represent my husband, my daughter, and the muses that threaten to draw me away from them.

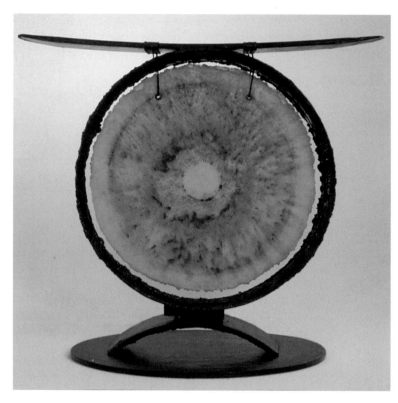

Ruth Gooch, *Circle of Life, Series IV.* Found metal, rust, encaustic, and pigment on rice paper, 23 x 20 x 4 inches (58.4 x 50.8 x 10.2 cm), 2006.
Collection of Isadore and Meredith Lurman.

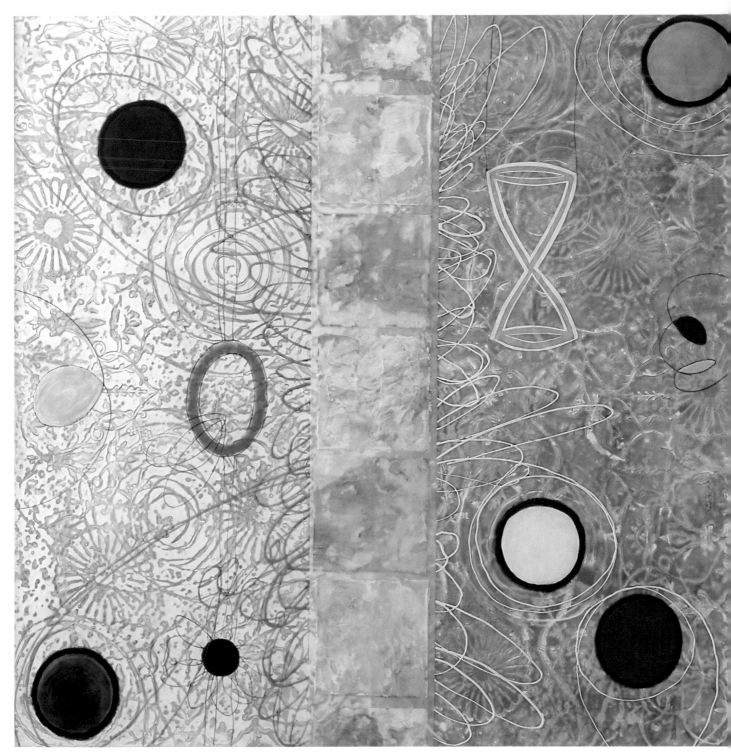

Lissa Rankin, *Both Sides Now.* Encaustic and encaustic monotype on rice paper, oil stick on panel, 60 x 60 inches (152.4 x 152.4 cm), 2008.
Photo by Matt Klein.

SILK SCREEN PRINTS

A smooth encaustic surface can serve as a ground for silk-screening images. You can either silk-screen directly onto a prepared wax surface or silk-screen onto absorbent paper, which you can then collage into a piece.

ABOVE Silk screen in Christy Hengst's studio in Santa Fe, N.M.
Photo by the author.

LEFT Jeff Schaller, *Jaclyn.* Encaustic with silkscreen, 24 x 24 inches (61 x 61 cm), 2006.
Photo courtesy of the artist.

in any small air holes with wax and then uses a single-edge razor blade to smooth the surface. He warns that, if it is not smooth, the silk screen will glide over the "divots," and the image will not come out properly. When the smooth wax surface has cooled, he pulls the water-based inks through the screen and onto the wax and allows the silk-screened image to dry. Then he paints a coat of clear medium over the image to encase it, and, finally, he heats it very carefully with a heat gun, taking care not to blow out the silk-screened image.

To create *Travel,* Christy Hengst silk-screened onto paper and collaged the print into her sculpture with encaustic medium. Hengst says, "The words are from a letter the man who later became my husband wrote to me while in South America. The swan or boatlike shape seems to be suspended beneath waves of memory."

Christy Hengst, *Travel*. Beeswax with porcelain and
silk-screened paper on panel, 6 x 6 x 1½ inches (15.2 x
15.2 x 3.8 cm), 2005.
Photo courtesy of the artist.

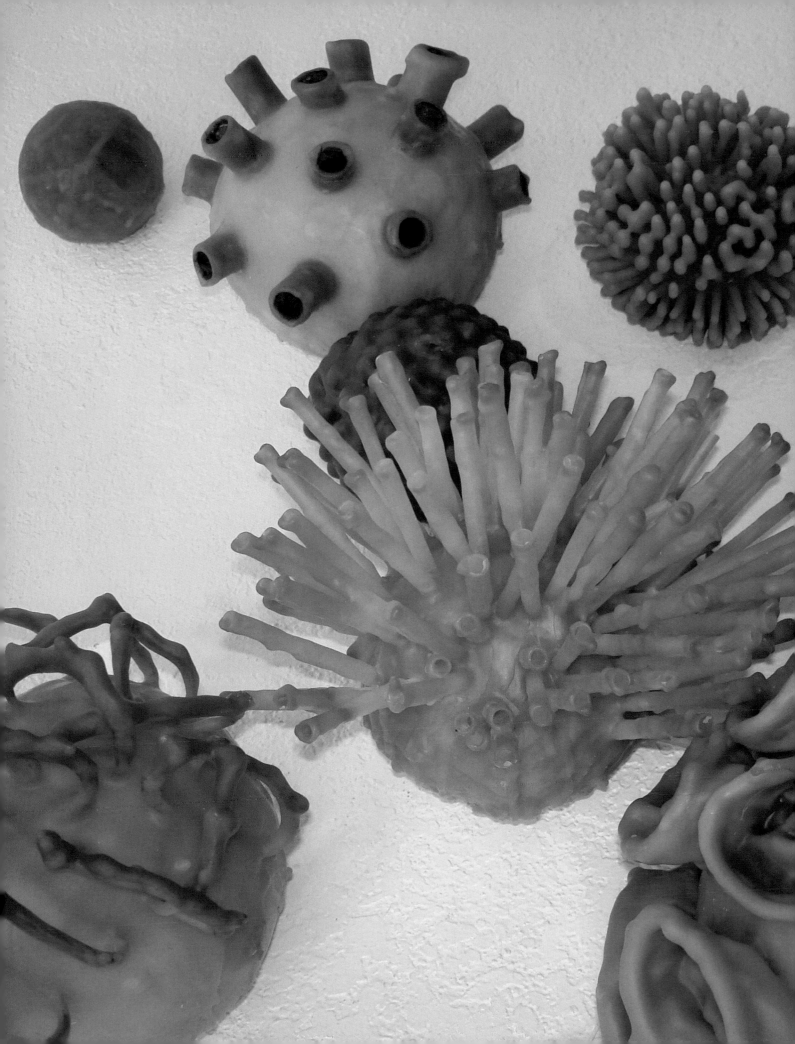

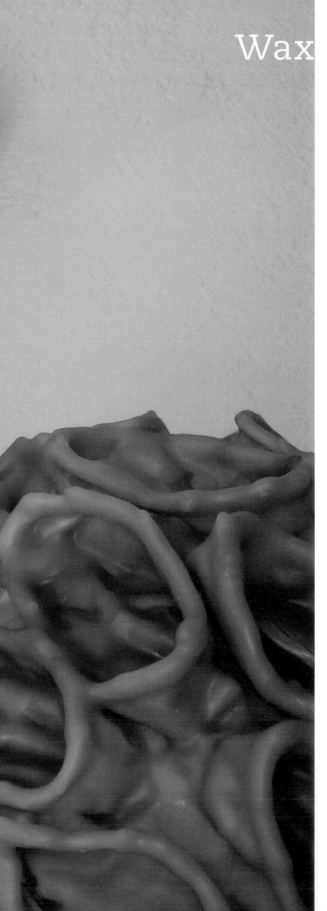

Wax and Sculpture

When you look back at the history of art, you'll notice that wax has long been used as a coating for sculpture, including many Renaissance marble sculptures. In the world of contemporary sculpture, wax has found new life. Artists use it to coat clay, porcelain, plaster, wood, fabric, and stone surfaces. Used as a surface treatment, encaustic medium or paint imparts an organic, skin-like aspect to the sculpture. Historically, artists have also used wax to cast metal sculptures—sculpting the wax directly and then "sacrificing" it through a lost-wax technique. But some artists are now discovering that the material itself lends itself to creative expression and need not be lost to have value.

Miles Conrad, *Orb Series* (installation detail). Mixed media and encaustic, size variable, 2007.

Courtesy of Conrad Wilde Gallery.

CERAMIC AND WAX

Ceramic and encaustic have certain similarities; yet while both possess a quality of fragility, the goals these media served have traditionally been very different. Many ceramic works are created to be functional, but most artists working with wax are creating fine art—often meant to be appreciated hanging on a wall. Over the history of art, however, wax has often been used to seal sculpture, and wax's inherently skinlike surface lends itself well to embellishing ceramic. Using wax on the surface of fired clay creates a translucent layer with depth, somewhat like a glaze. Unlike traditional glazing, however, the application happens post-firing, which allows for more flexibility and mixing of media. The ceramic surface must be porous for the wax to adhere well, so unglazed but fired clay works best. Encaustic medium or paint should be fused after you apply it to ensure that it binds to the underlying sculpture.

Christy Hengst masterfully combines her ceramic art with encaustic techniques. When we spoke, I expressed my surprise that there were not more ceramic artists incorporating wax into their process. "I think I know why that might be," she said. "As a ceramic artist, the goal is often linked to function, especially if you are making art for public spaces. A primary reason for using ceramic material revolves around the durability and weatherproof qualities that fired clay offers. Adding wax to the process reverses some of that, making it a more ephemeral creation. I had some resistance to purposely making my pieces more vulnerable. But then I started to get into that very aspect of these two materials, wax and porcelain. They both ride a double edge of impermanence and fragility on the one hand (wax melts and is susceptible to fingernails; delicate porcelain breaks) and preservation and durability on the other (wax seals and makes things archival; vitrified porcelain is impervious to weather and will never disintegrate into dirt again)."

Hengst usually mounts her ceramic pieces to wood panel before coating them with encaustic medium. Of her work, she says, "There are themes that I am thinking about, such as birth, death, and relationships, but most of all I hope I am able to tap into and create forms that reach viewers on a preverbal, gut level. I am interested in the humanness of us all, how it connects us, and also in the unthinkable ways in which that bond is disregarded. The biggest influences on my art have been my relationships, and chief among these is being a mother. It is such a primal experience of love and separation."

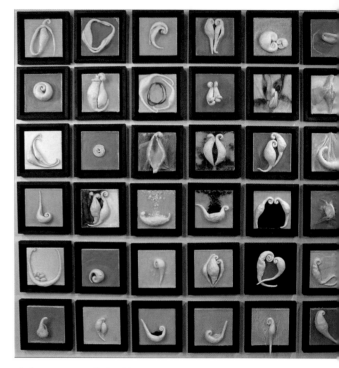

Christy Hengst, *Relationships*. Porcelain, beeswax, and mixed media on panels, grid of thirty-six framed pieces, each 8 x 8 x 2 inches (20.3 x 20.3 x 5.1 cm) (dimensions of grid: 60 x 60 x 3 inches [152.4 x 152.4 x 7.6 cm]), 2007.
Photo courtesy of the artist.

COMBINING CERAMIC AND ENCAUSTIC

Here are the steps Christy Hengst follows when creating her ceramic-encaustic works:

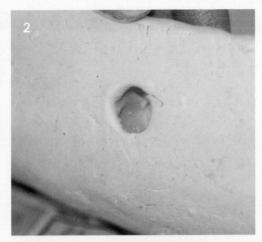

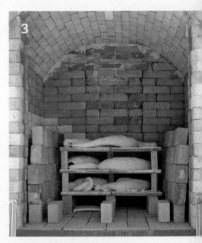

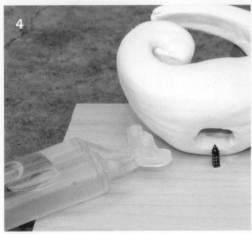

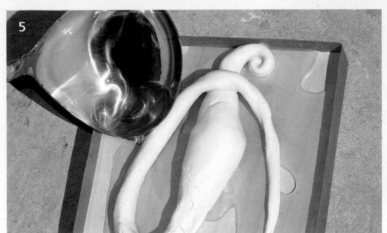

STEP 1 Hengst first sculpts the porcelain.

STEP 2 She hollows out a cavity in the back of each ceramic form before firing.

STEP 3 She fires the porcelain forms in the kiln.

STEP 4 To mount the ceramic forms to panel, she drills a hole through the panel for a countersunk bolt, which fits into the hollow space in each ceramic form. Filling the cavity with epoxy putty, she glues the bolt to the ceramic.

STEP 5 Finally, she pours encaustic paint or medium around or onto the ceramic objects.

Photos by the author.

Kim Bernard creates sculpture with wood, plaster, and terra-cotta clay and then uses wax as a skin to coat her pieces. With a degree in sculpture and a background in ceramics, Bernard became frustrated with the unpredictability of the glazing process. Because the process of firing is unpredictable, her ceramic sculptures would sometimes emerge from the kiln in unexpected colors or with bubbles marring the glaze. Drawn to wax for its immediacy, its reliability, and the luminosity of the color, Bernard now works with fired terra cotta, using encaustic instead of glaze. She also casts plaster sculptures, which she paints with wax. About *Nautilus,* Bernard says, "This piece is from a body of work using multiples to create a whole. Each of the twenty-eight units is separate and leans against the others. When I work this way, I enjoy playing with the many ways it can come together. The 'play' often yields ideas for other sculptures."

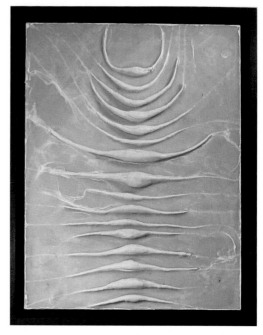

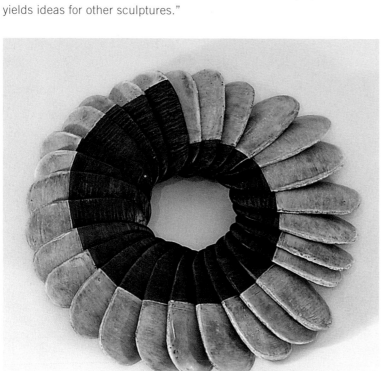

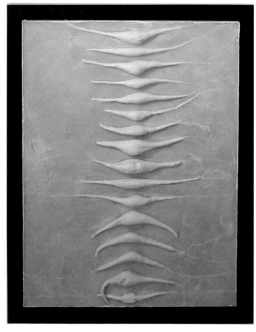

ABOVE Christy Hengst, *Spine* (diptych). Porcelain, beeswax, and pigment on panels, 54 x 20 x 2 inches (137.2 x 50.8 x 5.1 cm), 2006.
Collection of Lissa Rankin and Matt Klein. Photo courtesy of the artist.

LEFT Kim Bernard, *Nautilus.* Encaustic on fired terra cotta, 3 x 15 x 15 inches (7.6 x 38.1 x 38.1 cm), 2006.
Photo courtesy of the artist.

EPOXY CLAY AND ENCAUSTIC

Epoxy clay is a two-part, self-hardening clay: When the resin and hardener components are mixed together, the clay dries within hours. Chris Reilly makes his sculptures using epoxy clay over a variety of armatures. Before painting the hardened epoxy clay with encaustic, Reilly first primes the surface with acrylic gesso. He then coats it with layers of a wax-friendly absorbent gesso, such as gypsum, and then paints the surface with BioShield clay paint for color, so that he can paint over a tinted ground.

About his sculptures, Reilly says, "They are personifications of me. Through psychotherapy and archetypal men's groups, I have identified these parts of me in order to have a dialogue with them, so they do not drive me unconsciously. I seek to accept them rather than repress them and thereby to use their energy, which seems inexhaustible. *Buddhaboy* represents the contented eternal child. I think of the white encaustic paint he is covered with as symbolizing the divine mother's milk. His pose is confident, peaceful. The work is inspired by Eastern and Western religious art. He is without past and future, so he lives in this moment of perfect repose."

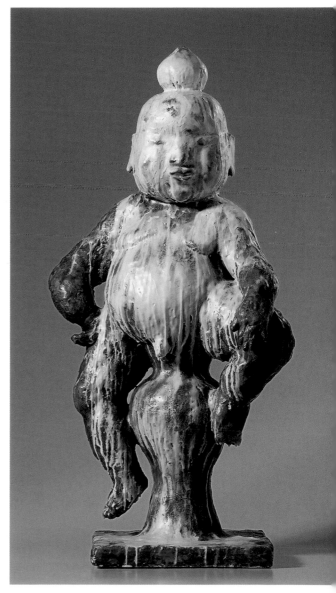

Chris Reilly, *Buddhaboy*. Encaustic, clay paint, and epoxy clay, 36 x 16 x 14 inches (91.4 x 40.6 x 35.6 cm), 2008.
Photo courtesy of Jeff Lancaster.

WOOD AND WAX

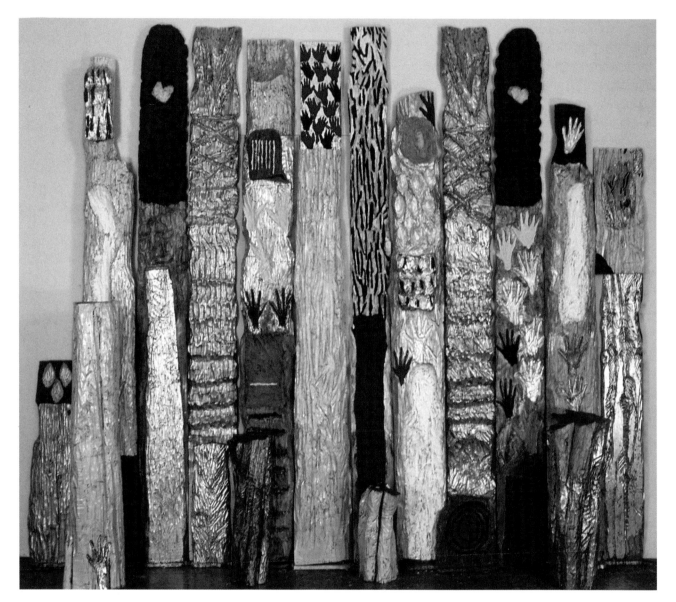

Because it is porous and absorbent, wood also lends itself well to being combined with wax.

Nancy Azara sculpts the way Abstract Expressionist painters paint, expending a lot of physical energy. First, she draws on the wood and then uses a wood chisel and mallet to carve into the wood before painting it with pigmented wax, oil paint, or tempera. She applies gold, palladium, or aluminum leaf to some of her pieces. When painting a piece with encaustic, she pours or brushes the wax onto the piece, using a hair dryer to keep the brush and wood warm while she paints.

Nancy Azara, *Maxi's Wall.* Carved and painted wood with gold, aluminum, and palladium leaf and encaustic, 10 x 12 x 3 feet (304.8 x 365.8 x 91.4 cm), 2006. Photo courtesy of Nick Ghiz.

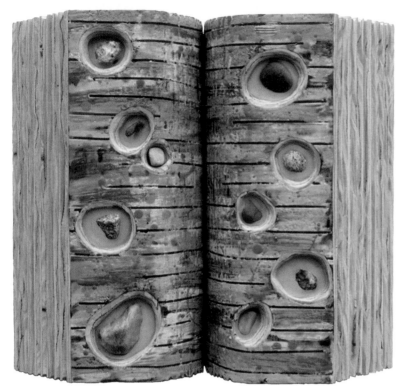

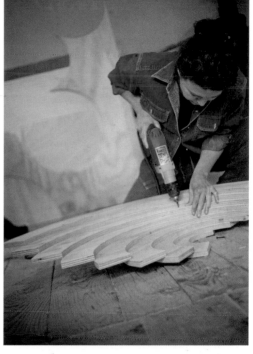

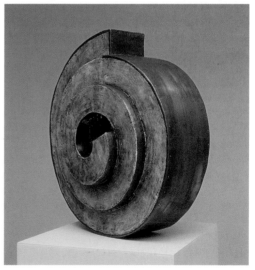

Azara discovered encaustic by accident. In the mid-1990s, she was looking for a material that would add a new dimension to her sculpture, and she happened on encaustic paint on a shelf in Pearl Paint in New York City. She appreciates the glasslike quality wax adds to her mix of materials. Azara says, "The colors and forms reflect an inner sense of myself, a visual description of the unseen and unknown that we all live with every day."

For some of her sculptures, Kim Bernard uses her woodworking skills to create a plywood base and then attaches strips of lead to parts of the wood and coats the exposed wood with layers of encaustic medium, finishing the pieces with layers of pigmented wax and oil stick. About *Chambered Nautilus,* Bernard says, "The spiral is an ongoing theme in my work. I appreciate that it recurs in archaic imagery and represents coiled energy. With the copper inside, when the light hits it just right, the sculpture seems to glow from within."

Kristy Deetz constructs relief sculptures from laminated frames of plywood that she carves, burns, and paints with encaustic. Of her work, Deetz says, "The sculptures are visual metaphors of the book form as well as autobiographical explorations. Playing off concepts like palimpsest, aporia, and table of contents, these pieces operate in one sense as visual puns and connect ideas of language to both body and earth."

TOP LEFT Kristy Deetz, *Touchstones.* Carved wood, encaustic, beeswax, and stones, 20 x 20 x 6 inches (50.8 x 50.8 x 15.2 cm), 2006.
Photo courtesy of the artist.

TOP RIGHT Kim Bernard constructing the wooden base of one of her sculptures in her studio in North Berwick, Maine.
Photo by Monique Feil.

ABOVE Kim Bernard, *Chambered Nautilus.* Encaustic, plywood, lead, and copper, 31 x 15 x 29 inches (78.7 x 38.1 x 73.7 cm), 2007.
Photo courtesy of the artist.

TEXTILES AND WAX

Because textiles are so absorbent, they marry perfectly with encaustic. Combining fabric and encaustic can also transform opaque fabric into sheer, translucent art that refracts light in luminous ways.

Lorrie Fredette creates sculptures using either 100-percent cotton muslin or the interfacing material used in the cuffs and collars of men's dress shirts. Of her sculptures, Fredette says, "My work is really about the misrepresentation of information and its presentation. I use techniques from traditional mapping practices. I take these serious practices (sample collection, recording specimens, etc.) and falsify my findings to misrepresent my investigation. I gathered a multitude of microscopic images, using the Internet, and I collected physical samples. The microscopic images were documented with garbled sketches. The physical samples were recorded through digital photography and distorted, using the computer. The newly false images were then stored on my hard drive in intentionally mislabeled files to continue a form of contamination. The garbled files were combined and translated into sculptural forms that had little resemblance to any of the original data."

To create pieces like *A Study of Division,* Fredette follows this process:

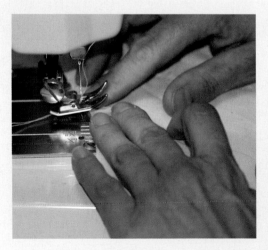

STEP 1 If necessary to provide support, she sews artistic wire into the fabric.

STEP 2 She arranges the fabric pieces.

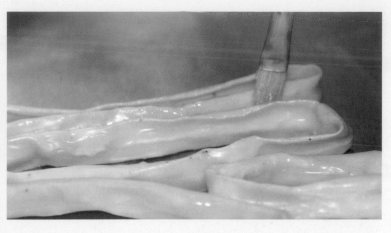

STEP 4 She attaches the segments together, using a brush to apply the wax and a heat gun to fuse.

Photos by the author.

STEP 3 She dips the fabric into encaustic medium.

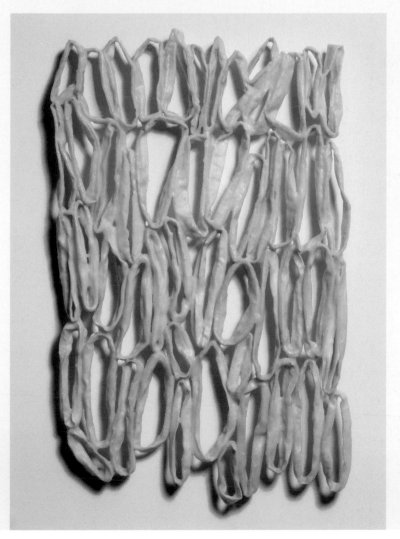

Lorrie Fredette, *A Study of Division.* Encaustic and muslin, 22 x 13 1/2 x 3/4 inches (55.9 x 34.3 x 1.9 cm), 2005. Photo courtesy of John Lenz.

METAL AND WAX

It is unsurprising that some artists are drawn to pairing metal and wax. While metal conjures thoughts of architectural foundations, strength, and the Industrial Revolution, wax feels organic, pliable, yielding, and soft. The juxtaposition between the two becomes a study in dichotomy that draws the viewer in and invites contemplation.

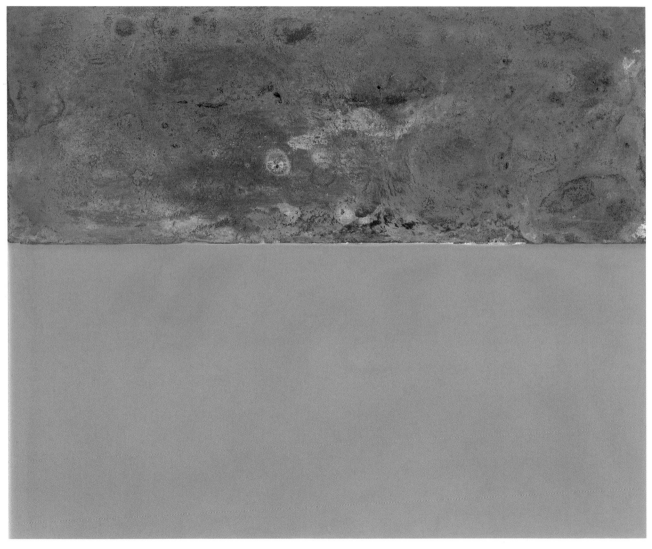

Kris Cox, *Scape*, 20.02.3. Cast lead and beeswax on wood panel, 20 x 24 x 1 inches (50.8 x 61 x 2.5 cm), 2002.
Photo courtesy of the artist.

Intrigued by that dichotomy, Kris Cox mixed cast lead with wax in his *Scape* series. Creating a border around a Baltic birch plywood panel with several layers of blue painter's tape, Cox poured pigmented beeswax about ¼ inch deep, using a pin to prick any air bubbles that appeared to achieve a pristine surface. About this work, in which the cast lead is juxtaposed with the poured wax, Cox says, "The diptych

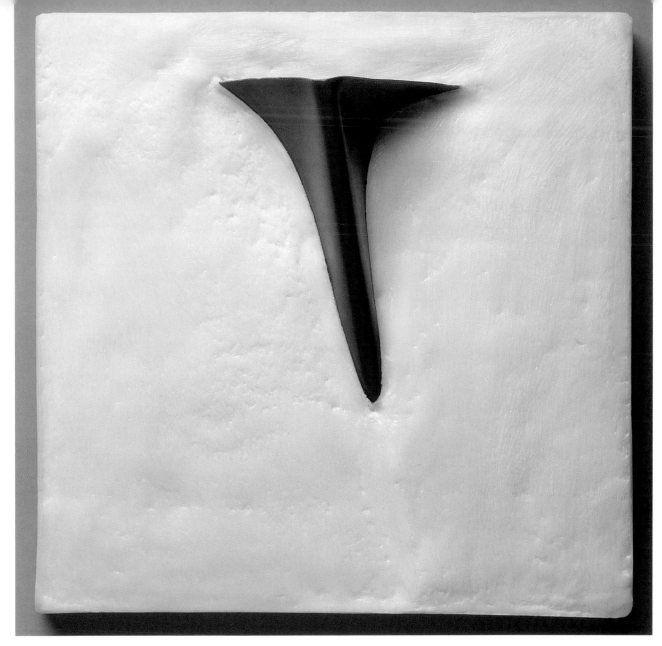

Ed Angell, *Homage to Maya Lin*. Beeswax and lead, 12 x 12 x 4¾ inches (30.5 x 30.5 x 12.1 cm), 2006. Photo courtesy of the artist.

Scape series references land/seascapes. I cast both lead and pigmented beeswax: One material, a pure element from the earth, is heavy and inorganic; the other, created by bees through a complex restructuring of materials, is organic and light. My process of taking solids, heating them till molten, and then casting them into new forms symbolically references earth's dynamic metamorphosis."

Ed Angell combines metal and wax for two distinct reasons: authenticity and process. He says, "To explain authenticity, my current work is based on visual interpretations of geological phenomena—faults, fissures, and plates. What better material than lead could be chosen as a visual element? Lead is a natural element that has been part of our earth for several billion years. Also, the workability of lead has virtually no bounds. In combining wax and metal, I often find numerous solutions to my quest for the perfect visual. I find the interplay between materials to be a very rich source of ideas, if one is willing to experiment."

PLASTER AND WAX

Highly absorbent and easily manipulated, plaster combines readily with wax. When I wanted my body of work to evolve to include sculpture, I was drawn to plaster gauze bandages, a material I already knew how to use because of my work as a physician.

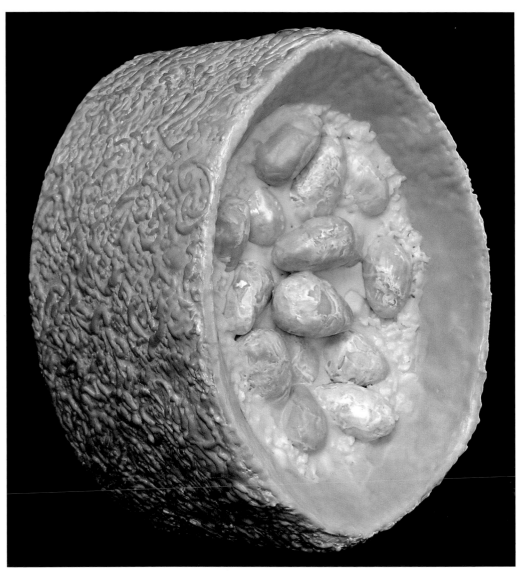

Lissa Rankin, *Which Came First?* Encaustic, plaster, and wire mesh, 27 x 14 x 15 inches (68.6 x 35.6 x 38.1 cm), 2007.
Photo by Matt Klein.

Because I was trained as an obstetrician/gynecologist, eggs and other reproductive imagery have remained recurring themes in my art. Responding to recurring dreams of wax-filled vessels, I longed to create a sculpture that honored these dreams. I created *What Came First?* by building the vessel shape with drywall mesh and covering it with medical-grade plaster, which is ordinarily used to make casts for bone fractures. After the plaster dried, I coated the piece with layers of encaustic paint and medium. To create the egglike forms, I painted encaustic on panel, fused, and then scraped up the wax with a clay loop tool, forming the wax into egg shapes with my gloved hands and then carving them with ceramic tools. To adhere the eggs to the waxed vessel, I poured encaustic medium over the composed piece.

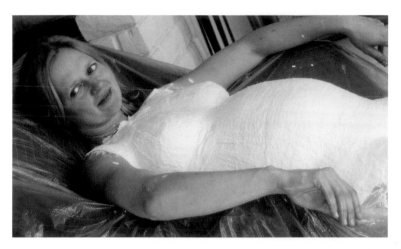

I also used plaster and wax for a series of sculptures for The Woman Inside project. Porous and easy to work with, plaster works well for casting human forms, and the skinlike properties of wax make it a natural material for coating plaster casts of the female figure. For this project, I cast the torsos of dozens of breast-cancer survivors. After interviewing these women, I would hold up the cast and say, "This is what the world sees of you. Now tell me about the rest of you." After the interview, I painted the casts with encaustic and, for the catalog, transcribed their stories as first-person narratives about the beauty within each woman.

Because plaster is fragile, I used a variety of support materials to reinforce the insides of the casts before painting them with encaustic. If you use two-part epoxy resin, as I did with *Susan,* you must apply the resin to the inside of the cast *before* you paint with wax. (The chemical reaction that occurs when you mix two-part epoxy resin can generate a great deal of heat as it hardens, so you must apply the resin to the interior of the cast before painting; otherwise, the resin may melt the wax. Also keep in mind that two-part epoxy resin is highly toxic and must be used with a respirator to minimize exposure.)

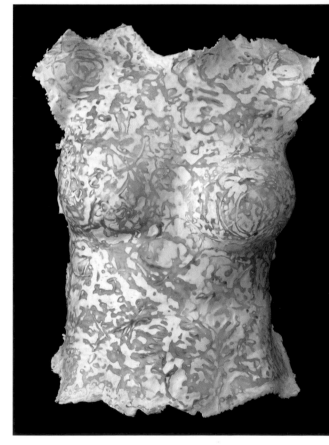

TOP Casting Carmen Tallent's pregnant figure with plaster.
Photo by the author.

ABOVE Lissa Rankin, *Susan.* Encaustic, plaster, and resin, 20 x 16 x 6 inches (50.8 x 40.6 x 15.2 cm), 2007.
Photo by Matt Klein.

SCULPTING DIRECTLY WITH WAX

Working at the boundary of painting and sculpture, Laura Moriarty creates intricately imagined environments made of clustered fragments of deconstructed paintings. Working like an archaeologist, she exposes what is beneath the surface.

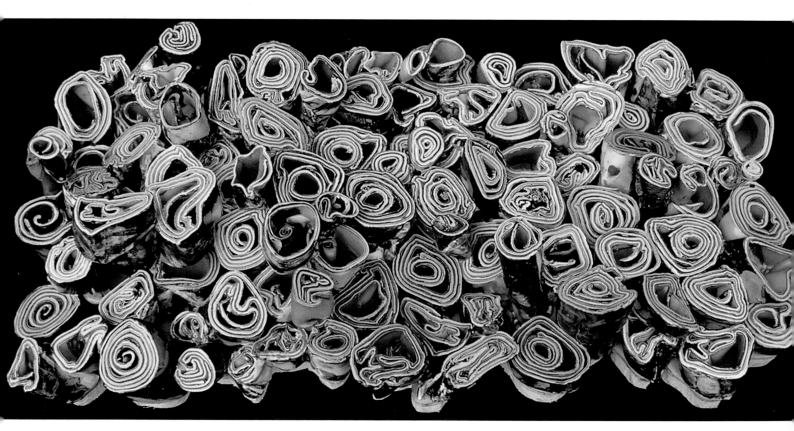

Each of Moriarty's pieces begins as a flat painting on panel. She thinks of these flat paintings as sites for exploration. Excavating their surfaces, she compresses the warm, pigmented wax into forms that resemble fossils, geodes, bones, and shards. Collecting and individualizing these elements in order to reassemble them into high-relief paintings that erupt from the wall, she pushes the boundaries of sculpture and painting. By meticulously building colorful layers of encaustic paint on panel and then scraping them away, she creates exotic shapes that, although they may appear to result from wax accidentally dripping off a heated palette, are actually produced through a carefully studied process of building and scraping.

Similarly scraping, carving, and building, Natalie Abrams discovered her abstract style through happy accident. Once, while scraping wax off a board, she found that she gathered an interesting mound of

TOP Laura Moriarty, *Trunks*. Beeswax, tree resin, and pigments, mounted on wood panel, 18 x 9 1/2 x 5 1/4 inches (45.7 x 24.1 x 13.3 cm), 2006.
Photo courtesy of the artist.

ABOVE Moriarty in her studio in Upstate New York.
Photo courtesy of Ty Chennault.

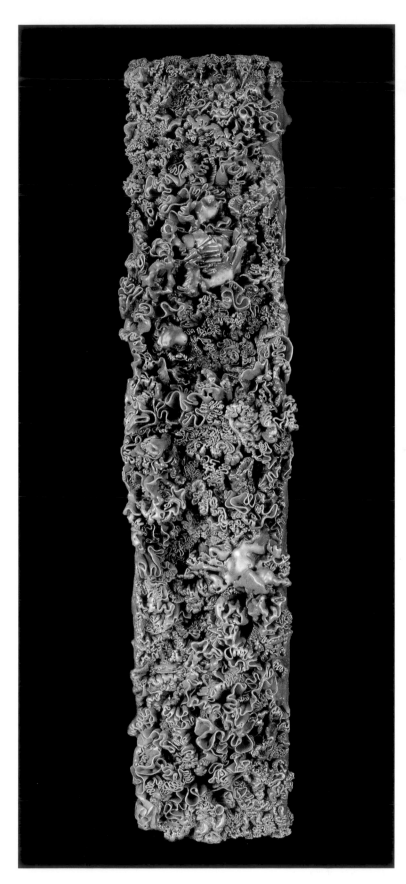

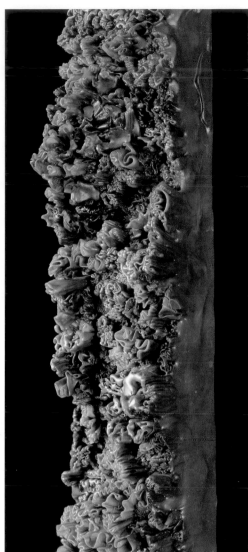

LEFT Natalie Abrams, *No. 25 (Deep Water)*. Wax on panel, 16 x 3 x 3 inches (40.6 x 7.6 x 7.6 cm), 2007.

ABOVE Natalie Abrams, detail of *No. 25 (Deep Water)*.
Photos courtesy of Bob Abrams.

wax in her hand. Through experimentation, she found that by controlling the thickness and temperature of the soft wax, changing the angle and temperature of the paint scraper, and carefully positioning her hands, she could create subtle, ribbon-like strands. She mounts these ribbons of wax to a support and then anchors the elements by pouring wax over the support to embed the ribbons in a wax matrix. Abrams says, "Aesthetically, I've always been very attracted to the visceral impact of texture. Awareness becomes a tangible event through touch. There is something tactile in the nature of art, where the reality of the piece is conveyed through its texture. The *Ribbon Paintings,* such as *No. 25 (Deep Water),* particularly appeal to those very basic attractions. I find working in encaustic to be very much like almost anything in life. If you have an experimental nature and are open to all the subtle and varying possibilities presented, it teaches you how flexible

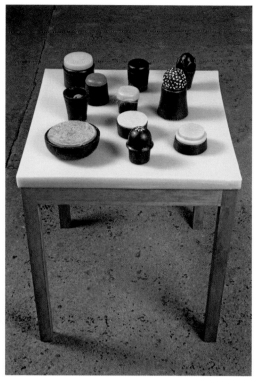

ABOVE Michelle Stuart, *Seed Containers #1.* Encaustic, sculpted beeswax containers, seeds, sculpted beeswax table top on pine structure, 37 x 25 x 26 inches (94 x 63.5 x 66 cm), 1993.
Photo courtesy of Karen Bell.

LEFT Andrea Schwartz-Feit, *Mother and Child,* from *Some of the Missing.* Beeswax, damar resin, and pigment, 7½ x 7 x7 inches (19.1 x 17.8 x 17.8 cm), 2001–2002.
Collection of Katherine Feit. Photo courtesy of Bill Bachhuber.

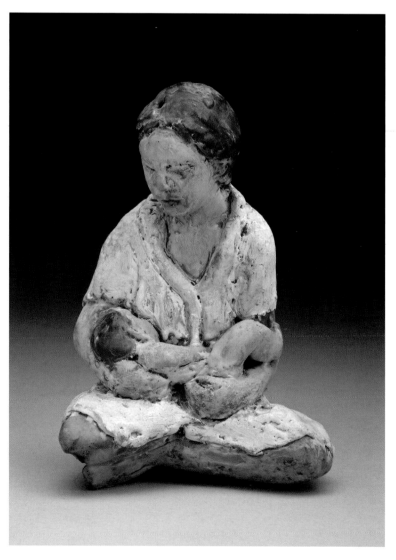

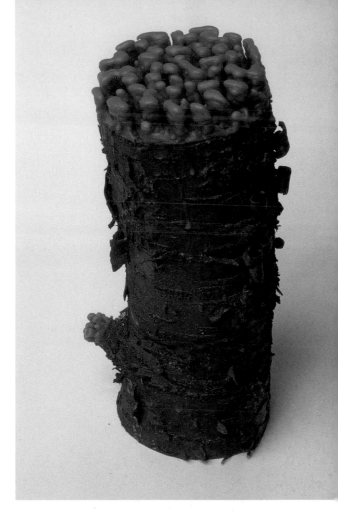

this medium is and how extensively it can be manipulated. As long as the wax isn't ruined (any maybe even if it is), if the experiment doesn't work, one can just scrape it up, melt it down, and use it again."

Andrea Schwartz-Feit shapes and carves freestanding sculptures from pigmented beeswax mixed with damar resin. Of her piece *Mother and Child,* from the series *Some of the Missing,* Schwartz-Feit says, "I began making this series in response to the events at the World Trade Center and the Pentagon on September 11, 2001. Reports of family members and friends searching for their loved ones grew, while the absence of reports of wounded and dead took on a haunting tone. As I listened to the news, increasingly distressed, my personal memorial took shape. Each figure represents a person from a country that lost a citizen to the terrorist attacks. Now, years later, I continue to add to the memorial. The series provides me with a powerful means to express my love for the human form and the depth of my feelings."

When creating *Seed Containers #1*, Michelle Stuart began by casting wax in molds. She then used dental tools to sculpt the cast-wax pieces, combining them to create the installation.

Taking the process of sculpting wax a step further, Martin Kline creates paintings from sculpture wax, using the accretion technique. In a variation on the lost-wax technique, he then sacrifices these paintings at a foundry—the wax melts away during the casting of the metal—to create unique bronze, stainless steel, copper, and iron sculptures. The stainless-steel sculpture *Wounded Healer* was created by sacrificing a piece similar to *Wounded Tree.*

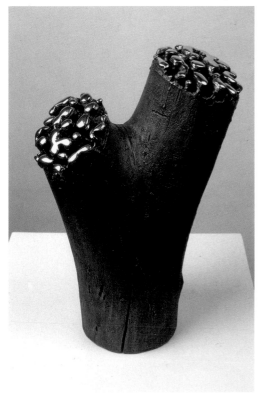

TOP Martin Kline, *Wounded Tree.* Beeswax on cherry stump, 15 inches (38.1 cm) tall, 1999.
Photo by Kevin Noble.

RIGHT Martin Kline, *Wounded Healer.* Unique stainless steel, 16 x 10 x 5½ inches (40.6 x 25.4 x 14 cm), 2000.
Private collection, New York.
Photo by Kevin Noble.

CASTING WAX

You can find or create molds to create wax likenesses. Adele Louise Shaw searches thrift stores for candy-making molds, cake molds, and other objects with cavities she can fill with wax. She attaches the wax objects she casts to her encaustic paintings, as in *(A Little Romance between) Now and Then*. About her work, Shaw says, "Wax tiles cast from soap molds add pattern to an interpreted scene. I enjoy the search for soap, candy, and cake molds around town. The wax tiles are cast and set in the freezer for easy release. They are applied wet-to-wet to the surface of the painting. In paintings with larger or thicker cast pieces I use sticks and dowels fixed into the wood surface for extra stability against fracture and jarring."

To create the bird in *This Sweet Mocking,* Shaw applied a mass of wax to the surface in thin layers, fusing each layer carefully and then carving the completed mass and painting in the details. About this painting, Shaw says, "Linear patterns in the background suggest a correlation between the majesty found in the landscape and that built into architectural structures. The spry attitude of the mockingbird, who makes eye contact with the viewer, goes beyond just engaging in courtesies. It prods one to take a closer look at their world, by reminding us that things happen simultaneously. It's sweet, it's mysterious, it's mocking, all the while it's free."

LEFT Wax casts made with molds in Adele Louise Shaw's studio in San Francisco.
Photo by the author.

ABOVE Adele Louise Shaw, *(A Little Romance between Now and Then)*. Encaustic and mixed media on panel, 36 x 20 inches (91.4 x 50.8 cm), 2006.
Photo courtesy of the artist.

Adele Louise Shaw, *This Sweet Mocking.* Encaustic and mixed media on panel, 24 x 24 inches (61 x 61 cm), 2007. Photo courtesy of the artist.

Impasto Modeling Wax

Impasto modeling wax, which is available from both R&F Handmade Paints and Enkaustikos! Wax Art Supplies, is a good wax to use for casting. Made with beeswax and microcrystalline and developed primarily for sculptural purposes, impasto modeling wax has a higher melting point than encaustic paint, which means it can be painted with encaustic and fused without melting. Because microcrystalline can yellow over time, impasto wax should be painted over or pigmented before casting.

CREATING MOLDS FROM CLAY

You can create your own molds from clay, silicon, plaster, or other materials. For my piece *It Wasn't Me*, I created a wax cast by pushing screws and found objects into clay, using the technique described here:

Lissa Rankin, *It Wasn't Me*. Encaustic, cast wax, encaustic monotype on rice paper, and oil stick on panel, 48 x 36 inches (121.9 x 91.4 cm), 2006.
Courtesy of Lanoue Fine Art. Photo by Matt Klein.

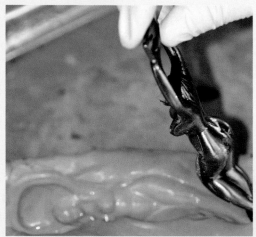

STEP 1 Choose an object whose shape you wish to reproduce. Coat the object with linseed oil to prevent the object from sticking to the clay.

STEP 2 Flatten the clay with your fingertips or by rolling with a rolling pin. White or gray clay works best, as terra-cotta clay can discolor the wax. Press the object firmly into the clay, pushing clay against the edges to make the impression more precise. Remove the object from the clay; the impression will be your mold.

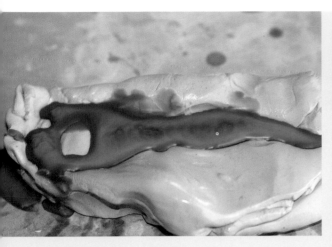

STEP 3 Pour molten wax into the mold. Allow the wax to harden.

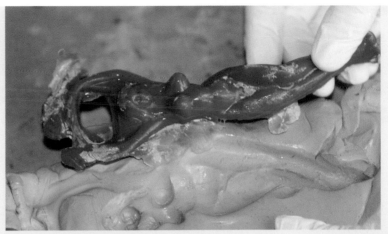

STEP 4 When the wax has hardened but is still warm, remove the clay from around the wax cast. Use a sculpting tool or spatula to clean excess wax from around the edges.

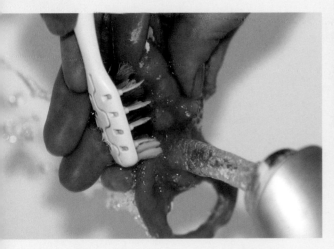

STEP 5 Remove clay residue from the wax sculpture with a toothbrush, using soap and water. Dry thoroughly.

STEP 6 To adhere the wax cast to an encaustic painting, heat the painting's surface until it is very soft. Flatten and heat the back side of cast on your heated palette. Place the cast on the painting's surface and apply pressure, anchoring it in the softened encaustic. Using a small brush, apply encaustic medium around the edges of the sculpture, filling in any gaps. Fuse carefully with a small blowtorch, fusing the medium without melting the wax cast.

Photos by the author.

Upon entering the three-dimensional environment of *Ashes in Arcadia,* we witness a dark and devastated wasteland constructed from earth, rocks, plants, glass, metal, refuse, and ashes—the charred remains of a "paradise lost." Scattered across this ash-covered terrain and amidst the barren branches of a few surviving trees, lie dozens of sand-cast artifacts, fossils, and tools, as well as volumes of books written in languages from around the globe—Arabic, English, French, German, and Italian—that have been entombed in wax and earth. These archaeological relics of knowledge, measures of human wisdom and potential, are now victims of humanity's irresponsibility to life on this planet.

Susan Stoops, catalog essay for *Michelle Stuart: Ashes in Arcadia.* Waltham, Mass.: Rose Art Museum, Brandeis University, 1988

Wax and Installation Art

When wax is used in installation art, it is usually just one of many materials used to create a mood and establish a sense of place. Because it collaborates well with other media, it serves as an ideal unifier. Michelle Stuart's use of wax demonstrates this most effectively. In 1988, Stuart created *Ashes in Arcadia* for the Rose Art Museum at Brandeis University in Waltham, Massachusetts, as an expression of her distress about the nation's irresponsible treatment of the natural environment.

The installation's three enclosing walls, each measuring 11 feet high and 27 feet wide, were lined with modular units of encrusted refuse embedded in encaustic on muslin-mounted rag paper. The walls' texture was tactile, and their appearance evoked the all-over approach of abstract painting.

Michelle Stuart, *Ashes in Arcadia*. Mixed-media installation, 10 x 24 x 26 feet (3 x 7.3 x 18.6 m), 1988. Wall paintings: rocks, earth, shells, plants, ashes, glass, metal, rubbish, and encaustic on muslin-mounted rag paper; floor: sand-cast Hydrocal and Structo-Lite, branches, books, beeswax, sandpaper, reflector lights, Black Beauty slag, and ashes; audio: *Songs of the Humpback Whale.* Commissioned by the Rose Art Museum at Brandeis University, Waltham, Mass., with funds from the New Works Program of the Massachusetts Council on the Arts and Humanities. Photo by Michael Peirce.

In the show's catalog, Stuart herself wrote *Ashes in Arcadia*,

Nothing left but the call of the whale
All silent
With our knowledge we let
the planet die
Instead of seeds
we planted ashes in Arcadia

Christel Dillbohner creates elaborate installations of pigmented and waxed paper cones, suspended from above by fine filaments. Creating a visual pool that invites meditative contemplation, Dillbohner's installations conjure images of landscape, lily ponds, and dark pools and invite the viewer to share in the inner landscape expressed by the artist. To create her installations, Dillbohner dips paper cones into a suspension of water, oil, and pigment. After they dry, she dips them into molten beeswax, which provides structure and support, before suspending them in arrangements she calls "pools." *The Green Pool (Extended),* installed at the Monterey Museum of Art, Monterey, California, in the fall of 2007, could be viewed from the floor or from above, where the subtle movements of each cone could be truly appreciated.

To create *Wax Sedimentations,* Dillbohner punched holes in sheets of heavy mulberry paper before coating the paper with beeswax and mounting each sheet to a thin bamboo stick. The sticks were hung on a 12-foot-long bamboo rod, which was suspended from the ceiling. Floating lights in between the hanging sheets warmed the wax and filled the installation space with the smell of honey.

To create *Hypnagogia Scrolls,* an installation exhibited at Monterey Peninsula College Art Gallery in April 2009, Tracey Adams used an encaustic monotype technique inspired by her work with Paula Roland. She dipped rolls of paper on a HotBox on which she had applied encaustic medium and paint; mixed-media tools were used to create the linework and shapes on the scrolls. About the work, Adams says, "The process of working on scrolls parallels my own personal challenges to live in the present without focusing too much on the past or future. By working in sections as wide as my arms will reach, then rolling the paper up and not going back to look at what I've done until much later, I am immersed in the moment, working from present impulse without a lot of thought about what went before and what will come after."

Robin Hill incorporates wax (among many other materials) into her art, primarily by using encaustic medium as a binder or a coating. When I interviewed Hill, an art professor at the University of California

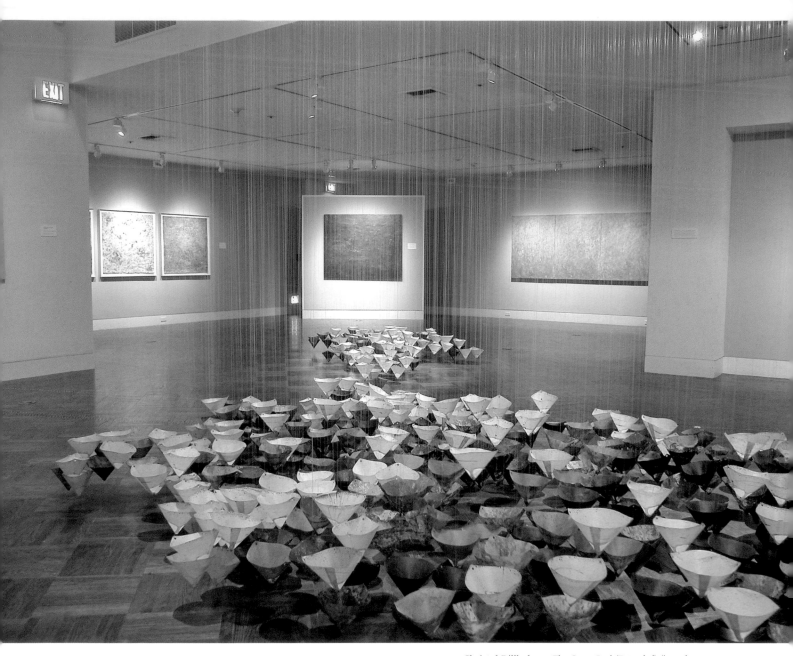

Christel Dillbohner, *The Green Pool (Extended)* (installation view). 550 pigmented and waxed paper cones, each 5 x 5 inches (12.7 x 12.7 cm), individually suspended by filament from the ceiling, overall dimension 12 x 18 feet (3.7 x 5.5 m), Monterey Museum of Art, Monterey, Calif., 2007.
Photo courtesy of the artist.

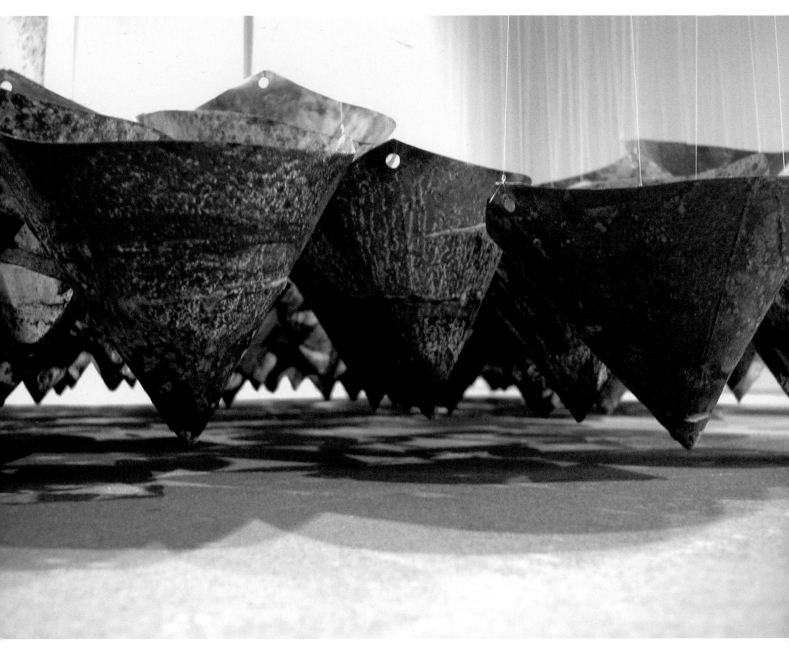

Christel Dillbohner , *The Green Pool*. 365 pigmented and waxed paper cones, each 5 x 5 inches (12.7 x 12.7 cm), individually suspended by filament from the ceiling, overall dimension 9 x 12 feet (2.7 x 3.7 m), Stewart Gallery, Boise, Idaho, 2005.
Photo courtesy of the artist.

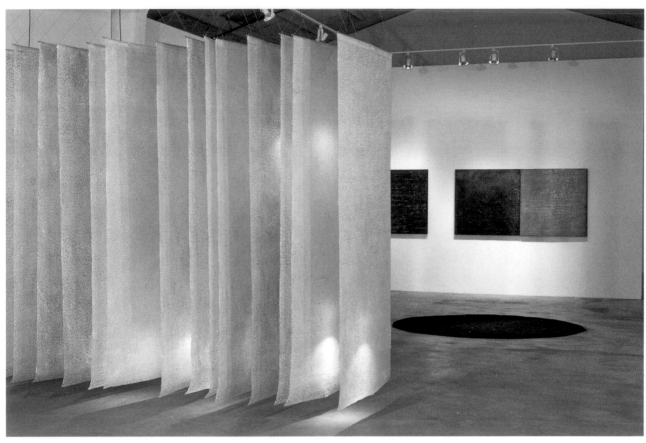

TOP Christel Dillbohner, *Wax Sedimentations* (part of the installation *About Sippwells and Other Places*). Eighteen sheets of perforated, waxed mulberry paper suspended from the ceiling, four hanging lights, 10 x 8 x 3 feet (3 x 2.4 x 0.9 m), Ellen Kim Murphy Gallery, Santa Monica, Calif., 2000.
Photo courtesy of the artist.

LEFT Tracey Adams, *Hypnagogia Scrolls*. Encaustic and pigment monotype on kozo paper, each scroll 16 feet x 18 inches (4.9 m x 45.7 cm), installation at Monterey Peninsula College Art Gallery, 2009.
Photo courtesy of Renee Balducci.

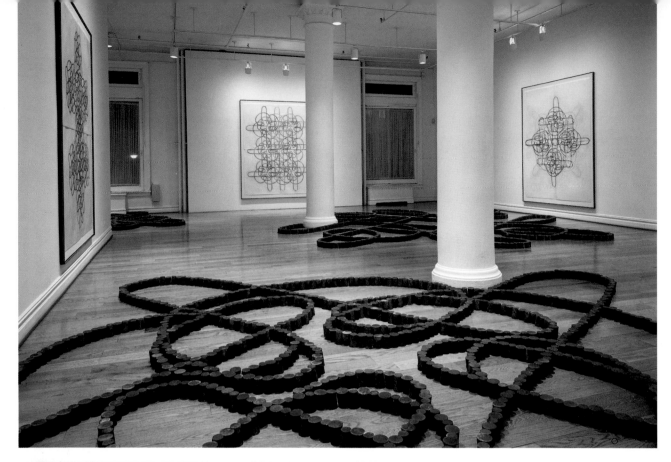

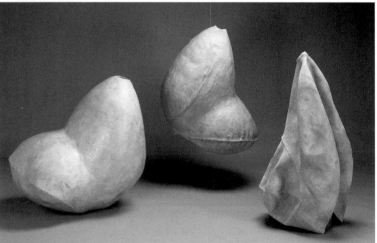

TOP Robin Hill, *Blue Lines* (installation view). Floor: cast plaster with pigment; walls: oil stick on waxed paper, dimensions variable, 1995.
Photo courtesy of Lennon, Weinberg, Inc., and the artist.

LEFT Robin Hill, *Ro Cham Beau*. Wax, mulberry paper, glue, string, and latex rubber, 60 x 60 x 60 inches (152.4 x 152.4 x 152.4 cm), 1991.
Photo courtesy of Lennon, Weinberg, Inc., and the artist.

at Davis, she hesitated to provide specific instructions for working with wax. For her, personally exploring her materials informs her art to such a degree that she worries that "leapfrogging" past that critical step might limit the way an artist works. "But I guess it's kind of a paradox," she said. "If this information had been available when I was a student, I would have probably avoided it. I needed to come to wax, or any material, through my evolving sensibility, not as a technique."

Hill began using wax, resin, and paper in her sculpture and drawing in the early 1980s as a way of investigating translucency in form and to generate a feeling of mutability through materials. About her current work, Hill says, "I try to cultivate an openness to working with what I have or what comes my way. Expansion, rather than reduction,

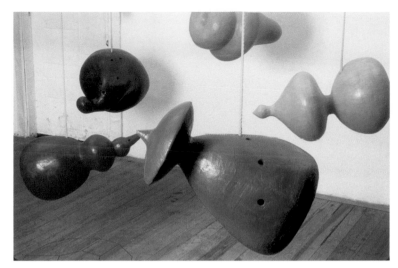

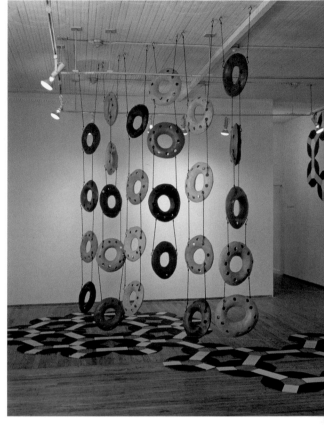

is the outcome, physically and perceptually. Physically, I am trying to transform little things into bigger things, shape nuance, and relocate familiar things in an unfamiliar order. I hope to awaken in the viewer a feeling of familiarity and distance, resourcefulness and impracticality, and maybe even inspire a willingness to see a molehill as a mountain, to shift one's perception to embrace small as big, simple as complex, ordinary as elegant, low-end as high-end, easy as difficult, accidental as purposeful, incidental as noteworthy."

Sylvia Netzer is interested in form and surface. Her forms are hand-built clay and brick, and her surfaces are saturated with warm, seductive, colorful encaustic. About her work, Netzer says, "Encaustic is the right material for me to use because of its color, texture, luminosity, and soft, skinlike surface."

Netzer says, "The sculptures in *Baby Barry Family* are part of a larger installation called *Miasma Morph,* which references early evolution and primitive forms. Dangling from the ceiling, the sculptures interact as they twist and turn, suggesting relationships between forms that I consider both male and female, floating in an atmosphere that is the primal ooze. They are meant to be walked through and experienced."

"*Torus-Lifesaver,*" Netzer says, "is part of a large installation that was commenting on museums, in this case a science and art museum. My closest friend was dying of breast/brain cancer, and the sculpture was a hypothetical safety net to fight cancer. The piece *Glen Gery Olympia* was inspired by Manet's painting *Olympia*. As an art student, I learned that the subject was a courtesan, daring the viewer to question her power. Impressed by the subject's radically independent and powerful demeanor, I challenged myself to create *Glen Gery Olympia* from encaustic and carved brick. I used encaustic on the surface to create a visual tension between the hard, rigid brick and the soft, vulnerable surface of the wax."

Using her signature technique of coating fabric with wax, Lorrie Fredette created a site-specific installation for her solo show at The Gallery at R&F Handmade Paints in Kingston, New York. To sculpt this

TOP LEFT Sylvia Netzer, *Miasma Morph: Baby Barry Family* (detail). Stoneware clay, encaustic, and rope, dimensions variable, 1996.
Photo courtesy of David Lubarsky.

ABOVE Sylvia Netzer, *The Miasma Morph Museum: Torus-Lifesaver.* Mixed media, clay, and encaustic, 11½ x 8 x 2 feet (350.5 x 243.8 x 61 cm), 1999.
Photo courtesy of David Lubarsky.

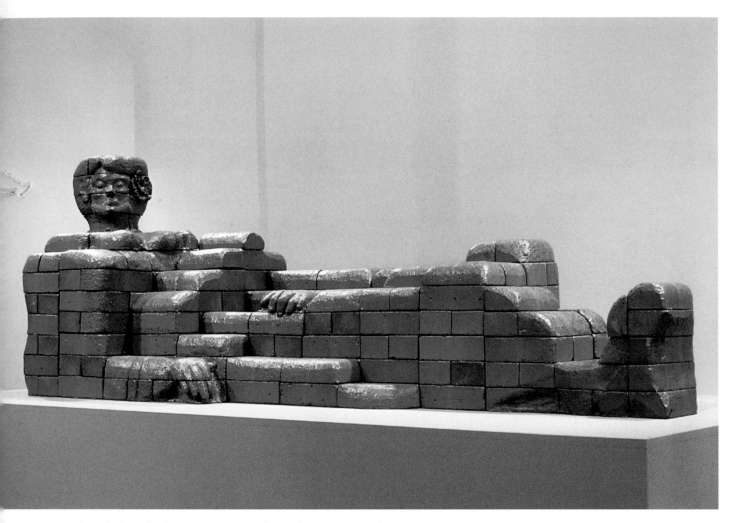

Sylvia Netzer, *Glen Gery Olympia*. Carved brick and encaustic, 31 x 83 x 29 inches (78.7 x 210.8 x 73.7 cm), 2004.
Photo courtesy of David Lubarsky.

installation, Fredette made twenty-five differently shaped wooden patterns. Using these patterns, she created up to fifteen wire armatures for each of the shapes, for a total of 330 elements. She hung these elements at varying heights from a custom-made grid suspended from the gallery ceiling.

About Fredette's work, gallery director Laura Moriarty says, "Lorrie Fredette's delicate new suspended installation sprang from an unlikely source for artistic inspiration—an outbreak of poison ivy. Two years ago, the artist used her own skin as a site for intense study—drawing, photographing, and further manipulating images of her rash digitally and storing these images on her computer. Through further research, her databank expanded to include a voyeuristic collection of images of other people's rashes, as well as encompassing current environmental and political issues related to climate change (because it turns out that poison ivy thrives and becomes more potent with an increase in carbon dioxide). At a certain point, Fredette had collected so much information that she had to devise a system for sorting and storing it. She made a purposeful decision to keep this process as random as the dealing of cards, intentionally skewing her data. *A Pattern of Connections* is a chain of-events story that has both evolved and

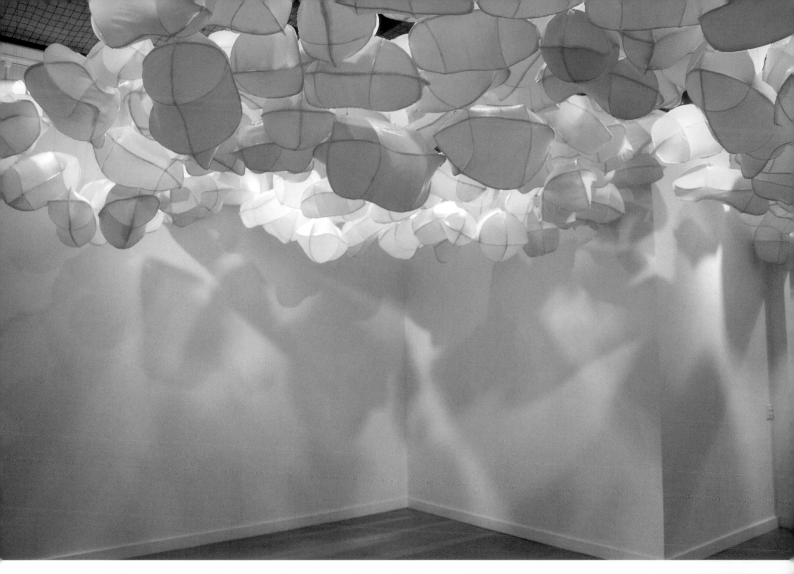

degraded over a long period of time, with each new link containing a new 'misrepresentation.' The finished piece, suspended from the gallery ceiling like an undulating canopy, becomes a demonstration of how information is morphed by the very processes that attempt to collect, store, and represent it."

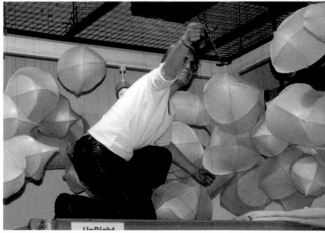

TOP Lorrie Fredette, *A Pattern of Connections* (view of installation at The Gallery at R&F Handmade Paints, Kingston, N.Y.). Encaustic, muslin, and brass, 320 square feet (29.7 square meters), 2008.
Photo courtesy of Jeff Rey Drucker.

ABOVE Lorrie Fredette installing *A Pattern of Connections* at The Gallery at R&F Handmade Paints.
Photo courtesy of Danielle Correia and R&F Handmade Paints.

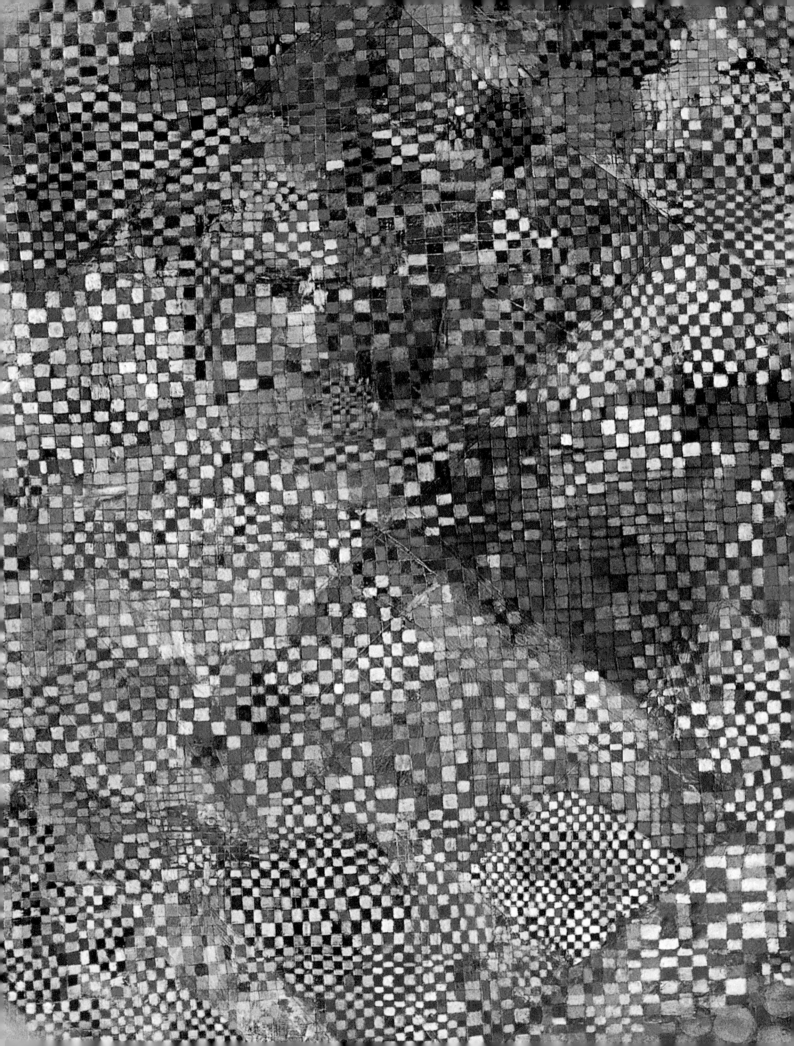

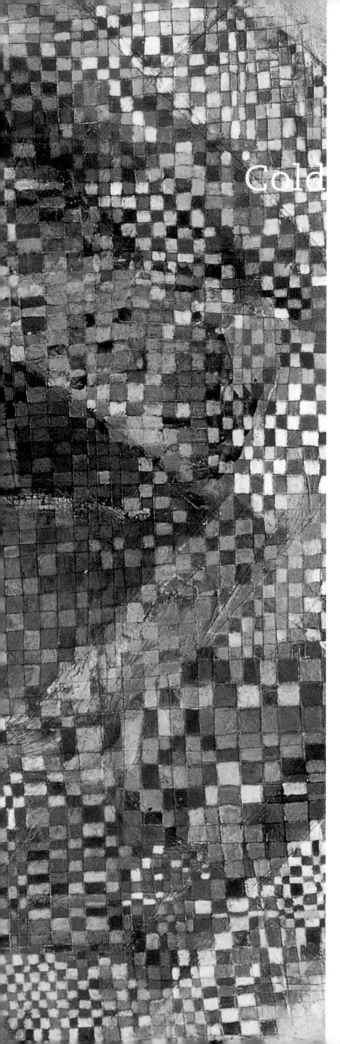

Cold Wax Medium

One of the oldest materials used in art, wax plays a part in the process of many artists whose work is not technically encaustic, since *encaustic* refers to wax that is applied hot and then fused. Some artists mix commercially prepared cold wax mediums with oil paint, giving the paint a waxy finish. When added to oil paints, cold wax medium changes the properties of the paint, making it thicker and more matte; as the ratio of cold wax medium to oil increases, the paint acquires a translucent, waxy quality. Since cold wax medium decreases the flexibility of oil paints, Scott Gellatly, of Gamblin Artists Colors, recommends that painters use this material on rigid rather than flexible supports. This surface can simply be left to dry for a matte finish, or it can be buffed with a soft cloth to achieve a soft luster.

Andrea Schwartz-Feit, *Big Diamond* (detail). Oil and cold wax on wood, 60 x 48 inches (152.4 x 121.9 cm), 2002. Photo courtesy of Bill Bachhuber.

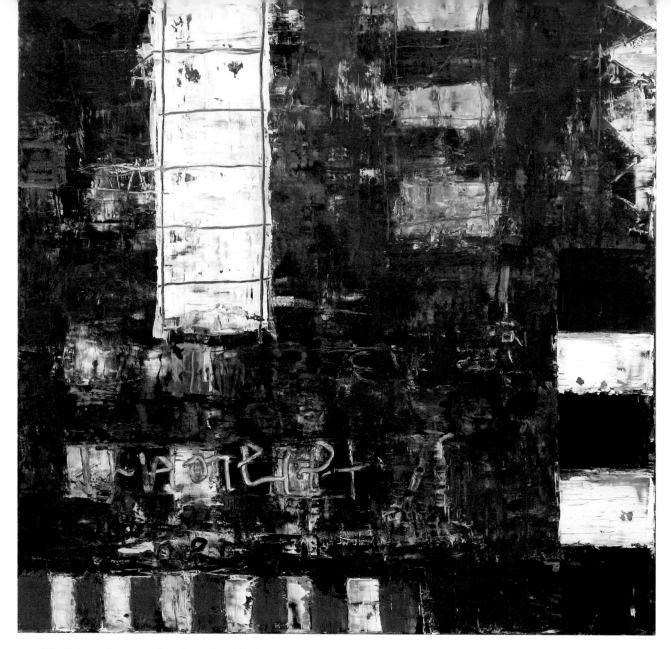

Bill Fisher mixes equal parts of Gamblin's Cold Wax Medium and oil paint and applies the mixture to panel with a putty knife. In the past, he painted with traditional encaustic, but he was drawn to the immediacy of working with cold wax. He describes the mixture as "very forgiving," and he feels less constrained by this process than he did when working with encaustic. Because no fusing is necessary, he does not have to worry about losing the linework and gradations of color he creates, allowing him greater spontaneity. Because the cold wax is mixed with oil paint in such high concentrations, it takes several weeks for his paintings to dry completely—unlike traditional encaustic, which dries almost instantly. Because the paint dries so slowly, applying multiple layers of paint requires patience. Fisher cautions that the cold wax medium does not work as well when added to oil at concentrations higher than 50 percent. About his art, Fisher says, "I paint in a reductivist manner, relying on surface and spatial tensions to convey the content. The imagery in my work is based on childhood memory,

Bill Fisher, *Untitled 6*. Cold wax and oil on panel, 54 x 54 inches (137.2 x 137.2 cm), 2007.
Courtesy of Arden Gallery.

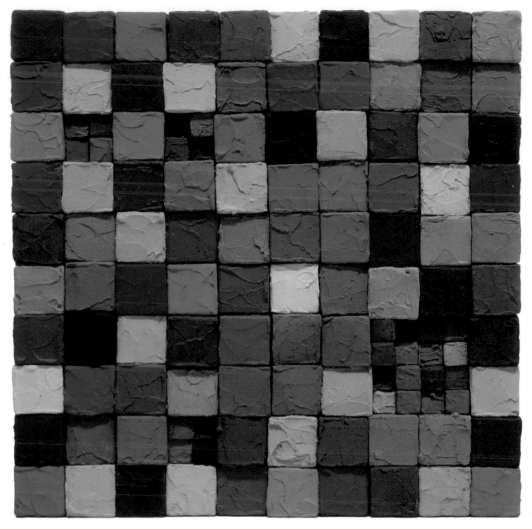

appropriated diagrams, and reflections of the visual realities of urban decay. My work expresses a continuing dynamic of time, experience, and personal perception."

Carlos Estrada-Vega utilizes wax as a primary part of his process, but because he never heats the wax, his medium cannot be called encaustic. Earlier in his career, Estrada-Vega used wax exclusively; later, in an effort to make pigment the primary element in his art, he altered his materials. Feeling that the pigment was always overwhelmed by the wax and preferring the matte finish of cold wax to the polished look of encaustic, he concocted a formula that combines wax, pigment, oleopasto, limestone, and linseed oil. Consisting of about 50 percent wax (in the form of Dorland's Wax Medium), his art showcases what he considers best about wax—its lush materiality, its flexibility, and even its smell. But because he allows the pigment to take center stage, his work radiates color. Estrada-Vega says, "Although I think of each square as a painting in and of itself, each individual painting is not as important to me as the labor of producing a large composition. Color combinations are arranged by intuition, random selection, and personal taste."

Carlos Estrada-Vega, *Liesje*. Oil, pigments, oleopasto, and wax, 10 x 10 inches (25.4 x 25.4 cm), 2004.
Courtesy of Elizabeth Leach Gallery. Photo courtesy of Tony Cuhna.

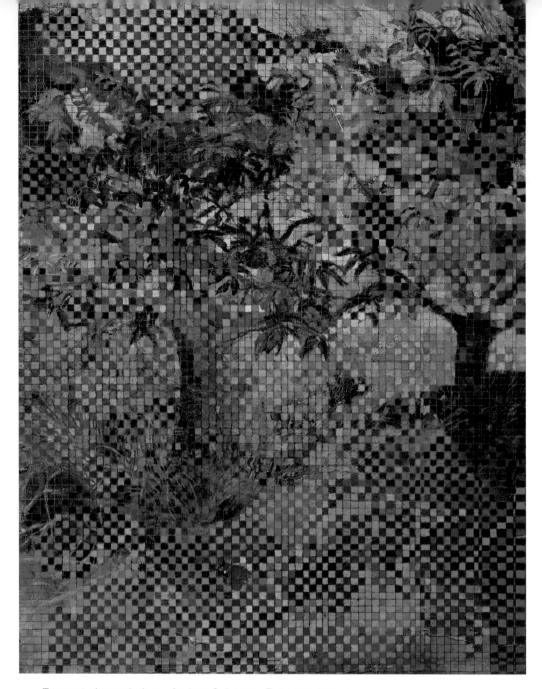

To create her paintings, Andrea Schwartz-Feit uses both en-
caustic and cold wax mixed with oil paint. For some, she prefers the
luminosity of encaustic. For others, she mixes oil paint and Dorland's
Wax Medium in a ratio close to fifty-fifty to achieve a more matte
finish. Schwartz-Feit says, "When working exclusively in encaustic,
the medium itself serves as both teacher and ingredient in the act of
painting. One of the pleasures of working solely with encaustic is that
the process itself becomes a determining factor of the work. Perhaps
due to its organic nature, the wax, in its application, has a life of its
own. Its versatility and movement within the process are part of the
feedback loop and can function as both material and subject in the
painting. Painting with oil and cold wax, however, allows me to act
more singly within the painting process. The material serves me, more
than the artist and material being joint-creators. So there are times

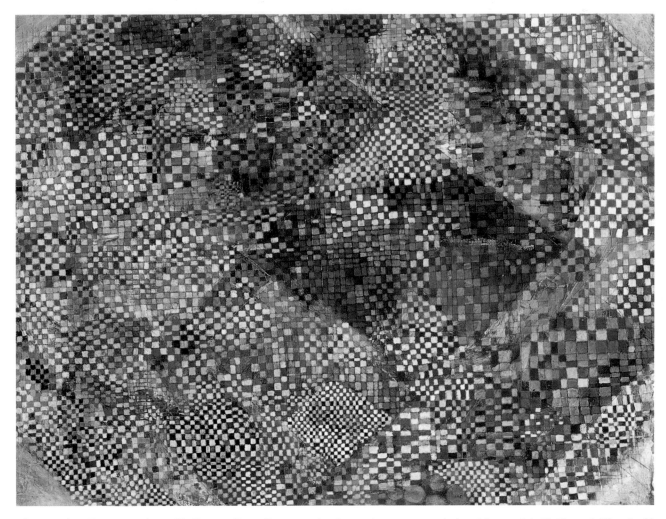

when, rather than engaging with the medium, it seems simpler and more direct to act as a painter alone."

About the two works reproduced here, Schwartz-Feit says, "My artistic practice over the past decade has been guided by the abiding sense that place, the Columbia River Gorge and some others, has affected me deeply in my travels, meditations, and spiritual geography. A Zen master once said, 'Moment to moment, the universe is your teacher.' The Columbia River Gorge, with its wildness, beauty, and profusion, provides a rich visual landscape from which to learn. *Big Diamond* echoes aspects of my visual milieu and the cycles of life as they manifest in this extraordinary place, where the land teaches its own lessons. *Garden (Under Construction)* is the pivotal painting in a new series of work based on the biblical story of Genesis. In this painting, one sees the Garden of Eden as it is being created, with the two named trees, the Tree of Knowledge of Good and Evil in the foreground with the Tree of Life (Immortality) set back slightly. And an angel watches and guards the area. My process is time-consuming, and I use it as a meditation."

ABOVE Andrea Schwartz-Feit, *Big Diamond*. Oil and cold wax on wood, 60 x 48 inches (152.4 x 121.9 cm), 2002. Photo courtesy of Bill Bachhuber.

OPPOSITE Andrea Schwartz-Feit, *Garden (Under Construction)*. Oil and cold wax on wood, 48 x 36 inches (121.9 x 91.4 cm), 2007.
Collection of Nancy and Frank Brenner. Photo courtesy of Bill Bachhuber.

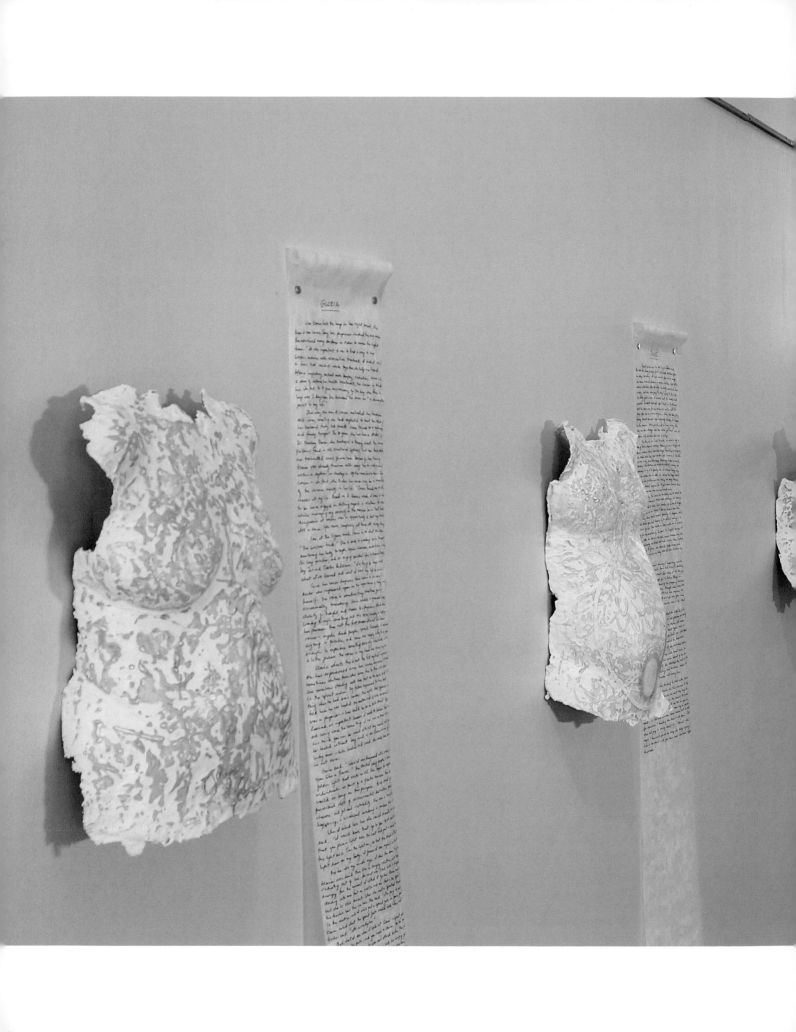

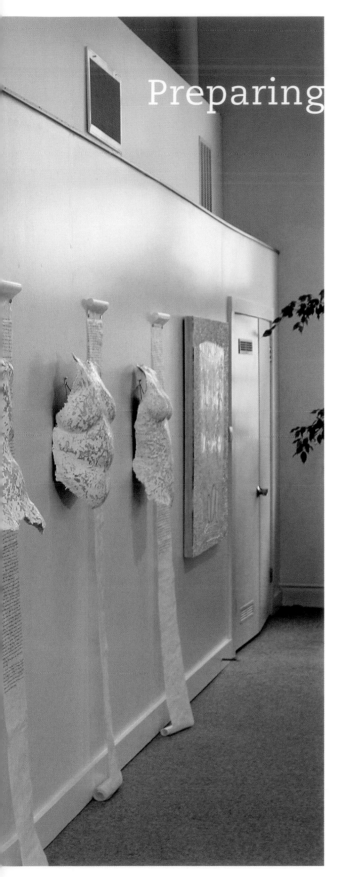

Preparing Encaustic Art
FOR DISPLAY AND EXHIBITION

After the wax cures, then what? Unlike art created with other media, encaustic art does not need to be varnished, and it often does not need to be framed. It dries almost instantly, and, unlike an oil painting, an encaustic painting could be sent to a gallery the day after being painted.

While encaustic art dries instantly and offers unmatched luminosity, exhibiting it carries some unique challenges: A gallery might want to display your work near blazing hot windows in direct sunlight on a summer day in the desert. Or viewers may find touching your work to be an irresistible temptation. This chapter aims to help you communicate with art dealers and museum curators about how to bring your art out into the world.

Lissa Rankin, *The Woman Inside Project*. Sculptures: Encaustic, plaster bandages, fiberglass resin. Scrolls: Ink on kozo paper, encaustic monotype. Installation view of "She Lives" exhibition at Commonweal, in Bolinas, Calif., January 2010. Photo by Matt Klein.

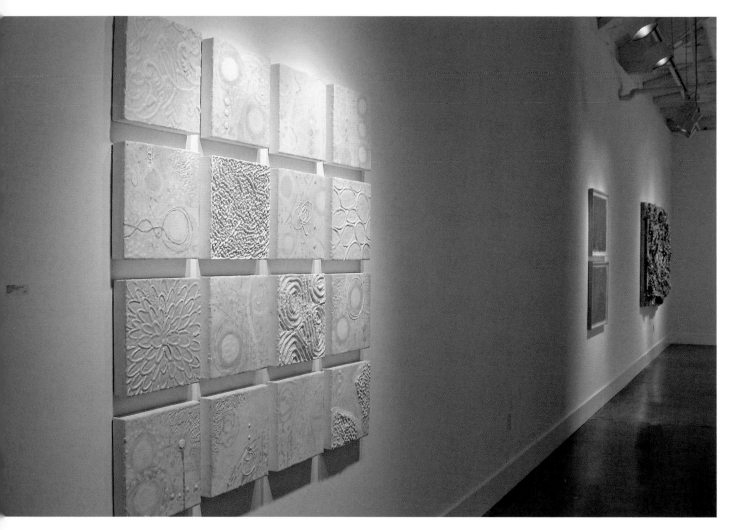

It is nevertheless important to understand that encaustic art does change over time, as the wax hardens and becomes more translucent. Getting encaustic art ready for exhibition can pose a few challenges. Out in the world, the art is subjected to stresses it might never encounter in the studio. Unpredictable shippers and extremes of temperature conspire to damage the art. Nearly every artist I interviewed had a horror story to tell: art that chipped when it fell off a wall, art that cracked when shipped in the depths of winter, art that melted when left in the back seat of a car in midsummer, art that lost chunks of wax from its edges when dealers pulled the art out of gallery racks.

When properly hung on a wall, encaustic art encounters few dangers, but art in transit and in storage faces many risks. With proper care, however, encaustic art can enjoy distribution as wide as art created with any other medium. Many of the artists in this book demonstrate this, exhibiting internationally with few mishaps.

Lissa Rankin, *The Big Chill* (installation view at Bill Lowe Gallery). Encaustic and oil stick on sixteen 12 x 12–inch (30.5 x 30.5 cm) panels, 2007.
Courtesy of Bill Lowe Gallery.

FINISHING EDGES

For those who paint on wood panel, finishing the edges of a panel requires some decision-making and problem solving. Should you leave the inevitable wax drips in place or clean them away? Should you paint the edges? Should you provide galleries with a system for protecting the edges? There is no right answer, but artists resolve these issues in a variety of ways.

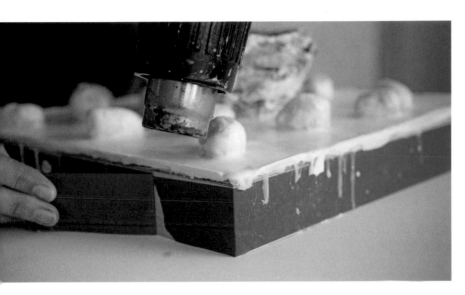

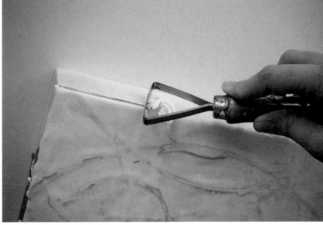

LEFT Using blue painter's tape to prevent wax drips over the panel edge.

ABOVE Using a clay loop tool to scrape the deckled edge of an encaustic painting.
Photos by Monique Feil.

DRIPS OR NO DRIPS?

It's almost inevitable that drips of wax will spill over the edge of a panel when you paint in encaustic. As the artist, you have a choice about whether you wish to prevent this from happening, leave the drips in place, or get rid of them after finishing the work. Some artists and dealers I interviewed love the natural dripped edge, appreciating its painterly quality. But such edges can create problems, as the drips can chip off if the work is not properly handled—sometimes pulling a piece of the painting's surface off, too. If you want to prevent dripped edges, cover the edges of the panel with blue painter's tape before you begin painting. When the painting is complete, use the heat gun to soften the wax on the edges and carefully remove the tape, leaving a clean edge that aligns with the edge of the panel. If you've already painted without the tape, you can use a heat gun to melt the drips along the edges, wiping the edge clean with paper towels.

Another way of creating a smooth edge is to remove the drips with a heat gun and then, while the edge is still warm, use a clay loop tool or other scraping tool to scrape the drippy, deckled edges of the panel, removing excess wax.

WOOD PANEL EDGES

Leaving the natural wood of the panel edge exposed works well and is simple to achieve. If you have used blue painter's tape to protect the panel edges, a clean wood edge remains after the tape is removed. If you use high-quality wood for your pane's cradled edges, this finish appears very professional and requires little or no additional work. If the edges do get stained with pigment, sand them to clean them up.

Rodney Thompson prefers to pretreat his panel edges with wax before he begins to paint. When he removes the drips at the end of the process, the wax coating prevents the pigment in the paint from staining the wood edge.

Whether to leave the clean wood edges unfinished or to stain or varnish them is another question. Of course, this is also your choice, but many of the dealers I've spoken with prefer a natural wood edge over other options.

LEFT Side view of wax-prepped cradled panel. Rodney Thompson, *Two Theories Regarding the Nature of Time, #2 (Red)*. Encaustic, paper, and pastel on panel, 22 x 22 inches (55.9 x 55.9 cm), 2007.

RIGHT View of wax-prepped recessed panel in box-jointed beechwood frame. Rodney Thompson, *T&C #10*. Encaustic, tea-bag paper, and coffee, 14⅝ x 10⅝ inches (37.1 x 27 cm), 2006.

Photos courtesy of Rodney Thompson.

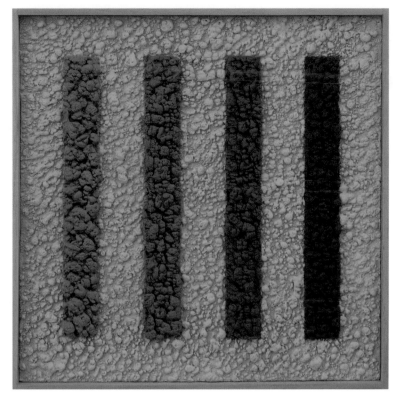

WOOD-FRAMED EDGES

For both his panel business and his personal art, Rodney Thompson sometimes builds recessed panels with built-in frames. Thompson preps the panel with clear medium and paints on the recessed face of the panel. When his painting is complete, he cleans the frame back to the waxed wood and is left with a frame that both finishes the piece and protects the edges.

Because a recessed panel would have prevented him from using the accretion technique employed in *Wild at Heart,* Matt Klein created a wooden frame using pine base molding (usually used for floor base-boards) to protect the fragile edges of the piece. I myself use this sort of system to protect the edges of my large paintings, thereby avoiding the chipped edges that can occur when gallery workers slide the piec-es in and out of racks. A collector who buys one of these works may keep the frame in place or remove it once it has been safely installed.

ENCAUSTIC-PAINTED EDGES

Using encaustic to paint the edges of a panel gives the painting a very sculptural, three-dimensional effect that many collectors prize. Edges must be well fused to avoid chipping. Because encaustic edges are particularly susceptible to damage, you need to provide galleries with a means of protection for any painting with an encaustic-painted edge. (Dealers often rest paintings in racks or on the floor, and edges may be damaged if the painting is not protected.) For my smaller paintings, I

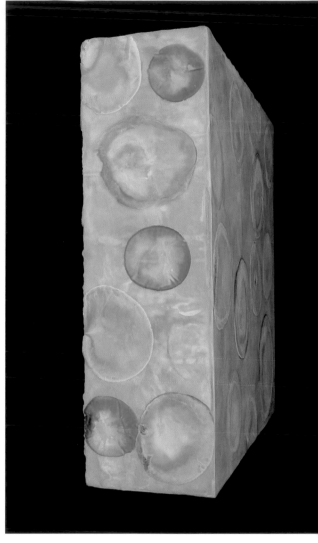

TOP LEFT Matt Klein, *Wild at Heart.* Encaustic on panel with pine frame, 16 x 16 inches (40.6 x 40.6 cm), 2007. Photo courtesy of the artist.

ABOVE Side view of wax-painted panel edge. Cari Hernandez, *Oh . . . Luscious.* Beeswax, damar resin, and pigment, 24 x 24 x 6 inches (61 x 61 x 15.2 cm), 2007. Photo courtesy of the artist.

paint the edges with wax and provide dealers with foam envelopes in which they can be stored when not hanging on the wall.

ENCAUSTIC RIM ON WOOD EDGES

If you want the painting to give the impression of having a wax-painted edge without painting the entire edge, you can mask the edges in blue painter's tape before beginning to paint, leaving a thin rim of wood showing above the tape. When the painting is completed and before the tape is removed, paint the edge and fuse, removing the tape while the wax is still warm. When the tape is removed, a clean line remains around the painting's edge, although the majority of the wood is left unfinished and is thus less susceptible to damage.

PAINTED OR STAINED EDGES

Of course, you can always finish your edges the old-fashioned way, with primer coats followed by paint, wood stain, or varnish. For the larger paintings in my *Plainsong* series, which are mostly white, I prefer to paint the edges white with an oil-based primer and a top coat of white paint, so that the edges blend seamlessly with the painting but are less fragile than wax-painted edges would be.

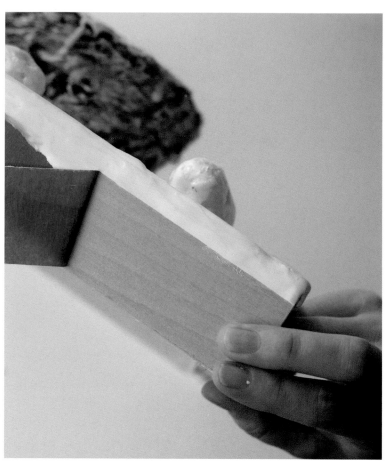

Encaustic rim on wood panel edge.
Photo by Monique Feil.

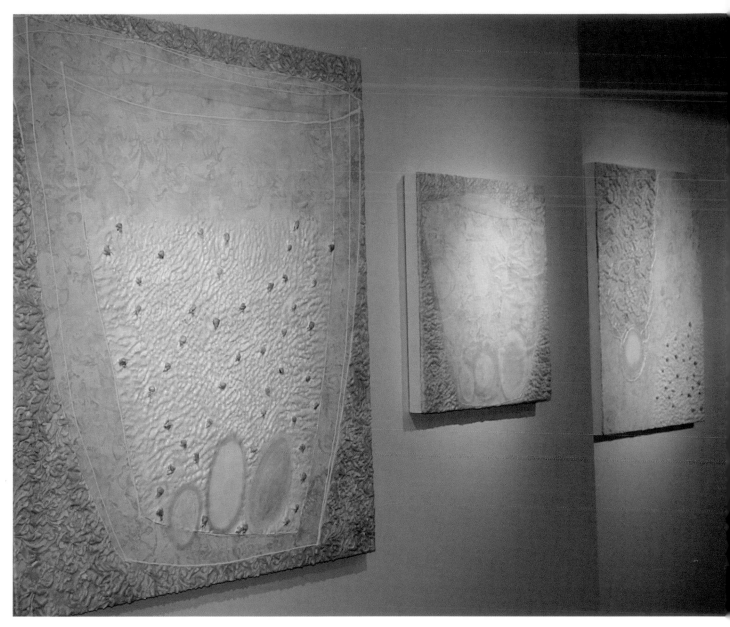

Wood edges painted with an oil-based primer paint.
Installation view of Lissa Rankin, *Here Today, The Shape
of Things to Come,* and *The End of the Affair* at Lanoue
Fine Art, Boston.
Photo courtesy of Lanoue Fine Art.

SAFE HANDLING OF ENCAUSTIC PAINTINGS

After you have finished the edges and prepared the art for hanging or display, it is time to send it out into the world. Many shy away from shipping encaustic art, for understandable reasons. Encaustic art, particularly if shipped in extreme temperatures, can chip, crack, flake, soften, or melt. For years, my husband dutifully loaded up the back of our SUV with my paintings, driving hundreds of miles to deliver them to galleries as far from our California home as Santa Fe, New Mexico. But now that I show in galleries on the East Coast, I have had to overcome my reluctance to use professional shipping services.

PACKING AND CRATING

Rodney Thompson makes his own storage boxes for his artworks, using heavy corrugated cardboard lined with upholstery foam to cushion the art, which fits snugly into the foam lining. On the lid, he places another piece of foam, covering it with silicon release paper to prevent the foam from sticking to the wax surface. The lid is secured with Velcro or webbing straps. These boxes fit inside wooden crates, protecting paintings during shipping and providing the dealer with a safe way to store paintings at the gallery.

Miles Conrad, who is both an artist and the co-owner of Conrad Wilde Gallery in Tucson, Arizona, carefully packs and ships his own work but has also been on the receiving end, having improperly packed or shipped paintings delivered to his gallery. Conrad recommends a box-within-box/crate system to minimize damage. To ensure that nothing touches the surface of the art, surround the painting with foamcore side strips that rise at least ¼ inch higher than the surface of the art. Then attach end pieces of foamcore to the top and bottom of the box to protect the art inside the inner box formed by the

LEFT One of Rodney Thompson's storage boxes (shown containing Thompson's *Ryokan #11*, encaustic, paper, comb wax, and maple leaves, 8 x 6 inches [20.3 x 15.2 cm], 2006).
Photo courtesy of Rodney Thompson.

ABOVE Paintings in foam pouches stacked in Lissa Rankin's studio in Monterey, Calif.
Photo by Monique Feil.

foamcore. Wrap the inner box in bubble wrap, then place it inside an outer box fitted with thick foam rubber. Try to keep the painting vertical while packing, which helps prevent damage by evenly distributing any shock. The inner box should not jiggle within the outer box. If the art is lightweight, a corrugated cardboard box usually suffices as the outer box. If it is heavy or traveling far, a plywood crate offers more protection. You can hire shipping or crating companies to pack and crate the art for you, but you will pay a lot for this service.

For small paintings, you can use corrugated slot-and-tab pizza boxes for shipping. Pad the inside of the lid with small-bubble bubble wrap and line the interior of the box with glassine to protect the work. By affixing a photograph of the painting to the exterior, you'll make it easier for your dealer to sort through the boxes. When sending the boxes, wrap each one in two separate layers of bubble wrap and place up to four boxes in a larger box for shipping. The exterior bubble wrap protects the works in transit, while the small pizza boxes keep the works safe in storage.

For larger paintings, professional art handlers recommend meticulously crating the art to protect it from multiple factors that conspire to damage the art in shipping. Although you can label the crates with "Fragile" stickers, don't trust shippers to pay attention to this warning.

When crating a painting, first place the painting in a slipcase made from corrugated cardboard and padded inside with small-bubble bubble wrap and lined with glassine. Secure the painting inside with a strip of masking tape, and then wrap the slipcase in another layer of bubble wrap and insert it into a bubble wrap–lined wooden crate, packed with layers of flat foam insulation.

By the way, don't expect your dealers to hang onto the crates, boxes, or shipping frames for you. Their storage space is limited. While they may appreciate a neatly labeled protective storage box, the outer crates and boxes will end up in the dumpster (or will be recycled by enterprising artists who search through gallery dumpsters, as reportedly happens in New York City's Chelsea district).

SHIPPING ART

Some artists are lucky. When Betsy Eby finishes her paintings, the dealers who represent her send art handlers to her studio to load her paintings onto a temperature-controlled truck that safely delivers her work to the galleries. While this method is expensive for the gallery, it allows Eby to focus on what she does best—paint.

But you will probably have to arrange for shipping yourself. After you have carefully packed the art for shipping, crating it yourself or

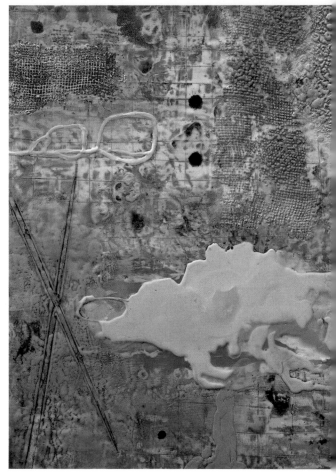

TOP Stack of storage boxes in Rodney Thompson's studio in Redding, Calif.
Photo courtesy of Rodney Thompson.

ABOVE Lissa Rankin, *The Perfect Storm*. Encaustic and oil stick on panel, 48 x 36 inches (122 x 91.5 cm), 2007.
Photo by Matt Klein.

using a crating service, you'll need to choose a shipping service. This involves making a few decisions. Several of the artists I interviewed try to avoid shipping their art during the middle of summer or winter. While heat might seem like the biggest enemy of encaustic, cold can cause damage that's even more severe. Although encaustic doesn't melt until the temperature is approximately 160°F (71°C), the back of a truck can get that hot in the middle of summer, and the art can be damaged, especially if something directly touches its surface. But the hair-raising disaster stories I've heard from artists and dealers more often resulted from freezing temperatures, which can cause craterlike cracks across the surface of a painting or cause it to separate from its support.

If you can avoid subjecting your art to these extremes of temperature, you will buy yourself a little security. That said, gallery schedules force most artists to ship in extreme temperatures from time to time. The insulated packing described above helps, and shipping your art with a company that uses temperature-controlled vehicles is ideal. Unfortunately, most shipping companies do not provide affordable temperature control. Sometimes you are at the shipper's mercy, so the less time your art spends in transit, the safer it will be. When I send my art via freight companies, I ship on Mondays because I prefer to leave extra time before the weekend, just in case the delivery is delayed for some reason. This way, the art is less likely to end up in the back of a shipping truck sitting on the hot pavement or gathering icicles in a parking lot over the weekend. If you must ship during extreme temperatures, it helps to allow the crate to acclimate slowly to the new environment. When the crate gets delivered to the gallery, it should be allowed to sit inside for a while before unpacking. This way,

LEFT TO RIGHT Storage box fitted inside a crate built by Rodney Thompson.

Packing materials protecting the box inside the crate.

Packed crate, ready for shipping.
Photos courtesy of Rodney Thompson.

Loading Lissa Rankin's paintings for long-distance delivery.
Photo by Matt Klein.

the insulated crate can come to gallery temperature slowly, rather than going immediately from 0 degrees to 80 degrees.

When I ship small pieces, I usually use FedEx, as do many of the artists I interviewed, but alternatives to the big commercial carriers do exist. For large pieces, I use a temperature-controlled independent art handler who traverses the country, picking up art from artists and delivering it to dealers. To prepare my paintings for cross-country travel, my husband fits each painting with a shipping frame, a rudimentary plywood structure that keeps anything from touching the surface when the painting is blanket-wrapped. Paintings can also be prepared for transportation with a temperature-controlled fine art shipper by wrapping each piece in silicon release paper, surrounding it with bubble wrap, and then placing pieces of cardboard between the artworks. Because the art is temperature controlled and carefully handled by the services I use, I don't have to fully crate each piece, which saves me both time and money.

Richard Purdy, who in addition to being an artist also works for a crating company that crates art for the Museum of Modern Art in New York, offers the following advice for shipping encaustic art: "The museum's standard method for packing any painting with sensitive surface issues is to secure the work with oz clips into a T-frame or

Lissa Rankin, *Eden*. Encaustic and gold leaf on panel,
60 x 12 inches (152.4 x 30.5 cm), 2005.
Collection of Dr. Dana Chortkoff. Photo by Matt Klein.

shallow box. Oz clips are folding brass clips that attach to the back of the artwork and remain there permanently to minimize future handling. For shipping, they are folded out and secured to the container with carriage bolts and wing nuts; for display, they fold flush to the back of the artwork. It is necessary to allow a 3-inch perimeter on all four sides. The amount of space over the face of the work should be no less that 1 inch, regardless of what lid materials are used. A safe allowance for possible deflection of the lid needs to be considered. This packing method ensures that there will be no contact with the face or sides of the work. To avoid damage from careless freight handlers, it is worth the extra money to ship with a recognized fine-art carrier. Most of them can be trusted not to allow works to freeze, but as a precaution it should be part of the shipping arrangement that work be climate protected."

Alexandre Masino, who lives in Canada and therefore often has to deal with freezing temperatures, offers this advice: "I would stress that a key element is proper fusing throughout the entire painting process. For me, safe shipping starts in the studio. I have shipped large paintings across Canada and the U.S. and to Europe and have never had any problems when the paintings were properly packed. In extreme temperatures, an art mover is a better choice than freight carriers, especially when shipping several paintings or shipping large paintings. The larger the painting, the more susceptible it is to cold. I heard of an encaustic painter who shipped a whole show to Montreal from Calgary in winter without asking for a heated truck. When they opened the crates, they found bare panels with chunks of wax at the bottom of the crates. Five days of bumpy roads in freezing temperatures without protection is asking for trouble."

Of course, little dings, scratches, or chips can happen even with proper packing, shipping, temperature control, and care. Howard Hersh taught some of his galleries to fix very minor damage with a simple repair technique using a hair dryer. As another option, some artists who are skilled in encaustic have offered reciprocal repair help. Through no fault of her own, a painting of Daniella Woolf's arrived at her Philadelphia gallery slightly damaged. Lorraine Glessner, who lives in Philadelphia, did her the favor of visiting the gallery and offering a simple repair solution. In return, Woolf will offer her services should anything happen to Glessner's art on its way to galleries in Northern California, where Woolf lives.

EDUCATING DEALERS AND CURATORS ABOUT ENCAUSTIC

Although some dealers and curators are very familiar with encaustic, some have little experience with the medium and may appreciate your educating them and helping to allay their concerns. When I begin new relationships with galleries unfamiliar with encaustic, I send them information about encaustic that they can reproduce and hand out to clients. The effort has paid off. After we have addressed their concerns and corrected any misinformation they might have, they are able to pass on this reassurance to their clients.

Sometimes dealers are surprised by the resilience of encaustic art. When I was showing work to dealer Bill Lowe at Bill Lowe Gallery in Santa Monica, California, my toddler daughter stomped all over the art that was laid out on the floor. Brushing off the footprints and noting that there was no damage, he said, "Well, at least we know they're durable."

Tracey Adams's paintings at Bryant Street Gallery in Palo Alto, Calif. (sculptures by Bill Barrett and Natasha Juelicher).
Photo courtesy of Marti Somers.

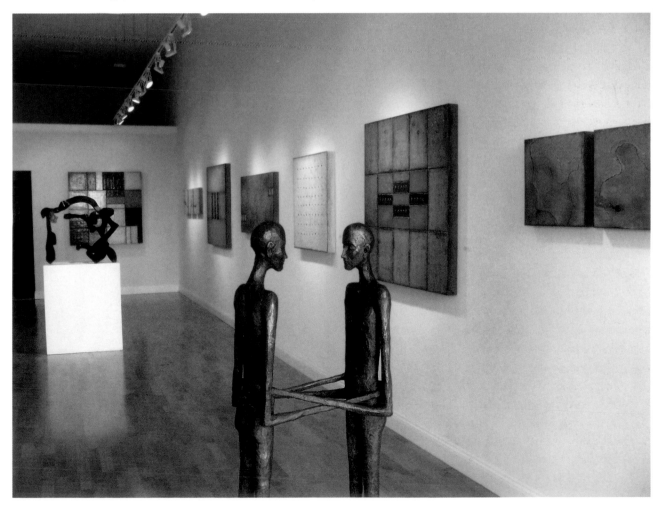

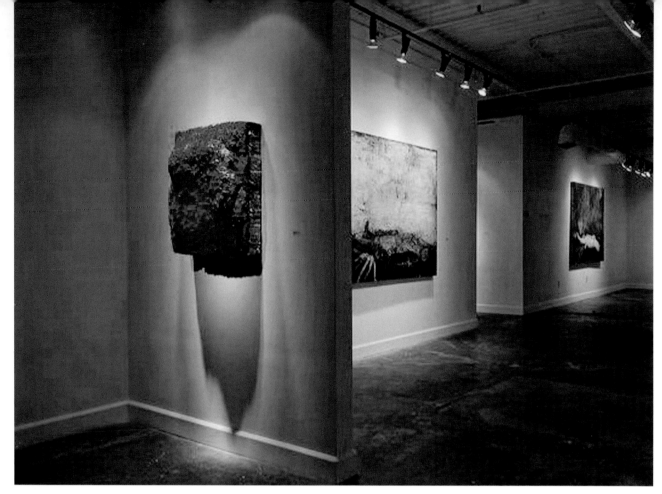

Michael David's paintings at Bill Lowe Gallery.
Photo courtesy of Bill Lowe Gallery.

Stephanie Walker, who served for eight years as the gallery director of Chase Gallery in Boston before starting Walker Contemporary (also in Boston), has enjoyed working with many artists who work with wax. Walker said, "Encaustic seems to be going through a renaissance. Its popularity has surged in the past few years. People are coming into the gallery specifically looking for encaustic. It's an exciting time for gallerists because we get to see a whole new group of artists and all kinds of different ways in which the medium is being used. The tactile quality and the wonderful sense of light and atmosphere you get from wax make it very inviting. The hardest thing is that everyone wants to touch it."

About collectors' fears about encaustic's perceived fragility, Walker said, "Occasionally people will ask how the wax stands up in heat or humidity or if it is difficult to ship, but overall I get very few people who are concerned about the medium's durability. When you talk about the history of the medium, how it is one of the oldest techniques and that encaustic paintings still exist from thousands of years ago, any hesitation seems to disappear. When it is time to make decisions about shipping, I tell them that shipping encaustic art is similar to shipping any fine art. Stick with the pros!"

All fine art is fragile to some extent. Oil paint can chip, canvas can puncture, mixed-media elements can fall off, and ceramics can break. Encaustic is no different. No matter which medium you work in, it is always worth making the effort to protect your art.

EPILOGUE: wax on

You've read this book, you've dripped wax on it, your creative juices are flowing, and you're brimming with inspiration. You're dreaming waxy dreams, imagining how to expand your artistic repertoire, conjuring up ways to integrate encaustic into your life, and expanding on your ever-growing knowledge of the medium. Regardless of your background in art, this is an opportunity for you to grow as an artist. Whether you're just getting started with encaustic as your first art medium or you've been painting with encaustic or other materials for decades, what you've learned will change how you look at the world and how you create art. May you take with you the philosophy that made this book possible and share your knowledge with other artists you encounter. Pass on what you learn in your own studio, be generous with your techniques, and pay it forward. As our collective knowledge regarding this exciting medium continues to expand, may we all become its heralds, spreading the word and sharing in the joys encaustic has to offer.

index

about the author

Lissa Rankin is a professional artist, author, and gynecologist. Her nationally recognized abstract encaustic paintings and sculptures are represented by galleries around the United States. Her touring art exhibition The Woman Inside Project, which shines light on the beauty within women with breast cancer, has received international attention.

Dr. Rankin is also the author of *What's Up Down There? Questions You'd Only Ask Your Gynecologist If She Was Your Best Friend* (St. Martin's Press, 2010). She practices holistic women's health in Mill Valley, California, and lives in Marin County with her husband and daughter. An innovator in all forms of healing, she is also the founder of Owning Pink, a community committed to healing the world by holding sacred spaces within which people explore their authentic selves and own all the facets of their wholeness. To join the Owning Pink community, visit www.OwningPink.com. For more about Lissa Rankin, her art, her medical practice, and her books, visit www.LissaRankin.com.

To help you grow in your love and understanding of encaustic art, Lissa Rankin has compiled a website that shares resources, encaustic how-to tips, photos of encaustic art, and creative inspiration. Visit www.EncausticandBeyond.com to continue your exploration.